MW00805004

YOUR OWN

The Politics and Poetics of Self-determination Movements
Curated by Daniel Tucker
Catalog edited by Anthony Romero

Soberscove Press
Chicago
2016

CONTENTS

ACKNOWLEDGEMENTS

Major support for *Organize Your Own* has been provided by The Pew Center for Arts & Heritage, with additional support from collaborating venues, including: the Averill and Bernard Leviton Gallery at Columbia College Chicago, Kelly Writers House's Brodsky Gallery at the University of Pennsylvania, the Slought Foundation, the Asian Arts Initiative, the Museum of Contemporary Art Chicago, and others.

Project Staff: Abby Dangler (transcription and exhibition assistant), Paul Gargagliano (photography), Maori Karmael Holmes (administrative and communications support), Valerie Keller (video editor), Josh MacPhee (design), Anthony Romero (publications editor), Daniel Tucker (organizer and curator), Mariam Williams (exhibition engagement), and Nicholas Wisniewski (frame builder).

Exhibition Advisory Group: Maori Karmael Holmes, Billy Keniston, Lisa Yun Lee, Jennifer S. Ponce de Leon, Nato Thompson, Hy Thurman, and Rebecca Zorach.

Special thanks to: Bill Adair, April Alonso, Maggie Appell, Lily Applebaum, Maya Arthur, Lucas Ballester, Andrew Beal, Cat Bromels, Emily Bunker, Julianna Cuevas, Marnie de Guzman, Meg Duguid, Brad Duncan, James Fisher, Cecelia

Installation view, Columbia College, Chicago, 2016.

Organize Your Own: The Politics and Poetics of Self-Determination Movements

March 3 – April 9, 2016

colum.edu/ADGallery

Fitzgibbon, Al Filreis, Mashinka Furunts, Michelle Garrigan-Durant, Amleset Girmay, Jack Gruszczynski, Ramona Gupta, Pablo Helguera, Kaytie Johnson, Alli Katz, David Knight, Laura Koloski, Madeline Kirmse, Becca Lambright, Dylan Leahy, Dakota Lecos, Aril Lewis, Jessica Lowenthal, Paula Marincola, Jenn McCreary, Kristi Ann McGuire, Ian Thomas Miller, Kaitlin Moore, Peter Nesbett, Jacob O'Leary, Silvana Pop, Maura Reilly-Ulmanek, Chloe Reison, Danny Snelson, Amy Sonnie, James Tracy, Erika Van Veggel, Madeleine Wattenbarger, Megan Wendell, Roy Wilbur, Asia Williams, Autumn Wynde, Xerox Center (Kathy Krajicek and April Little), Meimei Yu, Connie Yu, the selection committee at The Pew Center for Arts & Heritage, colleagues at Moore College of Art and Design, and the participating artists, writers, and activists.

Thanks to the following media reviewers, writers, and producers for sharing words and reflections on *Organize Your Own*: WURD's Stephanie Renee, IHeartRadio's Loraine Ballard Morril, *Apiary Magazine*'s Mai Schwartz, *Philadelphia Citizen*'s Emma Eisenberg, artblog.com's Tina Plokarz, *National Catholic Reporter*'s Mariam Williams, *Chicago Tribune*'s Rick Kogan, *Hyperallergic*'s Chloë Bass, *Newcity Chicago*'s Michael Workman, CANTV, *Columbia Chronicle*'s Jessica Scott, Bad At Sports's Duncan MacKenzie.

Thanks to the following educators and organizations for bringing groups to the *Organize Your Own* exhibitions: Maggie Ginestra (Moore); Philip Glann (Tyler); Jennifer S. Ponce De Leon, Shira Walinksy, and Jane Golden, SPEC Art Collective (University of Pennsylvania); Joanna Grim, Rebecca Zorach (Northwestern University); Kera MacKenzie (Jones College Prep); the Hyde Park Art Center; Susan Giles, Annie Morse, and Lora Lode (SAIC); Harold Washington College; and Riverside Brookfield High School.

The
Pew Center
for Arts
& Heritage

GATHERING OURSELVES: A NOTE FROM THE EDITOR

Anthony Romero

The book you are holding in your hands was created on the occasion of *Organize Your Own: The Politics and Poetics of Self-Determination Movements*, a multi-city exhibition and event series that took place in Philadelphia and Chicago in

Works Progress with Jayanthi Kyle, Kelly Writers House, Philadelphia, 2016.

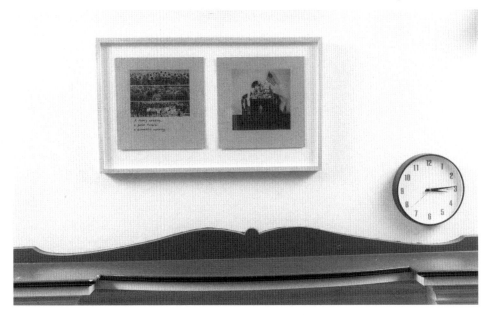

early 2016. Like the exhibition and the events that surrounded it, this book does not propose to present a history of social movements. Rather, it invites artists and poets to consider what it might mean to "organize your own" in the context of social and racial justice. What you will find in the following pages is a succession of responses, which take into account the various histories of organizing that form the foundation for contemporary notions of self-determination—ultimately bypassing those histories in favor of more interpretive and personal responses. There are existential questions hidden amongst the contributions—understanding "my own" necessarily requires that I first define myself. You will find nothing related to ownership here, as most of the contributors choose to think of 'own' not in the sense of ownership, but in the sense of an extended self—from Frank Sherlock's ruminations on Irish identity to Amber Art & Design's performative reimagining of the lawn jockey. In this way, "Organize Your Own" becomes "Gather Your Selves," and gather themselves the contributors do.

We've separated the contributions into three sections—across each you will find documentation of the exhibition's installations. The first section assembles a series of "Reflections," by writers and artists who we commissioned to supply us with texts that ruminate on the ideas, histories, and conversations surrounding the exhibition and events. The second section, a group of "Panels," consists of transcripts from the five public dialogues that took place in the locales where this project transpired. The third section, "Projects and Contributions," reflects what happened when we asked the participants to represent their contributions as they saw fit. As a result, this collection of scripts, notes, texts, and images, functions as both an extension of the physical exhibition and its material representation.

Much like the history that inspired our contributors, this is not a linear narrative, but rather a collection of intersecting accounts. Pick a place to begin that seems the most intriguing to you—that place will lead you backwards and forwards through the book, sometimes even simultaneously. It is for you then, dear reader, to gather up the many selves that occupy this collection.

REFLECTIONS

OYO: A CONCLUSION
Daniel Tucker

"Color is the first thing Black people in america become aware
of. You are born into a world that has given color meaning
and color becomes the single most determining factor of your
existence. Color determines where you live, how you live and,
under certain circumstances, if you will live. Color deter-
mines your friends, your education, your mother's and fa-
ther's jobs, where you play, what you play and, more impor-
tantly, what you think of yourself. In and of itself, color
has no meaning. But the white world has given it meaning—
political, social, economic, historical, physiological and
philosophical. Once color has been given meaning, an order is
thereby established."—H. Rap Brown (Jamil Abdullah Al-Amin),
Die Nigger Die!: A Political Autobiography (Dial Press, 1969)

"Social exclusion works for solidarity, as often as it works
against it. Sexism is not merely, or even primarily, a means
of conferring benefits to the investor class. It is also a
means of forging solidarity among 'men,' much as xenophobia
forges solidarity among 'citizens,' and homophobia makes for
solidarity among 'heterosexuals.' What one is is often as
important as what one is not, and so strong is the nega-
tive act of defining community that one wonders if all of
these definitions—man, heterosexual, white—would evaporate in
absence of negative definition. . . . At every step, 'uni-
versalist' social programs have been hampered by the idea
of becoming, and remaining, forever white. So it was with
the New Deal. So it is with Obamacare. So it would be with
President Sanders. That is not because the white working
class labors under mass hypnosis. It is because whiteness

confers knowable, quantifiable privi-
leges, regardless of class—much like
'manhood' confers knowable, quantifi-
able privileges, regardless of race.
White supremacy is neither a trick,
nor a device, but one of the most
powerful shared interests in American
history. And that, too, is solidar-
ity."—Ta-Nehisi Coates, "The Enduring
Solidarity of Whiteness" (*Atlantic
Monthly*, 2016)[1]

White people are always getting together. We get together in churches and workplaces and informal gatherings. We defy the geographic sorting that might explain our other get-togethers; we even hang-out on the Internet together. White people get together so much that it usually isn't even named. Except for those composed by extremists on the right or activists on the left, there tend not to be organizations that even acknowledge they are made up entirely or primarily of white people. People getting together—that is the organized power this is about.

Organize Your Own was an exhibition and event series inspired by the dispossessed and working-class white activists in Chicago and Philadelphia during the 1960s and 1970s (the Young Patriots Organization and the October 4th Organization), who sought to organize their own communities against racism. This book and the larger project it emerges from take up the question of people getting together generally, with specific examples of people who think they are white people and nonwhite people getting together, together and on their own.[2] This text will meander through a consideration of the relationship between current discourses around race and the role of politics and poetics in complicating and clarifying these ongoing conversations—the ones that happen when people get together.

★ ★ ★

Notes:

1 <http://www.theatlantic.com/politics/archive/2016/02/why-we-write/459909/>.

2 "On Being White . . . and Other Lies" by James Baldwin (Essence, April 1984) was the first text to formulate this phrasing, with its more recent usage introduced by Ta-Nehisi Coates in Between the World and Me (Spiegel & Grau, 2015).

3 Painter, Nell Irvin. The History of White People (New York: Norton, 2010), p. 383.

4 Ignatiev, Noel. How The Irish Became White (New York and London: Routledge, 1995), p. 1.

5 Painter, p. 396.

6 Sunkara, Bhaskar. "Let Them Eat Diversity: An Interview with Walter Benn Michaels," Jacobin Magazine (January 2011). Accessed online November 3, 2013.

7 Dubois, W. E. B. The Souls of Black Folk (New York: Fawcett, 1953; originally published in 1903), p. 105.

8 Mills, Charles W. The Racial Contract (Ithaca, NY: Cornell University Press, 1997), p. 9–40.

9 Mills, p. 11.

10 Carmichael, Stokely. "What We Want," New York Review of Books (September 22, 1966), republished in The Eyes on the Prize Civil Rights Reader: Documents, Speeches, and Firsthand Accounts from the Black Freedom Struggle (New York: Penguin Books, 1991).

11 <https://www.

Confusing discussion around race persistently impedes solidarity, while the category of whiteness baffles well-meaning anti-racists in particular and society in general. While race remains a loose[3] cultural paradox, defying any attempt to coherently claim its biological basis,[4] incredibly complex forms of oppression are often the result of political and economic agendas carried out with race explicitly or implicitly in mind. As historian Nell Irvin Painter describes it, "nonblackness," or whiteness, is a category in expansion, absorbing many people along national and skin-color spectrums, while "poverty in a dark skin endures as the opposite of whiteness."[5]

While we know that there are significant exceptions to such a formulation, Painter centers class as a consistent feature and characteristic of the nebulous category of race. Despite all the progress made in drafting anti-discriminatory policies, a thorough solution has yet to acknowledge the link between race and the economic poverty underlying the distribution of power in society. As cultural critic Walter Benn

Installation view, Kelley Writers House, Philadelphia, 2016.

Michaels argues, the turn towards a free-market fundamentalist culture of political discourse has no significant problem accepting the "political morality" of anti-discrimination on its own. As he states, "American society today, both legally and politically, has a strong commitment to the idea that discrimination is the worst thing you can do, that paying somebody a pathetic salary isn't too bad but paying somebody a pathetic salary because of his or her race or sex is unacceptable."[6] While Benn Michaels's argument for a hierarchy of oppression may seem to contradict Painter's point about the disproportionate racialization of poverty, the integration of the two perspectives offers a chance to consider more carefully the great efforts that are mobilized towards perpetuating white privileges within a capitalist economy.

In the United States, the experience of work and the opportunity for work is decidedly racialized (and historicized). The critical race theorist Charles W. Mills explains the depth of this condition when he describes the economic exploitation of nonwhite people and, in return, the psychic and economic payoff received by white people through a "Racial Contract." Mills discusses how the diverted income of slavery, the underpayment and denial of equal opportunity since Reconstruction has been calculated as equal to the entire wealth of the United States.[7] This builds on W. E. B. DuBois's 1903 assertion that the ongoing crisis for Black people in the post-Reconstruction American South is "debt in the continued inability . . . to make income cover expense, [which] is the direct heritage . . . from the wasteful economies of the slave regime." Mills concludes that:

White people, Europeans and their descendants, continue to benefit from the Racial Contract, which creates a world in their cultural image, political states differentially favoring their interests, an economy structured around the racial exploitation of others, and a moral psychology (not just in whites but

washingtonpost.com/posteverything/wp/2015/08/06/this-is-what-white-people-can-do-to-support-blacklivesmatter/>.

12 <http://www.nclej.org/poverty-in-the-us.php>.

13 Godsil, Rachel D. "Most Poor People in America Are White," The Root (December 2013. <http://www.theroot.com/articles/culture/2013/12/most_poor_people_in_america_are_white.html>.

14 Boggs, James. Manifesto for a Black Revolutionary Party (New York: Pacesetters Pub. House, 1969).

15 "Chapter 4: The Outsiders," in The American Revolution (Monthly Review Press, 1963/2009), p. 46–47.

16 For an explanation of how this "labor saving technological change" affected the US auto industry, which saw increased output despite outsourcing, see In and Out of Crisis: The Global Financial Meltdown and Left Alternatives by Greg Albo, Sam Gindin, and Leo Panitch (Spectre/PM Press, 2010), p. 85.

17 Ridgeway, James. Blood in the Face: The Ku Klux Klan, Aryan Nations, Nazi Skinheads, and the Rise of a New White Cult (Thunder Mouth Press, 1990).

18 "The Anti-Racist Action Points of Unity." <http://history.louisvillehardcore.com/index.php?title=Anti_Racist_Action>.

19 For a recent critique of

sometimes in nonwhites also) skewed consciously or uncon-
sciously toward privileging them, taking the status quo of
differential racial entitlement as normatively legitimate
and not to be investigated further.[8]

This powerful assertion suggests that a moral code underpins society with a set of agreements that empower those who identify as white to identify and determine the status of those who are not. Mills concludes, "All whites are beneficiaries of the contract, though some whites are also signatories to it."[9]

While there are historical examples of white activists contributing to the rights and liberation struggles of communities of color throughout the history of the United States—most notably through abolitionist work—the cross-cultural organizing around legal discrimination and general social conditions for African Americans that crystallized into the "Civil Rights Movement" offers the most cited legacy for today. Fifty years ago, the members of the Student Nonviolent Coordinating Committee (SNCC) civil rights organization made a historic call. SNCC leader Stokely Carmichael wrote, "One of the most disturbing things about almost all white supporters of the movement has been that they are afraid to go into their own communities—which is where the racism exists—and work to get rid of it. They want to run from Berkeley to tell us what to do in Mississippi; let them look instead at Berkeley. . . . Let them go to the suburbs and open up freedom schools for whites." He continued, "There is a vital job to be done among poor whites. We hope to see, eventually, a coalition between poor blacks and poor whites. . . . The job of creating a poor white power bloc must be attempted. The main responsibility for it falls upon whites."[10] Today the refrain can be heard again, with "Organize Yourselves" serving as the directive offered to the question, "What can white people do to support #BlackLivesMatter?"[11]

The largely unknown histories of the October 4th Organization in Philadelphia and the Young Patriots Organization in Chicago offer lesser-known examples of white activists focusing their energy within working-class white communities in Kensington and Uptown, respectively. Emphasizing the work of poor and working-class whites can offer a corrective to the incommensurate emphasis placed on Black and Brown images of poverty in the United States. True, the poverty rates amongst people of color are disproportionate to the population, but 70 percent of people living in poverty are white—in 2013, that meant 18.9 million whites were poor.[12] According to an article by Rachel Godsil for *The Root*, a blog focused on progressive politics from an African-American perspective, the stereotype of poverty as non-white:

[H]arms black people in myriad ways, especially because the political right has linked poverty with moral failure as a trope to undermine public support for government programs. . . . Our collective—and selective—memory can have a cost. When we benefit from government help but later don't acknowledge it, we are contributing to the effort to portray government programs as paid for by white people but not for us. And we are hastening their demise. We are and always have been part of these categories, so it's time we come out of the shadows and into the pictures.[13]

In a present-day context—where surpluses and scarcity of work, opportunity, and free-time are distributed unevenly—we have two options. We can either place the blame and responsibility on individuals to resolve this inequality, letting some climb to the top while others fall, proving exceptions exist within this often racialized dynamic. Or, we can create more general and generalizable forms/words/frameworks/practices that account for positions across the full spectrum of human experience and difference. If we fail to do this, those abandoned or, as James Boggs wrote in his *Manifesto for a Black Revolutionary Party* (1969), those "pushed out of the system by the system itself," will strike back.[14] What this will look like is known, and is certainly reflected in the disenchantment resulting from racist fear-mongering and other counter-productive behaviors. In 1963, Boggs, a Black auto-worker and political theorist living in

allyship, see "Accomplices Not Allies, Abolishing the Ally Industrial Complex: An Indigenous Perspective and Provocation," <http://www.indigenousaction.org/accomplices-not-allies-abolishing-the-ally-industrial-complex/> and the very instructive book which reprints it, Taking Sides: Revolutionary Solidarity and the Poverty of Liberalism, edited by Cindy Milstein (Chico, CA: AK Press, 2015).

Installation views, Columbia College, Chicago, 2016.
20 NIMBY, an acronym for

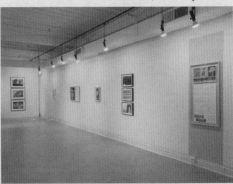

Detroit, outlined his analysis further when he claimed that "productivity can no longer be the measure of an individual's right to life. . . . Now that man is being eliminated from the productive process, a new standard of value must be found. This can only be man's value as a human being."[15]

The idea that there is liberatory potential in exclusion from the formal economy—where time could be distributed differently—stands in stark contrast to social policy focused on re-integration for continuous growth. Beyond work and welfare, consideration of these bodies and lifeforces is a necessary commitment, so that all people can have some work and some free-time, to avoid a situation of fewer jobs and more work.[16] It is a predicament premised on turning exclusion into a conversation about what it means to be human.

<p align="center">★ ★ ★</p>

These racists have plans! As a kid growing up in Kentucky and wandering the stacks of the Louisville Public Library, I came across *Blood in the Face*, a book about Neo-Nazi culture.[17] I was confronted with a map of racial bastions designed by David Duke, representing a proposal for the re-territorialization of the United States, based on sorting out the country's racial groups. These racists have plans! The map stuck with me for decades, serving as my earliest memory of the power of images to serve as visions for the future. It confirmed that those on the side of the angels did not have a monopoly on pre-figurative projections of the future, and despite the absurdity of the racist proposal—the anti-racists needed plans, as well.

My adolescent experiences with anti-racism involved a strange mix of retro civil-rights and hippie culture that advocated pacifism and more direct confrontation with the remnants of explicit racist culture—basically punks protesting whenever a handful of old Klansmen would roll into town to hold "free speech" rallies on the steps of a government building. The counter-demonstration was organized around points of unity such as, "We go where they go. Whenever fascists are organizing or active in public, we're there. We don't believe in ignoring them or staying away from them. Never let the Nazis have the street!"[18] Should we have ignored them? Would they have gone away or become emboldened (as they have today)? Each aspect seemed to engage in a backwards-looking orientation: a reverent approach to the successes of the 1960s and a disproportionate amount of attention paid to old dudes in sheets. Armed with an inherited ethical-sounding rhetoric of allyship[19]—anti-racists weren't visionaries with plans for the future—they became reactionaries, defenders of recent policy gains and social movement heritage, and NIMBYS.[20]

In the context of contemporary social movements concerned with justice and power—making plans and generating images for your plans are intimately intertwined. When #OccupyWallStreet, #IdleNoMore, #SayHerName, and #BlackLivesMatter spread images of their accomplishments and community actions, they also create a virtual gathering space for dialogue and a rallying cry to take the streets. Building on a long history of activism staged for the mass-media camera lens, these movements extend internal organization into external exhibition and become activist processes engineered for social media. Plotting, planning, deliberation, debate, and critique become public and transparent modalities through the use of comments and hashtags. Slicing through the mundanity of pet and baby photos, these dialogues, previously withheld from movements' official historical narratives until tell-all memoirs are published decades later, become the contemporary social movement archive that is the material from social media.

Through these powerful self-representations, movements can be viral and agile, while offering more people points of entry into the sub-culturally coded language and behaviors that may have previously served as exclusionary devices between activists and non-activists. Movements also open themselves up to the distractions of easy memes, fake campaigns, red-baiting, trends, cooptation, misrepresentations, comment trolls, and "Call Out" culture. Take for instance the debates pitting Caitlyn Jenner's transgender identity vs. Rachel Dolezal's transracial identity,[21] incessant privilege-checking,[22] or the largely fictive "White Student Union" pages on Facebook.[23] Underlying each of these instances is an opportunity for principled and thorough debate lost to visceral reactions and attacks, which begs the question: Does airing the movement's dirty laundry to a mass audience produce much-needed transparency or simply new forms of activist self-referentiality and subcultural marginality?

And yet this is far from fringe. Movements for racial justice impact mainstream politics, as presidential candidates

Not In My Back Yard, was utilized as early as 1980. <http://www.csmonitor.com/1980/1106/110653.html>.

21 <http://www.commondreams.org/views/2015/06/15/jenner-dolezal-one-trans-good-other-not-so-much>.

22 <http://newrepublic.com/article/121540/privilege-checking-debate-often-overlooks-income-inequality>.

23 <http://www.thecollegefix.com/post/25223/>.

24 <http://www.nytimes.com/2016/05/01/us/politics/donald-trump-vice-president.html>.

25 INCITE! Women of Color Against Violence (eds.). The Revolution Will Not Be Funded: Beyond the Non-Profit Industrial Complex (Boston: South End Press, 2009).

26 A well articulated version of this principle was STORM's revolutionary feminist views about "Sisters at the Center," reflected on in their 2004 summation document. <http://www.leftspot.com/blog/files/docs/STORMSummation.pdf>.

27 Guy, Roger. From Unity to Diversity: Southern and Appalachian Migrants in Uptown, Chicago, 1950–1970 (Lexington: Lexington Books, 2007), p. 2.

Following page spread: Installation View, Columbia College, Chicago, 2016

28 AREA Chicago is a publication focused on the

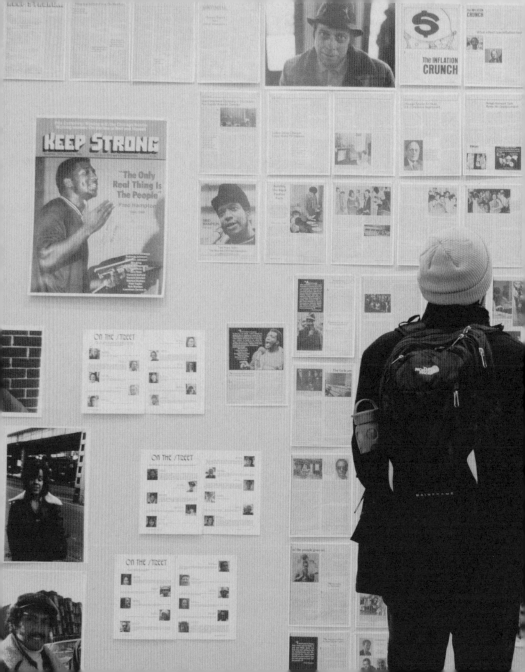

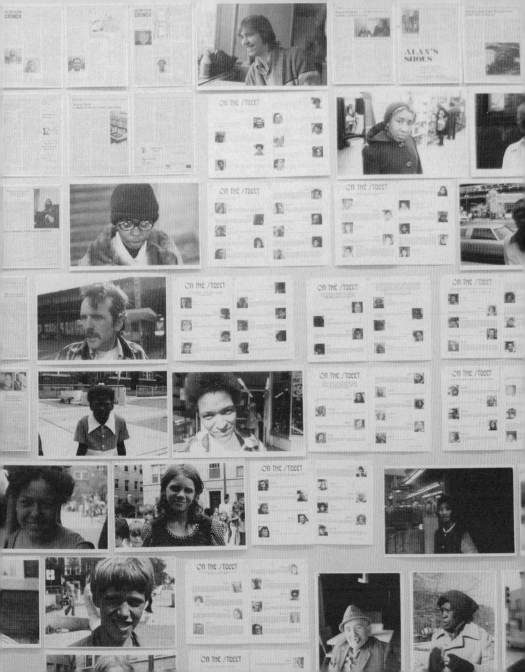

manipulate and negotiate their relationship to hybrid entities like #BlackLivesMatter, which are both discrete organizations and diffuse networks. Within the halls of government, racial identification has turned into precarious capital, where lip service is expected around subjects such as police brutality, mass incarceration, and reparations, as most white politicians concretely consider only the "demographic appeal" of certain campaign stops, polling statistics, running mates, and calculated social-media posturing.[24] This cynical appropriation of the beautiful aspirations of multicultural diversity has not been secluded to politicians. In the "non-profit industrial complex," tokenistic gestures about who sits at the metaphorical decision-making table have obscured more substantial conversations about the redistributive policies needed to create pathways to real tables and what is to be done once seated there.[25]

★ ★ ★

The brand of anti-racism that I was introduced to as an adolescent informed me that, as a white male, I should use the leadership roles I was afforded to "decenter" myself and "make space" for the voices and bodies of women and people of color.[26] Implementing these profound, if vague, principles was achieved with varying levels of "success," due to a combination of my own inabilities as a conscious organizer; statistical demographic constraints on the number of people of color relative to white people in a given context; and sociopolitical barriers that generate circumstances such that people don't want to be in rooms that are disproportionately made up of people with whom they do not identify. As my eclectic work began to take on public association with professions such as "editor," "curator," "administrator," "consultant," "advisor," "author," and "artist" (often under the broad umbrella of "organizer"), I became increasingly confronted with questions about representation: Who was at the table, how did they get there, what qualities did they find once they got there, what pathways existed for others to get there, and at which juncture did I have what responsibility to leave the table?

Over time, these considerations were often privately considered, as I found the rhetorical approaches of most white people to anti-racism surprisingly without nuance and not an appealing use of my energy to collaboratively interrogate. I often spent late-night and early-morning hours analyzing the demographic representation of projects that I organized, trying to be considerate while also avoiding direct conversation with my collaborators, co-workers, or employers. This work became further obscured as projects operated or were presented under organizational or collective authorship or in institutional settings. Most people I would discuss these issues with would either pay them little consideration, if at all, or fall victim to ambiguities that

conflated the power dynamics of political organizing with those of the cultural sector, through acts such as editing magazines or curating art shows. While my own education in anti-racism was deeply informing my work as someone empowered to frame and facilitate the work of others, I was often confused about the implications of erasing my own role in the process, as well as my own identity. I was becoming curious to develop a kind of inquiry that would be able to directly confront these tensions.

 The first time I heard of the Young Patriots and a Chicago neighborhood called "Hillbilly Heaven"[27] was from historian James Tracy at a dinner party following the 2006 National Conference on Organized Resistance in Washington, DC. It was right on the heels of founding the publication *AREA Chicago*:[28] within a few months, Tracy submitted an interview to AREA that he had done with Bob E. Lee, a member of the Illinois Black Panther Party involved in multi-racial coalition building with the Young Patriots Organization (YPO).[29] Following the further publication of articles on this history in AREA in 2008,[30] the release of *Hillbilly Nationalists*, a book by Tracy and Amy Sonnie, in 2011,[31] and my subsequent review of that book, which interwove my family's own history with that of the YPO, in 2012,[32] it felt like a broad community conversation was forming to correct a historical omission about the role of working-class white people in the movements of the 1960s and 1970s—one that highlighted the intersection of race and class in our present moment as well as our historical narratives. In the spring of 2012, I received correspondence from one of the original members of the YPO, Hy Thurman, and by fall of 2013, we had met on a walking tour of

intersections of art, research, education, and activism in Chicago founded in 2005 and continuing publication through the present, recently releasing their fifteen issue. <areachicago.org>.

29 Tracy, James. "Original Rainbow Coalition," AREA Chicago (2006). <http://areachicago.org/the-original-rainbow-coalition>.

Top: Opening Night, Kelley Writers House, Philadelphia, 2016. Bottom: Opening Night remarks by Daniel Tucker, Kelley Writers House, Philadelphia, 2016.

30 Sonnie, Amy and James Tracy. "Uptown's

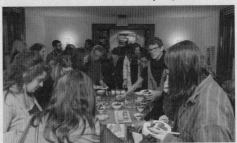

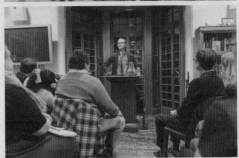

Uptown history he led with historian with Jakobi Williams. At that time, he presented me with an invitation to help recirculate out-of-print poetry by the YPO. By December 2013, my proposal to present the poems in the context of an exhibition on related contemporary art was accepted by Leviton Gallery at Columbia College—within a year and a half, the exhibition had been awarded funding from The Pew Center for Arts & Heritage to produce a Philadelphia incarnation of the project at Kelly Writers House, with dozens of participants enthusiastically accepting invitations to join in. Initiatives like *Organize Your Own* do not develop quickly or in isolation, but through a slow-burn of consideration and collaboration.

★ ★ ★

Opening Night, Kelley Writers House, Philadelphia, 2016.

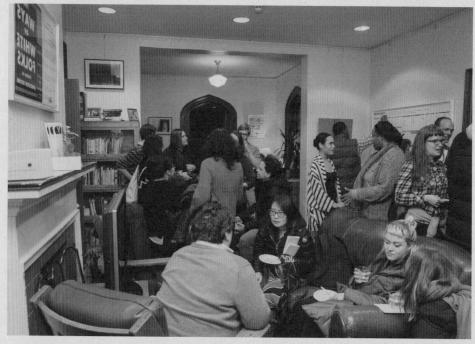

"Now more than ever we need words to help us think through that which cannot be thought. Poetry can help lift the ceiling from our brains so that we can imagine liberation."—Mariame Kaba, prison abolitionist (2016)[33]

"The Dream thrives on generalization, on limiting the number of possible questions, on privileging immediate answers. The Dream is the enemy of all art, courageous thinking, and honest writing. . . . The art I was coming to love lived in this void, in the not yet knowable, in the pain, in the question."—Ta-Nehisi Coates (2015)[34]

Colonialism and slavery are "deposits and sediments in time" that serve as the closest circumstances we have experienced as human beings to total domination, and as scholar Tony Bogues suggests they therefore deserve to be "foregrounded" in any conversation about human freedom.[35] Bogues qualifies this by saying that "the slave, the 'native,' always demanded freedom and equality as a bundle," and in turn, that domination was never absolute and human practices of freedom have always been able to be expressed even under such violent and demoralizing circumstances. But what do those "practices of freedom" look like? Are they protests or are they poems?

There is an archive at the foundation of this book that you cannot see—a record of practices of freedom that emerged from a deeply oppressive context. It is a collection of poetry that was published by the Young Patriots Organization, the group of Appalachian whites who migrated to Chicago's Uptown neighborhood and responded to police brutality and economic injustice by organizing alongside the Young Lords and the Black Panther Party. They called their publications, four in all, *Time of the Phoenix*, and wrote in their introduction to the second volume: "Search the shelves of bookstore or library

JOIN Community Union," AREA Chicago (2008). <http://areachicago.org/uptown%E2%80%99s-join-community-union/>.

31 Sonnie, Amy and James Tracy. Hillbilly Nationalists, Urban Race Rebels, and Black Power: Community Organizing in Radical Times (Brooklyn: Melville House Publishing, 2011).

32 Tucker, Daniel. "Young, White and Angry," Landline #2 (2012). <http://miscprojects.com/2012/04/07/young-white-and-angry/>.

33 Kaba, Miriam. "Imagining Freedom," Poetry Magazine (2016). <http://www.poetryfoundation.org/poetrymagazine/articles/detail/88726>.

34 Coates, p. 50.

35 Bogues, Anthony. "And What About the Human?: Freedom, Human Emancipation, and the Radical Imagination," boundary 2 39:3 (Durham: Duke University Press, 2012), p. 45–46. Notes from an updated version of this paper also come from attending Anthony Bogues's lecture at the Humanities Institute at the University of Illinois at Chicago on March 7, 2013.

36 From the Introduction to Time of the Phoenix, Vol. 2, n.d., n.p.

and you will find ample materials written for and about poor people but far and few in between are those written by poor people themselves. This anthology of song and poetry is written by poor people."[36]

In a review of the books at the time of their publication, Albert Vetere Lannon (author and former president of International Longshoremen and Warehouse Union Local 6) wrote that "The YPO—born of the streets they work in—recognized the talents among their people and encouraged poetry and songmaking along with rent strikes and revolution."[37]

The archive of out-of-print poetry was provided to the participating artists and poets featured in this book, alongside the above Stokley Charmichael quotation, and the 1969 film, *American Revolution 2*, which documents the first meeting of the Black Panther Party and the Young Patriots, as a kind of prompt.[38] The materials were intended to encourage and support the participants to share in a common language or points of reference, despite their diversity of cultural and geographic contexts and backgrounds. Inferred by this was a suggestion to the participants that they consider this history, but not be bound by it—the goal was not to produce yet another New Left/ Black Power/Civil Rights/Sixties Heritage nostalgia project. And yet intergenerational dynamics are all around us—from Hy Thurman's invitation, which serves as a foundation for this project, to reconnect with the poetry of the YPO to the persistence of #BlackLivesMatter activists calling upon white activists to organize themselves, in a manner that strikingly echoed Carmichael's call fifty years before. So it was not about avoiding history, but making use of it, after all.

There are, I think, good reasons this project became an art—and not a history—exhibition. Both ambiguous and critical concerns are bound up in any look at the past, let alone the present. The participants are living and breathing new life into their actions and their questions about racial justice and what "your own" means today. As many of the projects explore, there is not necessarily a coherent entity called the "Black community" (or let alone, "white community") that one can attach to—despite it attaching to our demographic and statistical selves all the time. And while there have been moments when race in the United States felt Black and white, that has never been the case—any calls to abolish racism or complicate over simplistic conceptions of race in society would start with an expansion and then complication of this premise. Further, the concept of "self-determination" underlying this book and exhibition, which was so powerful in its anti-colonial inception to fight "predetermination" of life and living, can and should include some consideration of how the self is both one and many. And finally, while there is focus on the 1960s and '70s for good reason, any deep exploration confronting racial oppression in the US has other equally important

connections to the indigenous, rebels, "race traitors," and nonconformists who have emerged before and after those pivotal decades. The future needs new plans. And it is poetry—in a broad sense, that includes the written and the visual—which can help us build on the plans that have already been generated to provide more direct paths to convoluted realities and inherited dreams.

Joan Didion once wrote, "The Dream is teaching the dreamers how to live."[39] The deformation that characterizes our present social life is untenable, and this has a great deal to do with race. It takes so much work to maintain the present configuration of social relations—and while that work is distributed unevenly, we are all demoralized and psychically beat down. Thus far, the attempts to confront such conditions have left many dead and wounded, while some continue to march under their banners more fiercely, and in some cases, more violently than ever. This includes the self-determinationists and the separatists, the racists and the police, the youth and those who gained ground long ago. Legal scholar Michelle Alexander recently offered up this challenge to our present moment: "The question that remains unanswered is are we going to be capable of extending care, compassion, and concern across lines of race, class, religion, nationality or are we going to be enslaved by our punitive impulses and respond to those we label 'other' with pure punitiveness? . . . [This] is ultimately a test of whether this multi-racial, multi-ethnic will succeed or fail in the long run."[40]

As we think about getting together and all that means today, depending on with whom and where and why we convene, there are no guarantees we will succeed, but at least we can stop dreaming the same terrible dreams and start making plans.

37 "Working Class Poets: Review of Time of the Phoenix," Guardian (June 6, 1972), n.p.

38 Gray, Mike and Howard Alk, dir. American Revolution 2 (Film Group, 1969).

39 Didion, Joan. "Some Dreamers of the Golden Dream," Saturday Evening Post (1966), republished in Slouching Towards Bethlehem: Essays by Joan Didion (New York: Farrar, Straus and Giroux, 1968), n.p.

40 Tippet, Krista and Michelle Alexander, "Who We Want to Become: Beyond the New Jim Crow," On Being with Krista Tippett (April 21, 2016). <http://www.onbeing.org/program/michelle-alexander-who-we-want-to-become-beyond-the-new-jim-crow/8603>.

Mark Nowak

A poem—
is first a dreamy note,
till it be wrote.
 —Ed Mampel, from "A Poem,"
 Time of the Phoenix, Vol. 4

Literary history is a curious motherfucker.[1] Let's take 1970, for example. On May 4, Ohio National Guardsmen open fire on a crowd of anti-war protestors at Kent State University. They kill four students—Jeffrey Miller, Allison Krause, William Schroeder, and Sandra Scheuer—and wound nine others. Eleven days later, at Jackson State University in Mississippi, police fire approximately 400 rounds of bullets and buckshot into Alexandra Hall to quell a protest. They kill Phillip Gibbs, a junior and the father of an 18-month-old child, and James Earl Green, a high-school senior.[2] Gil Scott-Heron releases his first album in 1970, *Small Talk at 125th and Lenox*. The album opens with "The Revolution Will Not Be Televised" and its cover proclaims Scott-Heron a "New Black Poet."

While events like Kent State, Jackson State, and "The Revolution Will Not Be Televised" produce ruptures and resistance across the American landscape, the Pulitzer Prize in poetry is given to Richard Howard's *Untitled Subjects*. Composed during the social turbulence of the late 1960s, and officially released in 1969, *Untitled Subjects* is far from a thermometer of the times. In fact, *Kirkus Reviews* asserts that if it were Howard's "intention to create a kind of historical almanac with fusty circumlocutions, garden party wit, and the flavor (rarely strained, though rarely infectious) of nineteenth century mores, obsessions, and somnolence, all done up in elaborate forms, mostly syllabic (oddly-enough, everything here could really be read as prose), then he

has eminently succeeded."[3] Indeed Howard's book is hardly a volume of poetry with any intentions to stand in solidarity with the times or "bring the war home."

The following year, in 1971, the accolades of institutional poetry (a.k.a., "Poetry") grow slightly sharper political teeth. When W. S. Merwin learns that he's been awarded the Pulitzer Prize for his volume *The Carrier of Ladders*, he authors a brief notice, "On Being Awarded the Pulitzer Prize," which is published in the June 3, 1971, edition of the *New York Review of Books*. Merwin opens by thanking the judges for their opinions about his work, but continues by asserting that after "years of the news from Southeast Asia, and the commentary from Washington," he is "too conscious of being an American to accept public congratulation with good grace, or to welcome it except as an occasion for expressing openly a shame which many Americans feel, day after day, helplessly and in silence." He concludes by asking that his Pulitzer Prize money "be equally divided between Alan Blanchard . . . a painter who was blinded by a police weapon in California . . . and the Draft Resistance."[4] One month later, in the pages of the same eminent magazine, Merwin's Pulitzer response is chastised by none other than W. H. Auden as "an ill-judged gesture," which "sounds like a personal publicity stunt."[5] Merwin, as might be expected, publishes a retort to Auden that is also printed in the pages of the *New York Review of Books*.[6]

This is how literary history is played out at the apex of the pyramid: *Reviews* review; secret judges secretly judge; younger male poets, for reasons solid and self-serving, attempt to slay their Oedipal elders in the pages of esteemed New York City-housed literary monthlies; and the singular genius is isolated from the masses of creative workers, excessively celebrated and handsomely rewarded. The years under discussion here represent a watershed period for publications in the people's history of poetry and the poetry workshop. The poems produced in community spaces and published during this historical moment are not only more

Notes:

1 With a nod to the opening of Bill Ayers's Fugitive Days: A Memoir ("Memory is a mother-fucker," p. 8).

2 Wyckoff , Whitney Blair. "Jackson State: A Tragedy Widely Forgotten." <http://www.npr.org/templates/story/story.php?storyId=126426361>.

3 "Untitled Subjects," Kirkus Reviews. <https://www.kirkusreviews.com/book-reviews/richard-howard-4/untitled-subjects/>.

4 Merwin, W. S. "On Being Awarded the Pulitzer Prize," New York Review of Books (June 3, 1971). <http://www.nybooks.com/articles/1971/06/03/on-being-awarded-the-pulitzer-prize/>.

5 W. H. Auden, "Saying No," New York Review of Books (July 1, 1971). <http://www.nybooks.com/articles/1971/07/01/saying-no/>.

6 Merwin, W. S. Untitled reply to Auden, New York Review of Books (July 1, 1971). <http://www.nybooks.com/articles/1971/07/01/saying-no/>.

Following page spread: *Time of The Phoenix*, Vol. 1 (Chicago: Columbia College Press, 1970).

profoundly engaged in the political climate of this radical era than many of the cele-brated and canonized volumes of the period, but also take on a more agitated, partisan stance. They are attempts to rewrite those "hidden episodes" of migration, war resis-tance, racism, police violence, sexism, and other struggles faced by poor and working people, particularly poor and working women of color.

So in contrast to a vertical and hierarchical literary landscape, the objective of what follows is not an engagement with the history of canonized poets and elite arts organizations, but the employment of what I've taken to calling a people's history of poetry and the poetry workshop. It is an analysis of more populist poetries produced during the same period by the non-canonized, non-elite, including school children in Brooklyn, inmates at Attica prison in the months following the riots, and social move-ment activists from the Black Panther Party, the Weather Underground, and the Young Patriots Organization.

The term "people's history" is, of course, borrowed from Howard Zinn's monu-mental study *A People's History of the United States*. In the book's opening chapter, Zinn argues for a new conception of history that is both creative and emancipatory: "If history is to be creative, to anticipate a possible future without denying the past, it should, I believe, emphasize new possibilities by disclosing those hidden episodes of the past when, even if in brief flashes, people showed their ability to resist, to join to-gether, occasionally to win."[7] Similarly, then, a people's history of poetry and the poetry workshop is a creative literary history emphasizing 'those hidden episodes of the past.' It encompasses poems that deeply engage suppressed histories, resistance practices, agency, and solidarity among their community's members.

One significant example of this kind of people's history of poetry and the poetry workshop is *The Voice of the Children*, an anthology collected from community-based poetry workshops facilitated by June Jordan and Terri Bush in the late 1960s in Brooklyn's Fort Greene neighborhood. In the book's afterword, Jordan describes the founding of the workshop, its unstable funding and geography, and the type of students the workshop attracted: "At first we were sponsored by The Teachers and Writers Collaborative Program," she writes. "Then, and ever since, we have continued on a volunteer basis, supported by the growing number of friends these Black and Puerto Rican teen-agers have gathered around them."[8] Finding a space for these community-based youth workshops was never easy. Jordan goes on to note: "[W]e had some trouble finding a place of our own: someplace warm with a window, tables, and an outlet for the phonograph . . . But finally, The Church of the Open Door gave us a room of our own. Then Doctor White Community Center has given us a space where we can be together, working with, fighting with, words."[9]

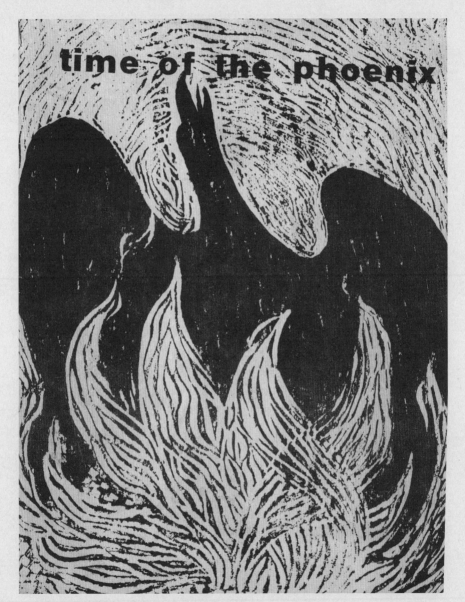

time of the phoenix

The young writers group met every Saturday, And though Jordan admits that Saturday's were usually "no time for school," she and Terri Bush "tried to set things so that the workshop would differ, as much as possible, from school." For the Black and Puerto Rican teenagers who participated in their workshops, Jordan believed "school is mostly a burial ground for joy and promise. School is where these poets and writers are often termed 'verbally deficient,' or worse."[10] One illustration of typical New York City public schools in the years leading up to the early 1970s can be found in Herb Kohl's classic volume *36 Children*. Kohl describes a school in which "there was no complete set of sixth-grade arithmetic books," and social studies units are "full of stories about family fun in a Model T Ford." In response to these textbooks, one of Kohl's students responds: "It's a cheap, dirty, bean school," while another concludes that the books are "phoney."[11] Conditions like these were ubiquitous in the schools attended by June Jordan's workshop participants.

Through poetry, however, Jordan's workshop students were given an opportunity to address this locus of their lives. The poems published in *The Voice of the Children* are divided into five sections: "Politics," "Observations," "Blackness," "Love and Nature," and "Very Personal." In "Politics," 12-year-old Veronica Bryant writes a poem in which she asks, "why women can't be president," while David Clarke, Jr., 14, declares in a prose poem that "We Can't Always Follow the White Man's Way." The predominantly rhyming couplets of "The Last Riot" by Vanessa Howard still ring true in our era of Ferguson and #BlackLivesMatter. Likewise, 10-year-old Christopher Meyer's mordant examination of "Wonderful New York" moves from an opening stanza that describes the decaying cityscape:

> The hypnotizing neon light
> the street banks like garbage dumps
> and the drunk vacuum cleaner
> who suck up whiskey like air

to stanzas where he links global New York to his personal experiences of the city:

> As New York provides a building for the U.N.
> so shall it provide its cemetery
> Invisible dangers are always around the corner,
> as hell is around the corner for me.

While this is both a stark and fiercely political ending for anyone's poem, it speaks even more vociferously when it comes from the pen and imagination of a child who has barely been in the world for a single decade.

Yet it isn't only the "Politics" section where the political poems are to be found. For example, the "Observations" section includes writings on "The Lost Black Man," "Children as Slaves," and "I'm No Animal," while the "Blackness" section includes a strong range of poetic subjects including "for Nina Simone wherever you are" by 15-year-old Linda Curry, young Miriam Lasanta's "My Soul Speaks Spanish," and the interrogative-laced, Black Arts–inspired "What's Black Power?" by Loudel Baez, age 12:

> Is Black power a knife in your back?
> Is Black power winning a fight?
> Is Black power killing a White?
> Is Black power having a gang?
> Is Black power getting high?
> Is Black power wanting to die?
>
> Or is Black power being proud,
> standing out in the crowd,
> standing with your fist held high?

This political tenor continues throughout the remaining sections of "Love and Nature" (with poems about the Vietnam War) and "Very Personal" (including a poem that employs the repetition of Lawrence Felinghetti's famous line, "i am waiting"). The Voice of the Children closes with a compelling haiku by 14-year-old Juanita Bryant—in which she reiterates the idea that is prevalent throughout the anthology—the idea that the personal is the political:

> No friends nor enemies
> cross my way
> And isolated I will stay

Unfortunately, but not uncommon for political verse, The Voice of the Children is published in precisely the same year as the much more apolitical and playful Wishes, Lies, and Dreams: Teaching Poetry to Children by Kenneth Koch and the students of P.S. 61. Koch's volume garners significant national attention (including a number of feature pieces

7 Zinn, Howard. A People's History of the United States: 1492–Present (New York: Harper Collins, 2003), p. 10–11.

8 Jordan, June and Terri Bush, eds. The Voice of the Children (New York: Holt, Rinehart and Winston, Inc.: 1970), p. 94.

9 Ibid., p. 95.

10 Ibid.

11 Kohl, Herbert. 36 Children (New York: Signet, 1968), p. 19–20.

12 "Wish" poems begin to densely populate state-sponsored poetry in the schools anthologies almost immediately after the publication of Koch's anthology. To cite but two examples from different regions of the country: Measure Me, Sky: The South Carolina Arts Commission Anthology of Student Poetry for the Poetry-in-the-Schools Program (1972) includes numerous wish poems; likewise, the inaugural publication of the Arkansas poets-in-the-schools program, i used to be a person (1973–74), is saturated with Koch-inspired wish, lie, and dream poems.

13 Lopate, Phillip. "The Balkanization of Children's Writing," The Lion and the Unicorn, 1.2 (1977), p. 101–02.

in the *New York Times*, *Life*, the *New York Review of Books*, and elsewhere). Koch's affable approach, rather than the radical agency of Jordan's *The Voice of the Children*, becomes a model for the poetry in the schools program funded by the National Endowment for the Arts in the 1970s and serves as the inspiration for literally hundreds of playful "wish" and "lie" and "dream" poems in anthologies published by state arts boards across the United States.[12] It becomes, quite simply, a Fordist model for the mass production of youth poetry. As Phillip Lopate argues in his assessment of Koch's technique, "[T]here is still something mechanically induced about the hip, modernistic surface of many of the *Wishes, Lies, and Dreams* poems . . . This method is a fail-safe pedagogic machine for the mass production of surrealist metaphors."[13]

By contrast to *Wishes, Lies, and Dreams*, the reception of *The Voice of the Children* is limited to a pair of brief, sober notices in the *New York Times*. On January 24, 1971, the *Times* publishes Eve Merriam's response to three new books, which includes *The Voice of the Children*. Accompanying her review, titled "For Young Readers," is an image of two darkened hands bound by shackles. Merriam opens her inept review by informing readers of the *Times* that, "Black consciousness-raising is an ambiguous phrase." She contends that it can "suggest raising the level of consciousness among whites about blacks" (of course she opens with what the term might mean to white people) as well as "making blacks more self-aware." She says almost nothing about Jordan's book, instead opening with a lengthy quotation from Christopher Meyers's poem "Wonderful New York," cited above. She follows this with two more lengthy quotations from poems by Michael Goode and Vanessa Howard, then concludes with a single sentence of her own, "One can only echo what June Jordan states in her Afterword: 'With all my heart, I wish the voices of these children peace and power.'" In the pages of the *New York Times*, the revolutionary agency of June Jordan's *The Voice of the Children* will decidedly not be televised.

Ten months after Merriam's dismissive notice, Martin Gansberg brings Jordan's book back to the *New York Times* readership when he pens the project's obituary. In "Voice of the Children Is Stilled," Gansberg's first sentence reproduces Merriam's final statement on wishing the children's voices "peace and power." After a brief overview of the workshops, Gansberg informs readers that "[n]ow comes word that their writing workshop . . . has been stilled for lack of funds."[14] After mentioning dried-up funding "from an earlier group called Writers Collaborative" and "some additional financial support when Holt, Rinehart & Winston gave the group an advance of several thousand dollars on the book,"[15] Gansberg concludes by citing poems already printed in Merriam's earlier review, including those by Michael Goode and Carlton Minor. Gansberg terminates his death notice by quoting a single all-caps stanza from Minor:

I'M NO ANIMAL
I'M NO ANIMAL
I'M NO ANIMAL

In the end, the principal newspaper of New York City chooses to barely notice Jordan's exceptional project while it thrives, but is seemingly all too happy to devote additional space for the project's detailed obituatry.

As the Koch anthology continues to be glorified in the press and in classrooms across the United States, numerous politically engaged poetry anthologies begin to appear in the first years of the 1970s, most receiving even less or poorer press coverage and classroom use than the Jordan-Bush anthology. In 1970, New York's World Press releases Herbert Kohl and Victor Hernández Cruz's magnificent anthology *Stuff: A Collection of Poems, Visions, & Imaginative Happenings From Young Writers in Schools — Open and Closed*. The following year, 5X Publishing in New York publishes a similarly noteworthy volume, *Three Hundred and Sixty Degrees of Blackness Comin' at You: An Anthology of the Sonia Sanchez Writers Workshop at Countee Cullen Library in Harlem*. Grove Press releases yet another compelling anthology of youth poetry edited by Irving Benig in 1971, *The Children: Poems and Prose from Bedford-Stuyvesant*.[16] The following year, American Faculty Press releases Nicholas Anthony Duva's outstanding collection of Jersey City middle school poets, *Somebody Real: Voices of City Children*.

Between the two reviews of June Jordan's *The Voice of the Children* in the *New York Times*, radical protests begin to break out in the expanding US prison industrial complex. On August 21, 1971, prison guards at San Quentin open fire on and murder writer, activist, and Black Panther Party member George Jackson. The following morning, inmates at Attica State Prison in Western New York fast and hold a silent protest in response to Jackson's murder.[17] Two weeks later, Attica inmates rebel and take the D-Yard (and

14 Gansberg, Martin. "Voice of the Children is Stilled," New York Times (Nov. 7, 1971), A18.

15 I believe Writers Collaborative here refers to Teachers and Writers Collaborative. And while I couldn't locate a source, it seems likely that the advance was a payment to the book's editors, not direct financial support of their workshop.

16 In the intro to The Children, Benig says that his decision to teach in Bed-Stuy was motivated by the war in Vietnam: "Someone told me that teachers teaching under the auspices of the Board of Education of the City of New York don't get drafted; that is, if they teach in a "bad" area, Harlem or Bedford-Stuyvesant . . . The bloodied hands of Lyndon Johnson, Robert McNamara, Dean Rusk, and W. W. Rostow, clutched at me and, with my tail between my legs, I chose the Board of Education." (p. vii–viii).

17 Wicker, Tom. A Time to Die: The Attica Prison Revolt (Chicago: Haymarket Books, 2011): p. 315. First published 1975 by Quadrangle/New York Times Book Co.

up to fifty hostages). After four days of negotiation and standoff, Republican Governor Nelson Rockefeller orders troops to retake the prison on September 13, which results in the death of 43 inmates and guards. While journalists are initially told that inmates slashed the throats of some of their victims and emasculated others, an independent coroner's report later concluded that all had died from "a bullet that had the name Rockefeller on it."[18]

Several months after the Attica revolt, Celes Tisdale, an assistant professor at Erie Community College in the nearby city of Buffalo, is invited to run a creative writing workshop at the prison. Tisdale's journal entries from his first workshop at Attica on May 24, 1972, are divided into sections titled "Anticipation," "Before the Great Wall," and "Within." The 6:15PM entry under "Within" reveals the deeper personal connection that the poetry teacher had to some of his new students at Attica: "The men are coming in now. I recognize some of them from the old days in Willert Park Projects and Smitty's restaurant where I worked during the undergraduate days. They seem happy to see me but are properly restrained (strained?)."[19] Tisdale finds something quite different from the media's portrayal of rebelling inmates who were supposedly slashing throats and severing genitalia during the Attica rebellion. "Their sensitivity and perception were so intense," Tisdale writes, "that each Wednesday night, I came home completely exhausted."[20]

Two years after Tisdale's initial workshop at Attica, Detroit's Broadside Press publishes an anthology of the participants' poems, as well as Tisdale's journal entries, in *Betcha Ain't: Poems from Attica*. In my reading of poems from *Betcha Ain't*, I want to draw on Joy James's essential work on the "(neo)slave narrative," a term she initially borrows from John Edgar Wideman's introduction to Mumia Abu-Jamal's *Love from Death Row*. For James, (neo)slave narratives "reflect the languages of master, slave, and abolitionist." The battle between these three subject positions "created the language of the fugitive or incarcerated rebel—the slave, the convict."[21] When addressing the long literary history of the (neo)slave prison narrative, James asserts that:

> Through their narratives, imprisoned writers can function as progressive abolitionists and register as "people's historians." They become the storytellers of the political histories of the captives *and* their captors. These narratives are generally the "unauthorized" versions of political life, often focusing on dissent and policing and repression.[22]

A single-stanza poem by Brother Amar (George Robert Elie), "Forget?," certainly registers as having been written by a "people's historian" of the Attica revolt, offering

readers, as James asserts, an "unauthorized version" of political life in the prison while "focusing on dissent and policing and repression":

> They tell us to forget Golgotha we
> tread
> scourged with hate because we dared
> to tell the truth of hell
> and how inhuman it is within.

Inmate Isaiah Hawkins addresses the bloodiest day of the revolt, September 13, 1970, in his poem "13th of Genocide," while Mshaka (Willie Monroe) writes of the Attica rebellion's aftermath in "Formula for Attica Repeats":

> and when
> the smoke cleared
> they came aluminum paid
> lovers
> from Rock/The/Terrible,
> refuser
> of S.O.S. Collect Calls,
> Executioner.
>
> They came tearless,
> tremblers,
> apologetic grin factories
> that breathed Kool
> smoke-rings
> and state-prepared speeches.
> They came
> like so many unfeeling fingers
> groping without touching
> the 43 dead men
> who listened . . .
> threatening to rise
> again . . .

Other poems in the collection also examine this bloody massacre, including Christopher Sutherland's "Sept. 13" and Sam Washington's "Was It Necessary?" The writers

18 Wicker, A Time to Die, p. 301.

19 Tisdale, Celes (ed.). Betcha Ain't: Poems from Attica (Detroit: Broadside Press, 1974), p. 51.

20 Ibid., p.12.

21 James, Joy (ed.). The New Abolitionists: (Neo)Slave Narratives and Contemporary Prison Writings (Albany, NY: State University of New York Press, 2005), p. xxv.

22 Ibid., p. xxxii.

in Tisdale's Attica workshop were certainly becoming, in James' configuration, "the storytellers of the political histories of the captives and their captors," perhaps none with such force as John Lee Norris's poignant, lyrical, and ultimately devastating poem, "Just Another Page (September 13–72)":

```
A year later
And it's just another page
And the only thing they do right is          wrong
And Attica is a maggot-minded black          blood sucker
And the only thing they do right is          wrong
And another page of history is writ          ten in black
blood
And old black mamas pay taxes to buy         guns that
killed their sons
And the consequence of being free            . . . is death
And your sympathy and tears always           come too late
And the only thing they do right is          wrong
    And it's just another page
```

In this atmosphere of a vibrant people's poetry surfacing everywhere from community centers in Brooklyn to prison classrooms in Attica during the early 1970s, is it all that surprising that revolutionary organizations of the same historical period begin documenting their encounters with racism, sexism, state repression, police violence, and the war in Vietnam through poetry? For the remainder of this essay, I'd like to look briefly at the writings of other "people's historians" in a coauthored volume by two members of the Black Panther Party and a poetry anthology by women in the Weather Underground, then conclude by examining a bit more deeply the verse collected in four volumes of *Time of the Phoenix*, a poetry magazine/pamphlet of writings by members of the Young Patriots Organization, the Rainbow Coalition, and fellow travellers in the early- to mid-1970s.

The connection between the United States prison industrial complex and the Black Panther Party and other radical movements runs deep—even as it relates to poetry. As Amy Washburn argues in "The Pen of the Panther: Barriers and Freedom in the Prison Poetry of Ericka Huggins," incarcerated Panthers like Huggins regularly turned to poetry not as an escape, but as a form of ongoing activism. Huggins spent three years, 1969–72, in prison at Niantic State Farm for Women, often in solitary confinement. According to Washburn, Huggins wrote regularly while in prison and "nurtured her devotion to revolution behind bars by writing about the deplorable social conditions she and her community experienced."[23] Some of these writings were

eventually released by acclaimed San Francisco publisher City Lights Books under the title *Insights & Poems*, a volume that also includes writings by Panther cofounder Huey Newton.

One of Huggins's poems in *Insights*, "A Reflection on Niantic," is a musing on prison life and the disproportionate incarceration of people of color that Michelle Alexander has cogently dubbed *The New Jim Crow*.[24] Huggins' poem opens by reflecting on the myriad ways in which she experiences "brown" at Niantic:

```
brown
fall the leaves of
golden yellow on
cold ground
brown the feet
of the dispossessed
        brown around
        the asphalt
that darkens the
road
```

Though the leaves themselves maintain a golden yellow—or do so at least momentarily in their autumnal transition in the Connecticut landscape—everything else is either described with the color brown or by words like "asphalt" or "darkens." In the lines that follow, Huggins sets this symbolic and politicized "brown" in a dialectical relationship to whiteness: "the winter comes/brown is covered/ with snow/ and heavy prison coats." These lines suggest several possible readings. In one, Huggins is simply documenting the changing landscape; the fallen leaves are being covered by winter snow as prisoners don winter coats in the inclement weather. In an alternate reading that incorporates race and struggle, the "heavy prison coats" represent the prison guards themselves, whose whiteness covers and attempts to silence the prisoners.

Huggins brings her reflection on life at Niantic State Farm for Women to a close by invoking the solidarity of sisterhood and re-invoking the symbolic color brown:

23 Washburn, Amy. "The Pen of the Panther: Barriers and Freedom in the Prison Poetry of Ericka Huggins," Journal for the Study of Radicalism 8.2 (2014), p. 56.

24 As Alexander notes, "The United States imprisons a larger percentage of its black population than South Africa did at the height of apartheid." In Michelle Alexander, The New Jim Crow: Mass Incarceration in the Age of Colorblindness (New York: The New Press, 2010), p. 6.

```
my sisters linger in the night air
  hover by the door
    handcuffed or not
the jail holds their bodies—brown;
  holds their minds—blue.
```

Throughout her writings in *Insights & Poems*, Ericka Huggins becomes a "people's historian" of Niantic, documenting the struggles of the incarcerated women, while employing the poem as a mode of activism and resistance. As Washburn asserts, "Repositioning women's political and cultural work with the black power/liberation movement shows a fuller, more inclusive vision of this historical period."[25] Likewise, Huggins's poetry demonstrates "the role aesthetic productions played for black women as critiques of white supremacy and heteropatriarchy in ways they could not do politically, socially, and economically due to [their] imprisonment."[26]

Sing a Battle Song: Poems by Women in the Weather Underground Organization, an anthology written and published during the same period as Newton and Huggins's *Insights & Poems*, illustrates other facets of the early-1970s political climate and the importance of alternative aesthetic practices. The untitled, anonymous introduction to *Sing a Battle Song*, dated January 1975, outlines how a collection of poetry penned by "people's historians" might be distinguished from the poetry of elite institutions. "We are not professional poets," the authors of the introduction declare. "We prepared this book of poetry as cultural workers, striving to create poems which are accessible to the people and responsible to the struggle."[27] This configuration of a poetics of *accessibility*, *responsibility*, and *struggle* is significant here; it establishes a poetics distinct from institutional poetry and centers poetic practice as a tool of people's active resistance.

The women of the Weather Underground—inspired, as they declare in their introduction, by radical women poets like Sonia Sanchez, June Jordan, Judy Grahn, and Diane di Prima (none of whom have ever receive accolades like the Pulitzer)—sought to engage what so much poetry of accessibility, responsibility, and struggle attempts to do: work between the first person singular ("I") and the first person plural ("We"), while simultaneously allowing space for both individual voice and group solidarity within a creative process. The writers of the introduction inform us that each poem is written by a woman who is an individual, yet they go on to highlight that each poem was also workshopped; each poem was "discussed collectively: praised and criticized for its content, its craftwomanship, its effectiveness." Overall, the women poets of the Weather Underground sought "to integrate individual and collective energies" as a means to "develop and improve" women both individually and as a collective social force.[28]

Contemporary literary history and criticism rarely examines the poetry of people's historians. Though recent volumes like Mike Chasar's *Everyday Reading: Poetry and Popular Culture in Modern America* are beginning to pay critical attention to more populist forms of poetry, the tenor of most literary criticism is seldom anything but derisive. Reviewing the reprint of *Sing a Battle Song* in the *Guardian*, for example, British poet and book reviewer Ian Pindar can only muster up a three-word phrase to describe the poetry of the women of the Weather Underground, dismissing it as "hectoring feminist verse."[29]

Against this widespread dismissiveness, I see a distinctive range of poetries at work in *Sing a Battle Song*. Some of it employs themes and strategies from progressive women poets, such as Muriel Rukeyser and her attention to "the road" and the nation-state in "The Book of the Dead: The Road." The anonymous poet who wrote "People's War" (Summer 1972) that was published in *Sing a Battle Song*, for example, talks about "the same road,/built and then destroyed and rebuilt," as well as "invisible trails . . . the path/ where headlights would betray," and "The streets/lined with legless beggars." In one central section, the poem uses the symbol of the road in relation to US imperialism in the context of the Vietnam War:

```
What is the road?
The Americans mark it on the map
a known line—
But its measure lies in other
        dimensions. . .
```

The poet uses the opening interrogative to engage the reader (again, this idea of *accessibility*) followed by a line that critiques United States's dominance and aggression. The use of "line/lie" in the third and forth lines of the stanza follow the opening question by examining whether the line marked by Americans is yet another imperial inscription, another one of the compounding lies of the US government

25 Washburn, "The Pen of the Panther," p. 71.

26 Ibid., p. 71–72.

27 Dohrn, Bernadine, with Bill Ayers and Jeff Jones, eds. Sing A Battle Song: The Revolutionary Poetry, Statements, and Communiqués of the Weather Underground, 1970–1974 (New York: Seven Stories Press, 2006), p. 74.

28 Ibid., p. 74.

29 Pindar, Ian. "Weather Reports," Guardian, Jan. 20, 2007. <http://www.theguardian.com/books/2007/jan/20/politics1>.

during the Vietnam War, or something *inaccessible* ("in other dimensions") about US involvement in the war. This brief excerpt even engages several of the categories of the poem itself (line/measure) to reflect on the larger context and connotations of poetic composition.

The interrogative is a mode frequently employed in many poems whose poetics are grounded in accessibility, responsibility, and struggle. In *Sing a Battle Song*, poems like "Venom II," written during the winter of 1974, pose significant questions like "What turns class hatred/inside out?" and "What is the bridge to you?" I find these persuasive inquiries to be irreconcilable with the notion of a 'hectoring feminist verse.' Additionally, to cite but one example, the opening stanza of "Venom II" appears to me as concise and well-crafted an opening to a poem as one might find in any issue of an institutional literary journal like *Poetry* magazine from the early 1970s:

```
I wonder about the
tight-faced
work-worried women
in cloth coats and curlers
spitting hate
in Birmingham or Boston.
```

Yet in the end, it's never a question of whether poems such as these might somehow be on par with poems of the literary establishment. Quite the opposite. The objective of the "craftwomanship" of "Venom II" isn't about entering the literary canon. In response to the question "What is the bridge/to you?" the author of "Venom II" inscribes a two-line response which also serves as the conclusion to the poem: the bridge is an action, i.e., "our struggle/to reveal it."

Although the poems of Ericka Huggins and the women of the Weather Underground have been published and reprinted by progressive presses like City Lights on the West Coast and Seven Stories on the East Coast, the vast body of poems published in *Time of the Phoenix*, a journal that emerged out of the Young Patriots Organization, have received almost no attention until now. Nevertheless, the poetry published across the four issues of *Time of the Phoenix* (1970–76) leaves a vast repository by "people's historians" on struggles with poverty, police violence, migration, and more, all in verse form.

Formed in Chicago's Uptown neighborhood in the late 1960s, the Young Patriots Organization (YPO) was part of a "vanguard of the dispossessed."[30] Its members were raised in Appalachia, and the organization's politics were inspired by the Black Panther Party and the Young Lords. In *Hillbilly Nationalists, Urban Race*

Rebels, and Black Power: Community Organizing in Radical Times, authors Amy Sonnie and James Tracy assert that the YPO "may have formed with or without the direct influence of the Chicago Panthers, but there is no doubt that the Black Panther Party lent primary inspiration, theoretical framework and a programmatic model to the Uptown organization."[31] And while members of the YPO were involved in varied activities such as creating breakfast programs and health clinics, several Patriots, including one of the YPO's founders, Doug Youngblood, "worked most of his ideas out in poetry and political essays."[32] The pages of each issue of *Time of the Phoenix* suggest that many other Patriots and fellow travellers in the early years of the 1970s turned to poetry, too.

The inaugural issue of *Time of the Phoenix* included a wide range of poetic styles and themes. The Patriots members' Appalachian roots were celebrated in poems like Georgia Atkins's "A Southern Band of People" and Ruth Gorton's "Mountaineers are Always Free." An emergent feminist critique is inscribed in poems like Gorton's "You Think 'Cause I'm a Woman" and others like it, many of them in poetic solidarity with poems by the women in the Weather Underground from the same historical period.

One of the more multifaceted poems of the first issue, a poem that engages many of the themes discussed throughout this essay as well as one of the first in *Time of the Phoenix* to discuss poverty and the political state of Uptown Chicago, is Patricia Gonterman's "Apathy, Confusion & A Wee Bit O' Irony." The poem opens by addressing an array of issues including prisons, cops, schools, alcoholism, and murder:

30 Sonnie, Amy and James Tracy, Hillbilly Nationalists, Urban Race Rebels, and Black Power: Community Organizing in Radical Times (Brooklyn: Melville House, 2011), p. 3.

31 Ibid., p. 69.

32 Ibid., p. 72.

Time of The Phoenix, Vol. 3 (Chicago: Columbia College Press, 1973.

Time Of The Phoenix

volume 3

```
Did you hear, Mary Scott had a boy?
When the jailer tells Billy Rand he'll jump for joy!
The police beat up on the boy down the way;
What with delinquency as it is, it happens every day.

The drunk left his wife again. He comes back every year,
Then goes when she's expecting another kid.
Last night in the alley a man was shot;
It's another old story, around here it happens a lot.
```

Gonterman's poem continues to expand its reach across social issues like welfare and social services: "That nice couple got their kids taken away./Welfare came and grabbed them." She includes a stanza about a hospital that refuses to treat a wino ("Guess they didn't know he'd die"), and then she turns to one of Uptown's largest problems, the lack of safe, clean, and affordable housing:

```
A rat bit the Bots boy on the face,
The housing shortage is a shame,
They're still trying to find another place.
```

In the very next line, the narrator informs readers that her taxes have gone up: "I guess the government needs the money/For war and such." This is followed by a stanza on two more boys who got shot, a stanza on the Vietnam War, then a concluding longer stanza that brings together themes such as police violence on college campuses with a feminist critique of the everyday lives of women in Uptown:

```
Yesterday the downstate college had another riot.
The police broke in and a few people got hurt,
At least today everything is quiet.
The world sure is in a mess,
Sure wish there was something I could do;
Well, better go home and cook, I guess.
```

The second issue of *Time of the Phoenix*, published in 1972, likewise contains poems that return to the Appalachian themes of the inaugural issue. Michael Browning's "The Coal Miner's Kid," for example, paints a stark picture of the generational cycle of coal mining in rural Appalachia. Readers are introduced to "the pot-bellied coal miner's kid" who's been "[b]orn through ignorance and reared in poverty." The child's landscape is bleak amidst "[c]rumbling, rotten tipples," the "dark, worked-out

mine shafts," and "a boarded-up commissary/and his playgrounds." We learn in the next stanza that the local school was "burned down and never rebuilt." The poem concludes with the repetitious life cycle that is unfortunately produced by this kind of Appalachian upbringing:

```
His security rests in a broken, pension-drawing
miner, coughing too hard
and drinking too much,
who tells about when this deserted,
poverty-ridden camp was booming and full of miners—
all working and spending and never saving.

With never enough clothes or food or money,
the coal miner's kid lives and grows
and finally digs coal for his own kid.
```

It's like an illustration out of some Appalachian version of Paul Willis's *Learning to Labor: How Working Class Kids Get Working Class Jobs*. Browning's poem encapsulates the geography, desperation, and "people's histories" that so many of the Patriots escaped, only to find a different kind of desperation and poverty in the North. Although Issue 2 of *Time of the Phoenix* includes fewer poems on Appalachia than the inaugural volume, it begins to directly address the place that was becoming YPO members' new home in 1972, the Uptown neighborhood of Chicago.

The second issue opens with poems like J. Schmidt's "The Uptown Woes" and Robert Emerine's "Inner City." Later in this issue, poems like Jean Tepperman's "New in Uptown" and particularly her serial poem "October Uptown," inscribe the new poverty of the industrialized North. After an opening section on a "Little boy smoking/With hill colored hair" who watches the Uptown traffic, we learn of the "Helpless hearing" of the new urban poor who can hear their "landlord/shut the furnace/At ten o'clock/The night of the first/frost." Tepperman's poem concludes with the solitary loneliness of this new Chicago geography:

```
3.
The light in the room
Darkens the street's dusk
If I can just see
Through the night
Maybe someone
Will walk up the sidewalk
For me.
```

The mountains and the coal tipples are gone, replaced by the isolation of Uptown's poverty and a people some called "simply too poor to organize."[33]

If Issue 2 of *Time of the Phoenix* signaled a move away from the central theme of Appalachia to poems grounded more in the geography and politics of Uptown, Issue 3 of the magazine saw a move away from the predominance of the "hillbilly nationalist" theme toward a wider inclusivity of poets from the "vanguard of the dispossessed." Early in the issue, two poems by Jesus Ledesma initiate this transition. The first of these poems, "Life in the Streets," illustrates Uptown from a perspective readers would not have seen in the first two issues of *Time of the Phoenix*:

```
Life in the streets ain't too cool
'Cause you always have someone who wants to
Make a fool or burn you. You drink a little
then you get busted for a bullshit charge
Like disorderly conduct. You want to cop some
Tea? Then you get burned, then you find him
And beat his head, not for takin your money
But it makes you lose your pride if
You don't do nothing about it. Then you go
Home with blood on your hands and your mother
Says, "Que pasa, hijo, you fighting again.
Que pasa you got no corazon.  all you do is fight."
And your sister's crying 'cause she knows
What is happening.  Wait till tu padre comes
from work.  and all you say is "I had a fight
con some blancos." "tu un malo muchacho"  "mira
La sangre."  and you say, "forget it, I'm going
To bed after I wash up." "Life in the streets"
```

A number of other poems in the third issue of the journal offer visions of Uptown from the perspective of Black and Puerto Rican writers such as Victor Rosa's "I'm a Proud Puerto Rican." This transition continues through issue four of the magazine as well in poems like Alfredo Matias' "Where Are The Latin Poets?"; several poems by David Hernandez (who would later go on to become Chicago's unofficial poet laureate); Eduardo Condes' "Tecato's Dream," and others. Perhaps this range of poetic styles, languages, and modes of address comes to full engagement in "Bla-Bla" by Cesar Quinones, which appears toward the end of this final issue of *Time of the Phoenix*:

```
La monja habla habla
bla-bla-bla
```

```
el colr a manto azota
ota-ta
el cristo se derrota
ya
Ante el pecado de otro
¡ja!
Nubes grises de anti-cristo
¡ra!
derrumbando un tonto mito
¡ya!
que no aplica ni revela
¡na!
ni a los tiempos ni a los hombres
¡na!
¿Hán de callar la materia?
¡ja!
¿Pára sublemizar el espiritu?
na
ya
bla, bla, bla
tan solo bla bla.
```

33 Ibid., p. 4.

34 See Note 1, above.

35 For an overview of these and other labor struggles in the 1970s, see Jefferson Cowie's Stayin' Alive: The 1970s and the Last Days of the Working Class. And for one source of poetry's engagement in Detroit's revolutionary union movements, see Marvin Surkin and Dan Georgakas's classic, Detroit: I Do Mind Dying (A Study in Urban Revolution), which includes several workers' poems.

Yet this is not to say that the YPO poets ever left Appalachia and its mountaineers completely behind. If "memory is a motherfucker,"[34] the writers published in the final two issues of *Time of the Phoenix* also kept the people's history of Appalachia alive in the public memory for years after they'd migrated north. In Issue 3, for example, Shelva Thompson's poem "The Hyden Disaster" re-examines the death of thirty eight miners in the Finley Mine Disaster in southeastern Kentucky in December 1970. And in Issue 4, Kathleen Sowers' "The Legacy of My Father" is a moving elegy to everything left behind when an elderly miner and family patriarch dies, including both a literal and symbolic mountain of memories:

```
My father left us a log house built
by him
in a hollow in Emlyn, Kentucky.
An acre of ground to grow our food
A gold spring that ran from an under-
ground source purified by rocks
```

Following page spread: *Time of The Phoenix*, Vol. 4 (Chicago: Columbia College Press, 1976.

```
over which it ran.
A corncrib on high stilt legs covered with
tin to keep out the rats.
A loving mother who would never
        forsake us,
and, best of all
he left us a mountain.
```

The four issues of *Time of the Phoenix* present a vast array of remembrances of Appalachian culture as well as the political and social adjustments to and challenges within the poverty and violent policing of the urban north in Chicago's Uptown neighborhood. They also illustrate the simultaneous establishment of the Appalachian-centered poetics of the early YPO and the expansion into a much more expansive "vanguard of the dispossessed" in the issues that followed. Finally, the poems published in *Time of the Phoenix* offer a varied and persuasive display of a poetics of accessibility, responsibility, and struggle on nearly every page.

This brief look at a people's history of poetry and the poetry workshop by schoolchildren in Brooklyn, prisoners at Attica, and activists in the Black Panther Party, the Weather Underground, and the Young Patriots Organization suggests that poetry in the early 1970s broke significant new ground in audience, authorship, and agency. It opens a range of questions about social movement spheres in which poetry might have been a tactic in other struggles of the era. For example, how might poetry have been used by postal workers in the US Postal Workers strike of 1970, by farmworkers in Delano during the UFW grape boycotts, by textile workers at the Farah Garment Factory in El Paso, by the League of Revolutionary Black Workers and organizations like DRUM (Dodge Revolutionary Union Movement) in Detroit, and countless other resistance movements by workers and the working poor?[35] My guess is that we still have an incredible amount to discover about the uses of poetry by social movements, with the poetic practices of the Panthers, Patriots, and others examined here leading the way.

TIME OF THE PHOENIX

Volume IV

ORGANIZE YOUR OWN TEMPORALITY: NOTES ON SELF-DETERMINED TEMPORALITIES AND RADICAL FUTURITIES IN LIBERATION MOVEMENTS

Rasheedah Phillips

"Even the singularity of a unique historical time that is supposedly distinct from a measurable natural time can be cast in doubt. Historical time, if the concept has a specific meaning, is bound up with social and political actions, with concretely acting and suffering human beings and their institutions and organizations. All have definite, internalized forms of conduct, each with a peculiar temporal rhythm."—Reinhart Koselleck, *Futures Past*

In the time-space offered within these pages, I will briefly reflect on and investigate the following series of questions; chiefly: How does a radical movement conceive of its own future in the face of hostile visions of the future? When the future was never meant for them? How does one reconcile a temporal fatality offered by the mechanical linear timeline,[1] with a belief in the temporal duration of one's own radical vision in change? How else can we position progress when we exist within our own spatial-temporal environments, and how do we join allegiance with others in spite of that, settling on common visions of the future?

If plotted along a linear time axis, one would note a pattern of relatively short active periods of events for many of the major American liberation movements that have risen and fallen in the past century, with a crudely defined start time and end time. Visually speaking, it may look similar to the following:

Such movements appear to be short in duration, but this is only if measured against the linear progress narrative, upon being superimposed onto a linear timeline as shown above. For example, in *Physics of Blackness: Beyond the Middle Passage*

Epistemology, Michelle M. Wright states that using "the linear progress narrative to connect the African continent to Middle Passage Blacks today" creates a logical problem, "because our timeline moves through geography chronologically, with enslavement taking place at the beginning, or the past, and the march toward freedom moving through the ages toward the far right end of the line or arrow, which also represents the present."[2]

If one repositions their temporal lens, these movements, by their very existence and through their radical futurities, meaningfully disrupt linear notions of time. Radical liberation movements reappropriate notions of time and temporality itself, stealing back time to actively create a vision of the future for marginalized people who are typically denied access to creative control over the temporal mode of the future, and redefining that future's relationship to the past and present. This may involve a reinvestigation and uncovering of hidden histories, and a hacking into future histories where they have already been erased, ensuring their appearance, their continued existence even when the movement's active period has ended on the linear progressive timeline and receded into the so-called, inaccesible past.

One of the tactics for hacking the future is through the technology of printmaking. Marginalized communities and liberation movements have always used printmaking to share their own news and real-time stories, in a world where mainstream media regularly distorts and misrepresents these groups of people. In the Black community, separate press and print media outlets were crucial to counteracting negative images and to preserving counter-memories and counter-histories of events. From *Freedom's Journal*, the first Black owned newspaper established by a group of free Black men in 1827, to *Fire!*, an African-American literary magazine published during the Harlem Renaissance, to the twenty issues of the Black Panther Party newspaper published from 1968 to 1973, Black print media has operated as a powerful voice for the oppressed, and one of the most

Notes:

1 Early on, many of us are taught to map out major events, world history, and even our own lives onto a timeline that runs from past to present to future. The timeline typically looks something like a straight line, with major events representing points on the timeline, where time comes from behind us and moves forward. The straight line moving from past to future also represents cause and effect.

2 Wright, Michelle M. Physics of Blackness: Beyond the Middle Passage Epistemology (Minneapolis: University of Minnesota Press, 2015), p. 57.

effective technologies for the transmission of culture, art, and news between people across space-time.

Similarly, *Time of the Phoenix*, which is being "re-presented and re-circulated" through the *OYO* investigation, is a series of four out-of-print poetry chapbooks featuring poems and stories of impoverished Uptown residents about race relations, urban renewal, police brutality, culture, and life. The name is fitting because isn't it always the time of the phoenix? These lost voices can be re-positioned as merely enfolded and submerged on the linear timeline, yet always present in the time of the phoenix, cycling through life/death/life. Such ephemera, objects, and artifacts recode time in the long form.

<p style="text-align:center">★ ★ ★</p>

"The before and after of an event contains its own temporal quality which cannot be reduced to a whole within its longer-term conditions. Every event produces more and at the same time less than is contained in its pre-given elements: hence, its permanently surprising novelty."—Reinhart Koselleck, *Futures Past*

In their essay "It's About Time: Temporality in the Study of Social Movements and Revolutions," McAdam and Sewell highlight four different temporal rhythms and temporalities that they find to be dominant in political and social movements and revolutions, using the Civil Rights Movement and the French Revolution as examples. The ones presented are (1) long term change processes, or those that "simultaneously destabilized existing power relations and afforded groups new organizational/associational bases for mobilization"; (2) protest cycles, which refers to the temporally narrow period which defines the most active phase of a given movement or revolution; (3) transformative events, that is, "the contingent features and causal significance of particular contentious events" and "the unique temporality of the singular event"; and (4) cultural epochs/master templates, which is an observation that "certain forms of contentious politics, once invented, tend to remain available for long stretches of time . . . and often across considerable reaches of space."[3] McAdam and Sewell ultimately argue for "a more event-centered approach" as the most viable platform for engaging with temporalities in social movements. Events, which are "punctual and discontinuous rather than cyclical, linear, or continuous" become, according to McAdam and Sewell, "turning points in structural change, concentrated moments of political and cultural creativity when the logic of historical development is reconfigured by human action."

An event-focused temporality shares many similarities with an Indigenous African spatial-temporal consciousness.[4] In general, an indigenous African time consciousness had a backwards linearity, in that when events occur, they immediately move backward towards *Zamani*, or macrotime. In many Indigenous African cultures and spiritual traditions, time can be created, is independent of events, and is not real until experienced. From this time perspective, time is composed of events: so days, months, and years are just

3 McAdam, Douglas and William H. Jr. Sewell, "It's About Time: Temporality in the Study of Social Movements and Revolutions," in Aminzade, et al., eds., Silence and Voice in the Study of Contentious Politics (Cambridge University Press, 2001), p. 112.

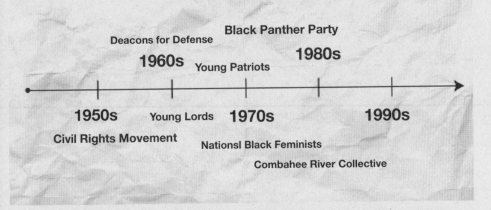

a graphic or numerical representation. In a worksheet, *A Comparison of the Western and African Concepts of Time*, the author notes, "we have to compare the Western linear dead physical timeline (with 'past', 'future' and a regularly moving 'now') with the African 'living time.'"[5]

Indigenous African notions of time were generally connected to natural events, such as rainfall and the rising and setting of the sun, or saw time as a natural rhythm or pacing, such as the time it takes you to walk from one place to another. Such an experience of time has such features as "concern for details of the event, regardless of time required; exhaustive consideration of a problem until resolved; and emphasis on present experience rather than the past or

4 It is important to note that temporal-spatial traditions varied widely across cultures, countries, groups, and individuals across Indigenous Africa, but that the observations presented in this essay are based on extensive research on space, time, and spiritual traditions of a number of African cultures and groups that yield basic generalizations and assumptions.

future."[6] Future events are situated in a potential time, until experienced or actualized. Those events do not depend on a specific clock time or calendar date for their manifestation. Instead, time depends on the quality of the event and the person experiencing it. Once the future event is experienced, it instantaneously moves backward into the present and past dimensions.

<p style="text-align:center">★ ★ ★</p>

"Male temporal consciousness has excluded women from its domain by denying ontological significance to birth, as event and as consciousness; male historical consciousness has written us out of its chronology by demeaning and ignoring our contribution, thus robbing us of our collective memory as women." —Frieda Johles Forman, *Feminizing Time: An Introduction*

Womanist and feminist movements have also articulated alternative modes of temporality, ones that "reveal to us [time's] multifaceted and multiform nature" from the perspectives and experiences of women. Womanist and feminist movements have studied temporal issues and tools to theorize on such issues as "time, age, change, choice, self-image, and the related implications of women's changing roles."[7]

In the essay *Femalear Explorations: Temporality in Women's Writing*, Irma Garcia notes that "women's time is purely affective time, disrupting pre-established schemas and structures," and how in feminine time in general, "notions of the past/present/future are interdependent and blend into each other."[8] The time traveling, Black woman protagonist Dana in Octavia Butler's speculative novel *Kindred* demonstrates this blended, affective temporality well. She had to ensure the continuation of her family's timeline in the Antebellum South, and by extension, her own birth, several hundred years into the future. Michelle M. Wright highlights how Butler and other Black womanist writers, such as Alice Walker, create "bold new models foself-defined or internally defined notion of tradition, one Black and female."[9] Tradition as understood here emphasizes an overlapping past and present temporal dimensions, and in relationship of those two dimensions to each other, necessarily involves a future trajectory, if considered within a traditional linear temporal construct of forward, progressive movement. I would argue in support of an articulated theory of Black womanist temporalities, given our unique, intersectional temporal experiences as Black and woman (For an example of a Black womanist temporal experience, see *Radical Futurities* essay soundscape by Black Quantum Futurism.).

★ ★ ★

"We have no dedicated sense-organ for the measurement of elapsed time, as we have for the measurement of vibrations in the air (forming sounds) or the wavelengths and relative positions of light-waves striking the retinas of our eyes. To speak of the 'perception' of time is already to speak metaphorically." —Alfred Gell, *The Anthropology of Time*

On the November 2015 cover of Wired, the words "Let's Change the Future" are written in bold pink neon, previewing an issue dedicated to race, gender, and equality in the digital age, and guest edited by tennis star Serena Williams. The issue features articles on the #BlackLivesMatter movement as the twenty-first-century Civil Rights Movement, the lack of diversity in the tech industry, and one on a perceived battle over diversity that recently erupted in science fiction culture. In the article "War of the Worlds," Amy Wallace notes that, "sci-fi that accommodates one future, one kind of politics, and one kind of person just isn't doing its job."[10]

Understanding the utility of science fiction to envision new futures and new worlds in concrete terms— particularly for society's marginalized—Wallace's words call to mind those of Octavia Butler, who, in an essay called "Positive Obsession," mused "What good is science fiction's thinking about the present, the future, and the past? What good is its tendency to warn, to consider alternative ways of thinking and doing? What good is its examination of the possible effects of science and technology, or social organization and political direction? At its best, science fiction stimulates imagination and creativity ... And what good is all this to Black people?"[11] A new generation of science fiction writers and creators are using their work to answer those questions. Grassroots organizations such as The Afrofuturist

5 A Comparison of the Westen and African Concepts of Time, <http://www.eldrbarry.net/ug/afrtime.pdf>.

6 Ibid.

7 Fisher, Jerrilyn. "Teaching 'Time': Women's Responses to Adult Development," in Taking Our Time: Feminist Perspectives on Temporality, p. 137.

8 "Femalear Explorations: Temporality in Women's Writing," in Taking Our Time: Feminist Perspectives on Temporality, p. 162.

9 Wright, Michelle M. Physics of Blackness: Beyond the Middle Passage Epistemology (Minneapolis: University of Minnesota Press, 2015), p. 56.

10 Wallace, Amy. "War of the Worlds," Wired (November 2015), p. 97.

11 Butler, Octavia E. Bloodchild and Other Stories (New York: Seven Stories Press, 2005; second edition). p. 134-5.

12 Metropolarity Journal of Speculative Vision and Critical Liberation Technologies, March 2013, Season 1, Episode 1 (zine).

Affair and Metropolarity Queer Speculative Fiction Collective are choosing "science fiction as our lens to create new worlds, identities, self-paradigms, and to destroy old, harmful ones."[12]

Other DIY and self-determination movements are affirmatively claiming or creating the future by actively engaging temporalities and adopting alternative temporal orientations and frameworks, which in turn helps to shift the meaning or placement of the future and the past (i.e., history), as well as shifts the means of access to the future and the past. Alternative temporalities embodied by such cultural movements as Afrofuturism, and DIY theories as Black Quantum Futurism, have developed practical tools and technologies for exploring reality and shaping past and future narratives.

Black Quantum Futurism (BQF) is exploring and developing modes and practices of spatiotemporal consciousness that would be more beneficial to marginalized peoples' survival in a "high-tech" world currently dominated by oppressive linear time constructs. In crafting new communal temporal dynamics that can function, BQF is developing and enacting a new spatiotemporal consciousness—BQF theory, vision, and practice explore the intersections of quantum physics, futurism, and Black/African cultural space-time traditions. Under a BQF intersectional time orientation, the past and future are not cut off from the present—both dimensions have influence over the whole of our lives, who we are and who we become at any particular point in space-time. Our position from the present creates what that past and future looks like, what it means at every moment. We determine what meaning and what relationships both dimensions of time have to our present moment.

CATEGORICAL MEDITATIONS
Mariam Williams

I.

Division. We learn it formally by third grade. The process has its own vocabulary—

```
Factor trees
2 goes into 24 how many times?
5 and 2 are prime factors of 10
100 divided by 20 is 5
100 divided by 20 equals 5
```

Interchangeable words and phrases create a language for separation—its being, its contributors, its equality.

What is the mathematical equivalent of unity?

II.

January 2016. I'm standing in front of a large white board, maybe 60" x 40", with about thirty red, blue, and green rectangles printed on it, featuring questions from the American Fact-Finder Survey, the National Health Interview Survey, and the Survey of the American Consumer. Instructions at the top of the board ask viewers to insert small, yellow-tipped mapping pegs to respond to each question, then insert small, black-tipped pegs to represent the three categories they most identify with. Finally, viewers who stick it out through the whole exercise will insert light, blue-tipped pegs

into the three categories in which they feel they are most likely to organize.

The work is vast and yet filled with minutiae.

```
How did you get to work today?
I took the bus/subway/elevated train.
I rode my bicycle. I walked. I drove.
Pets deserve to be pampered.
How long have you lived in your current residence?
```

It's a halting experience to see hundreds of survey questions blown up to a grand scale. If I were to stand the board horizontally on the floor next to me, it would ascend to more than half my height. The quotidian nature of categorization, whatever intangible quality, which has made it ingrained, has, for a moment, surrendered its power. I must think.

```
How many boxes can I put myself in?
        Who is asking this? Why do they need to know?

What use are the details of my life to them?
```

I volunteer, my hand guiding yellow-tipped pegs.

```
African American
Straight, that is, not gay
Number of children under the age of 18 in household: 0
```

I self-identify, but the categories' significance is prescribed. Someone else has deemed it important to know that I am a graduate student over the age of 34 who sees a primary care physician for her immediate medical needs, is in charge of the grocery decisions in her household, and doesn't attend religious services regularly. Someone needs to know the man next to me is white, gay, works in technology primarily for the salary, and often plans ahead. According to the surveys, there is no crossover in our lives, no place where we meet. Yet these details of our lives, these categories, are equally important to someone. They want to know so that they can sell me things that will make my life better. No one has asked me:

```
Do you believe Black people will ever be embraced by the
    country they built?
```

> Does that question make you wonder why you still want
> children?

Has anyone asked him:

> Do you understand the fears of the woman next to you? Have
> you ever thought about them? Why or why not?

What use to me are the details they want to know?

III.

When I hear the phrase, "organize your own," I think of SNCC in 1966. I think of people in 2016, people who likely live, worship, and socialize in places with people of the same race or nationality, talking to each other about racism in the United States and either how they experience it or what they can do about it. I picture people going home for Thanksgiving and reaching the point when they can no longer tolerate their drunk uncle using racial slurs to refer to Chinese people.

These are the factors for speaking: enough commonality but enough difference and no more tolerance. Same blood, same root. Different regions, generations, and incomes. Aunt Cora, PhD; Uncle James, factory line. When will you settle down and have some kids? When will your sister stop having all those kids? She's turning into a welfare queen.

What goes into organizing your own family? Please (don't) excuse my dear Aunt Sally (anymore).

IV.

I take public transit to work and school. The other commuters and I fall into a box, together. Yet some of our differences we can sense. Briefcases vs. backpacks. Shined wingtips vs. Timberlands. Local's accent vs. tourist's. Stench of street sleep vs. bed rest on laundered sheets.

What is required for any of us to take that impossible action, to "reach across the aisle?" These are my own, but to commute together, every day, same route, same time, is not enough to talk about race. I look at them and wonder:

Do these people feel lonely?

Have they reached their goals?

Does life at their age look like what they thought it would and what they think it should?

Do they procrastinate?

What was their day like today?

When was the last time they did something for the first time?

I don't want to know their:

political affiliation
gender persuasion
sexual orientation
educational motivation

I want to know, "Can you speak the language of unity?," even as I wonder, "How is that different from the language of erasure?" A thousand categories divide each human from the next, but a thousand categories—socially constructed, chromosomal, genetic, divinely imparted, chosen—make us who we are. A thousand, black-tipped pegs mapping out each opportunity to ask, "If 100 divided by 20 equals 5, do not all twenty parts have the same value?"

ON AMBER ART

Bettina Escauriza

I. The Photograph

Two Black men in lawn jockey outfits holding lanterns stand in symmetrical poses, as statues would, in front of a food store on Lancaster Avenue in Philadelphia. The cold interior light from the store spills out onto the street, casting blue shadows on the faces of the men, which are otherwise obscured by night's darkness. A giant decal of fresh seafood pasted on the left window dominates the scene: bright red crab legs create a downward curve next to a blush pink shrimp, pale potatoes, and a lone broccoli on the bottom left corner, all held within the embrace of an aluminum dish. Inside the store we see a certificate of some kind (perhaps of compliance) pasted on a clear plexi-glass partition, a juice dispenser filled with purple liquid, and in the far distance, the bright fluorescence of a bug light. But what is easy to miss in this photo is the third person standing just beyond the threshold of the large windows, inside the store, their face visible next to the end of the crab legs, partially bisected by the black metal border that holds the panes of glass in place, their body obscured by a large orange vinyl sign advertising a food special. To us, it's just a floating head really.

The image described is one in a series of photographs that document the performance piece entitled *Urban Space Jockeys* by Amber Art and Design. Though the image was constructed to follow a symmetrical/bilateral composition, it unintentionally follows the Rule of Odds. The three subjects form a strange triangle, oscillating between what is intentional and what is incidental, creating a composition in which the third person in the background is at the apex and center of the image. The strong architectural, geometric lines create a heavy symmetry—a repeated pattern wherein the objects in the individual quadrants formed by the architecture break the rigid

symmetry and generate motion for the eyes. The parallel positioning of the subjects constructs a strong sense of weighted balance, really appropriate for a pair of statues that that would flank an entrance—in this case, the statues flank the entrance to the obscured history of the roles of Black people and Black resistance to oppression in West Philadelphia.

In their performance piece *Urban Space Jockeys*, Amber Art engages the complex and hidden history of Lancaster Avenue in West Philadelphia. For the piece, Keir Johnston and Ernel Martinez dressed and posed as lawn jockeys, and were photographed as the statues in different locations. Lawn jockeys have a complicated, layered, and truthfully, unknown, origin. From the legend of Jocko Graves—the Black boy who inspired George Washington by waiting for him and subsequently freezing to death, lantern in hand, along the banks of the Delaware during the Revolutionary War— to the anonymous "faithful groomsman," or the black jockeys in the Kentucky Derby. By some accounts these statues were used as signal posts for stops on the Underground Railroad, when a cloth of a certain color tied to the arm of the jockey meant this house was safe for African Americans, who were fleeing slavery in the South.[1] In *Urban Space Jockeys*, Amber Art is referencing all of these histories by becoming the lawn jockeys and reinserting that particular narrative of Black history and the Black body into the contemporary space of the city.

Though by its nature, the *Urban Space Jockeys* performance is external and meant to be consumed by spectators, there is a deep internality to the work that viewers must excavate for deeper meaning. A profound truth of the work is that many aspects of it are only knowable to those who share the experiences of Blackness in this society that have been constructed around the violent and genocidal enslavement and oppression of Black people. The tension between what is knowable and unknowable in the work—depending on who experiences it—is a powerful antidote in a society that seeks to flatten and normalize everything and fix history in place as a story that can be told completely and, that in turn, can be fully understood. *Urban Space Jockeys* does not function as a didactic history lesson, but rather as an organic encounter with the public, if they are lucky enough to be out there during one of the performances, or view its documentation in an art gallery. For those of us who are familiar with the racist narrative and history attached to the lawn jockey as an object produced by a racist society, the first layer of the *Urban Space Jockeys* performance is readily apparent, but the ways in which this history is intertwined with the history of Lancaster Avenue lives in a deeper place.

II. The Avenue

Though there is nothing to mark the horizon, the severe angle of Lancaster Avenue is very palpable. The Avenue is loud and alive. During peak hours, a steady stream of people walk down the sidewalk and in and out of businesses, as the flutter of their conversations blends with the buzzing clamor of traffic. Lancaster Avenue has a rich history—originally it is said to have been an ancient LenniLenape road, before becoming the first turnpike, connecting Philadelphia to Lancaster, in 1795. As the first major paved road, it helped to transform the city by easing the flow of goods and commerce that came in on barges through the Schuylkill, then moving through West Philadelphia to Lancaster and beyond.[2] Eventually, Lancaster Avenue became linked to the Lincoln Highway, the

Urban Space Jockeys,
Amber Art & Design,
2015.

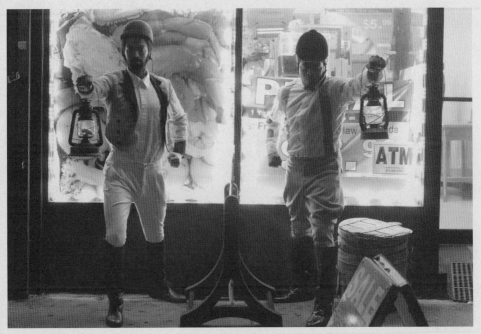

first-ever intercontinental highway in the United States, a single line stretching across the land, connecting Philadelphia to San Francisco.[3] Several houses that were stops on the Underground Railroad were located on the Avenue, so just below the surface of the present there is a powerful history of solidarity and resistance to oppression.

But, as one walks down Lancaster Avenue, this history is invisible. What Michel de Certeau wrote of New York is also true of Philadelphia (at least in this part of town)—"Its present invents itself, from hour to hour, in the act of throwing away its previous accomplishments and challenging the future."[4] The present's unrelenting devotion to becoming the future effectively silences the past. Time is a collection of surfaces that builds the sedimentary rock of the present, and in the orogeny of passing time, things get lost.

There is a certain degree of inevitability to this process of muting the past, but there are processes of power at play that shape the muting. Thus, if the history of the resistance to African enslavement, along with other histories, is hidden under the steady bustle of working-class neighborhood commerce, then it happens in service of some kind of logic. Some would say that it is not so nefarious, but I would argue that in a city so obsessed with its own past and its relationship to the beginnings of this nation, the long process that hides the hands and intentions of those who built the present is obscured in this particular narrative for a reason.

Urban Space Jockeys is an excavation and presentation of the image of the lawn jockey—both as a historical site of the oppression of Black bodies and of the complex archaeology that links these lawn jockeys to the Underground Railroad, while at the same time actively pointing to the current and virulent process of gentrification that seeks to consume Philadelphia in the coming years. The performance aims to engage the past in dialogue with the present to interrogate the future as it looms in the horizon.

In an interview I conducted with the artists, they explained that their aim is to amplify the voices of their community members by telling the history of Black Philadelphia. They are members of and live and work in marginalized communities that exist in a state of constant vulnerability by the forces of racism and capitalism. Through their public interventions, Amber Art seeks to engage with the public in a dialogue about the Black body, both its history and its present. By forging spaces for dialogue, they engage with people in neighborhoods who don't get to access art through conventional means of a museum or a gallery. Amber Art uses performance as a way of posing questions about race and power, and to bring to the surface Black narratives of resistance to oppression that have been silenced. There is a deep, resonating healing and corrective power to this work, as it actively constructs a world in which that

which has been silenced can speak. Their work asks questions about what survives in the collective memory of the colonized, the enslaved, and how these processes unmake, make, create, and recreate the word we live in every day.

The intersection of art and activism is rife with contradiction, as are all situations in which power is simultaneously manifested and contested. These contradictions cannot, nor should they, be avoided—they should be actively engaged and deconstructed to see what other formations may arise from questioning and making. As Walter Benjamin wrote: "Our life, it can be said, is a muscle strong enough to contract the whole of historical time. Or, to put it differently, the genuine conception of historical time rests entirely upon the image of redemption."[5] And perhaps, despite all our deconstruction and construction, we don't get to fix things—maybe we just make air holes, and that's okay.

Notes:

1 <http://www.antiquetrader.com/features/history_of_the_lawn_jockey_unclear>.

2 <http://www.phila.gov/CityPlanning/plans/Area%20Plans/LancasterAv.pdf>.

3 <http://lincolnhighway.jameslin.name/>.

4 De Certeau, Michel. The Practice of Everyday Life (Berkeley, CA: University of California Press, 1984), p. 91.

5 Benjamin, Walter. The Arcades Project (Cambridge, MA: Harvard University Press, 1999), p. 479.

CONDITIONS

Jen Hofer

conditions

what being seen to see past skeletal vigilance circulating exposure
what exposure vibrates to be seen what directed beam of sound
knifing through a public transit to be seen outside sight what record
of a future dividing line marked on the unautopsied body what bone-
dry foundation shattered at point-blank range at point-black range
what desiccated neutrality frictionless against motion stopped short
mid stream what blood mixed into the asphalt bone ground into the
desert wind blown where skin once weathered layers of undoing
layers of negation states of stoppage states of arrest what edge at
the edge of what might be done where feeling is in the blood sensing
is in the bone what impediment swiftly distends toward an edge what
imprisonment scintillates toward impact resistant threat resistant
structures pushing against air manufactured as a monstrous mouth
what limit of air breathed what wind knocked out of a body what is
produced for a body against a body's will what variables explode a
body one hundred and eleven immigrant bodies become citizens only
after militarized death what dying breath useless enfranchisement
final vowel unleashed into the not the no what no not to be negated
what not doing in the face of undoing what won't what a body won't
do what won't be done what is made to be done what bodies broken
granulated ground down to desert what topographies photographed
into oblivion kaleidoscopically shot

conditions

what ratios of switch what lexicons of task what legislations of
nothingness traces of death corrosive shards of gravity what portal what
vessel what channel what corridor what interlocking hexagonal armor
patterns on patterns fenced what fence what signal to all face the same
direction what purpose what focused beam of light diffusing into chatter
what overlay hand over hand all facing the same direction lines etched
into bodies lines etched into lines etched into flesh territory undefined
unreadable phrases etched into the land what restricted air remote
control order given to obliterate what we cannot see mounds indicating
tailings runoff or hidden bodies getting closer and closer until the image
dissolves what is seen that can no longer be seen what visible sight
no longer visible what weights measures graphic portrayals vibrating
magnified into our ears what need to know what perforated skin what
skein of subsistence resisting the puncture of the sound refusing to be
heard refusing to fade to worry about the future what worry what future
what fissure to worry about the flatlined futureless undermined body
worried with more than a dozen holes what sixteen what seventeen what
forty-one what holes do you worry each body with its completely different
musculature armature training refusal what moving differently while alive
what differently while not alive what barely controlled movement what
uncontrollable sound flattening the air unbreathable and who is doing
the controlling

conditions

what wordless speechless expressionless mouthless faceless
heartless wingless bodiless lifeless what faceless command seized
from the asphalt what expressionless failure to proceed failure
of protocol failure to recognize failure to begin to acknowledge
the personhood inherent in a person what personhood inherent
in a person brought here by force what lifeless person taken
thoughtlessly from a body from a day's take routine stop routine
processing routine pressure thoughtlessly routinized rituals of slow
death sped up what undoing undid what body undone what flight
wingless unbuoyed by airless unlift what body slammed grounded
electrified statistically fractional catalyst to nothingness lit up what
unscrutinized ritual of state to body combat where the body unseen
seethes what silence swells in the space where speech curtailed
would have hovered what body hovered high enough off the ground
to hang what life seethes not being seen not needing to be to be left
to live what death by unseeing brittle propulsive oblivion what death
by recognition tracked identified condemned in the presumption of
no one giving a fuck what question not asked or not being seen
splayed slatted sunlit what blinding bright negation inappropriate
insertion to be to be doubly seen or not mattering once she is gone
what matters after the faceless fact of her having been taken her
body taken being taken what matters is black lives is her being is
her being taken or her having been

conditions

what dateless body what we exacted or nixed or hexed in the eternal present of not being able to—what not being able to not be considered garbage or trashed by the bag what body precluded categorizations what we categorically denied what body unnamed in a plastic shroud what body's name we refuse to say—el nombre sin nombre callado—what body saying i'm gonna light you up—what light what you—six million eight hundred and fifty one thousand adult bodies catalogued curtailed what chance curtailed beyond even a moment to breathe for light to expand in an observant sternum—what historical body in choppy movements unhistoried unmoved behind the glass what body undertaken what tableaux of indescribable death—what death unrequested the question unformed—qué muerte más allá de qué pregunta—what tableaux of predictable death blanketing the countryside and its more than five thousand correctional facilities its correlative facilities—what blanket of death blanks out the body a blank a nothing a death unnamed a blank space or slate where the body was supposed to be written but disappeared interred invisibilized—what words not spoken what mouth shot shut what not being able to express what inkless sunspot glare uncontained what map across what unmarked trajectory steel-tracked into stubborn entanglements what water what board what textured uncommunicated breathless erosion what body carcerally exploded in the silence of not knowing what to say

conditions

what counts as news what unsuspecting headline or shot to the head
or soundless ricochet deafening what countless numbered nameless
never numbed never not embedded fingered indicated gripped taken
in ceaselessly enclosed ceaselessly counted what becomes mean-
while as we say nothing in the unblinking public eye indicted without
ever having said a word what word could be said to indicate an in-
defatigable enfranchisement what goes unsaid as a body dissipates
indistinguishable in distant distinct precision what prison precisely
clasps commerce what commerce trades in irreducible digits seg-
mented irreparably by law or immunity what not immune not pristine
not separate not fenced but flickered wanting blasted apart until the
term body—what term what body—won't stick endlessly named over
hundreds of years what is not done what is acquired what is traded
marketed shushed unsayable what is transacted what is liquidly ex-
changed what undoing undid what body undone what flight wingless
unbuoyed by airless unlifted body slammed to the ground grounded
electrified catalyst to nothingness what body might try not to let go
but too difficult lets go what body we deny or blur when we say our
body what silence swells in the space where speech curtailed our
body can't be said would hover what body hovered high enough off
the ground to hang at a pitch what question unasked hovering at a
torturous angle glimmering against a silence what negation what we
negates

BOBBY LEE'S HANDS[1]

Fred Moten

don't lay back on cuts, man

Held in the very idea of white people, in the illusion of their strength, in the fantasy of their allyship, in the poverty of their rescue, in the silliness of their melancholy, in the power of their contacts, in the besotted rejection of their impossible purity, in the repeated critique of their pitiful cartoon, is that thing about waiting for vacancy to shake your hand while the drone's drone gives air a boundary. Don't be a ghost, be a spirit, Baraka said, in a movie about white people, the socially dead. Can the socially dead organize their own? What are the socially dead, anyway? This is an ontological inquiry only insofar as it's concerned with what it is, or what it would be, to have an ontological status. What it would be to have an ontological status, and know it, is what it would be to be a white person. In that condition, that particulate dream, which is the eternally prefatory's tired aftermath, one is what it is to persist in having begun interminably to wait on being one. Such a one, that one who is not one but wants to be, is a ghost. How do you stop being a ghost? How do you stop being political in Lincoln Park? One must imaginatively practice oneself away into a whole other mode of service, Uptown's collective head, *speak 'em up and say 'em now.*

 For a minute, the mountains in Chicago—having come from nowhere but the gap, from undermelungeonal elsewhere in nowhere in the gap, already more and less than by themselves or as themselves, having brought the modern to the city in Junebug's homily and Preacherman's homeless vespers—had enough of waiting on being white. Sent to this in order to be sent by it, along with all that gathering he

carries that always be carrying him, was Robert E. Lee, III. The resurrector, having risen again to serve insurrection, didn't have a slave name, he had a ghost name, so they would recognize him. It's like in this buried clearing of the afterlife the ministers of espionage are Saul Alinsky and Jackie Mabley, but just for a minute, but you couldn't even time it, and it really had no place, just an irregular displacement of Sabbath in a clearing dug out of a chapel. There's a movie of this open secret movement but by the time the watching started, there were more watching, hunting, droning, than destroying and rebuilding. Even the movie couldn't frame it, but for a minute, more than having had enough of being dispossessed, the mountains give away what they would have been, which was held out to them and away from them as what they awaited, ghosts of the brutally unborn in settlement. Giving up the ghost was given in his exhaustion—in showing, in showing up, his already having given himself away in having come. Sister Ruby couldn't even look at him, at them, at what he and she were doing simply in their presence,

```
                    the panthers are here
            are here
     the panthers are here

                              for uptown
              for anyone who lives in uptown.
```

We're here for you, we're here to be used by you, says Bobby Lee, deep in the history of the slave revolt. What the mountains were trying to relinquish was not a privilege but a death sentence, continually executed in their own pronouncement of it and in their waiting, when the poor interdict an unowned theater of their own. You can't love nobody but the poor, he says. For it is given to the poor not only to be the object of that sentence but also to object to it, in preferment of their own miraculous showing. The generality of that precarity is our privilege, if we let it claim us. What whiteness seeks to separate, blackness blurs by cutting, in touch. The movie about the movement keeps the secret it reveals. The ruptural caress is on the cutting room floor or, deeper still, is underground. His hand waves in exasperation at people laying back in cuts. His hand presses someone's shoulder. Uptown can't improvise without contact, *we not movin', man, let's move, we can't move*. In the cut, laying back on cuts is given to dance in a laying on of hands, *we can't move without you*, and we're on the other side,

in sufferance of an already given rupture, in lightly hugging someone's neck just like a shawl. This practice of serrated handing, animation given in the disruption of the dead body's protection, struggle shared in tousle and massage, message come in touch, having claimed them, having come to be claimed by them, having come to show them, having come to see them to believe, is how the mountains became his own to organize, how they became what belongs to what's over the edge of belonging. They had to bear some whole other way of bearing and being borne so they could leave their own (ghostliness) behind, becoming something other than what they were not, something other than what they were waiting on. *The panthers are here, are here, the panthers are here* and, for a minute, the mountains move.

Notes:
1 This writing is indebted, and seeks to respond, to two films, each of which contains a scene, a view, of an extraordinary force that, in these particular manifestations, is known as Bobby Lee, an inveterate sociality in defiance of portraiture. The films are American Revolution 2 (1969), co-directed by Mike Gray and Howard Alk for the Film Group and Mike Gray's The Organizer: A Preview of a Work in Progress (2007). They are both to be found on Facets Video DV 86930 (2007).

```
well, he know how to cut yards
```

For a minute. This interlude in curacy, between a juke joint in Jasper and the Fifth Ward's gardens, is special now because of the richly alternative way some differences are felt. When interlude becomes impasse then a way out is held in knowing how to cut by touching. *And do you know a lot of people don't know how to cut yards? They don't know how to cut yards. But when he fix it it's so pretty. I love for him to do my yard. But what I don't like about him, he don't wanna take no money.* He cuts yards by touching, by a kind of tenderness sown on every weed, as if he serves at the weeds' pleasure, as if passage is booked in love with the idea of taking her out to dinner. *You can't build no block club by not doing something for folks.* How else can you know who are your own, the owned, the held, the held away, in shoes so they can walk to heaven, which is on the street where they live? Turning left and right toward itselflessness, gently refusing laying back on cuts, knowing how to cut yards, *you go and start chattin'.* There's an endless, insistently previous preview of our work in progress that is held, handed, in touch, in feel(ing) and there's no need to wonder about the ghostly

individual and his view. Seeing himself everywhere and calling it politics, he would—in the power of his gaze—be complete and indivisible, out of touch in self-possessed, self-picturing monocularity. Meanwhile, Bobby Lee is this other thing in tactile dispersion, practicing that haptic, active, organic *Phantasie* where one sees, because one is, nothing at all. It's nothing. It ain't no thing. Selflessness ain't about nobility or even generosity. The substance of its ethics is of no account, no count off, no one two, just a cut and then people be grooving. It's not about friendship with others, either. Society is not companionship or friendly association with others; it's companionship or friendly association without others, in the absence of the other, in the exhaustion of relational individuality, in consent not to be a single being. Bobby Lee is another name we give to the xenogenerosity of entanglement: the jam, that stone gas, a block club in a block experiment, an underpolitical block party, a maternal ecology of undercommon stock, in poverty, in service, genius in black and blur.

ORGANIZE YOUR OWN?

Moderators: Daniel Tucker and Nancy Chen, senior program manager
at Asian Arts Initiative
Participants: Dan S. Wang, Rosten Woo, Emily Chow Bluck,
and Aletheia Hyun-Jin Shin
Asian Arts Initiative, Philadelphia, PA
February 13, 2016

Using the histories and themes of the Organize Your Own *exhibition, this panel invited four Asian-American socially engaged artists to share examples from their respective bodies of work and how their status as insider or outsider, with respect to the communities they engaged with, has influenced their artistic processes and outcomes. This collaborative event was presented by the* Organize Your Own *exhibition and Asian Arts Initiative, a community-based arts center in Philadelphia's Chinatown North.*

DANIEL TUCKER: One of the things that we were specifically interested in exploring, as it related to some of the work that was also happening at Asian Arts Initiative—and with Emily and Alethia, who you'll also hear from on the panel—was the way that socially engaged art, broadly speaking, has a foundation in a lot of histories and ideas and the language of community organizing. So there's an idea that you're going into some community that you have access to, and that you're organizing them toward some common goal. There's a lot of different versions of that and ideas about what that looks like, but because that history is something that's often referenced in socially engaged art, a lot of questions come up for artists who are doing this kind of work, like, "Do you belong in this neighborhood? Do you belong with these people? Are these people your people, or are they other people's people? Are you even supposed to be here?" And lots of ethical questions arise around even whom you're supposed to be working with, and what the

nature of that commitment is. So what better way to have a focused conversation around that than to bring some of the artists who were working in other contexts, as part of the *Organize Your Own* exhibition, in conversation with some of the artists who have been doing this work in connection with Asian Arts Initiative.

EMILY CHOW BLUCK: I wanted to start off by talking a bit about my trajectory as an artist. I went to college at Scripps College in Southern California; it's in the outskirts of Los Angeles. When I was there, I primarily worked with Asian-Americans, my peers—Asian-American women, in particular— and Asian-American queer folk. These are some photos of my friends and peers who I worked with at the Asian American Student Union and me facilitating a workshop on Asian-American identity. That was really where I became interested in working in communities. Before that, I grew up in New Jersey in a predominantly white neighborhood, and getting involved at the Asian American Student Union helped to open my eyes as to the power of youth-led organizing campaigns that can happen, and how important it is for people of color to talk about our histories as a way of building solidarity and shaping our futures.

When I was working with the Asian American Student Union and other Asian-American organizations on campus, we did a lot of storytelling and story sharing. These photos are of collective life collages that we created as a way of trying to figure out ways in which our individual stories intersect with larger themes of an Asian-American history. We definitely worked with the materials that

Introductory remarks by Nancy Chen, Asian Arts Initiative, Philadelphia, 2016.

75

we had; we didn't have really fancy art supplies, so it was all about using magazines and using word clippings to piece together our lives.

A larger project that I ended up focusing on in my college thesis was mapping out social autobiographies in a visual way and the impact that has on shaping political formation in communities. The prompts were our collective histories: map out two moments from your personal history and two moments from history that might be important in general. A lot of folks brought up the LA riots (which were important to them as Asian-Americans), the Cultural Revolution in China, wars in East Asia, and then personal stories about going to Scripps College as the first person in their family to attend college.

Along with working with Asian-American communities, I also did community organizing in Los Angeles, primarily with multiracial organizations that created a lot of agitprop. After I graduated [Scripps College], I ended up at the Maryland Institute College of Art. Because of my political practice in California, I thought that it was very important to me to embed myself in a community organization as a starting point. I moved from working with Asian-American people and communities to primarily working with African American, low-income, and often previously incarcerated populations. This is a piece called *Community Corners* that I created through surveying communities about the state of the food environment in their neighborhood. I talked to both corner store owners—who were considered outsiders coming to the neighborhood to make a profit off of the local residents—and neighborhood residents who felt like they needed more food and more healthful options from the corner store owners. I think there's an interesting dialogue that I was able to weave together through that. But most importantly, the organization I was working with and I wanted to not just have this interesting artwork come from surveying the community, but also to hold an event where we served healthy food made by neighborhood residents—we also provided healthy food recipes as a way of engaging people in thinking critically about the things that they put into their mouths and how they cook them. Because it was a really large-scale event, we had this big projection on the façade of the corner store of the neighborhood. And it drew a lot of attention—it was a bright light shining in the middle of the night, on a street that doesn't necessarily have a lot of activity in the evening. It got a lot of people's attention, and we tried to use it as a platform for recruiting more people to work in the organization around food justice issues with us.

In graduate school, I met an artist—Rick Lowe—who was doing a residency here at Asian Arts Initiative. He invited my colleague Aletheia and me to come work with him. We were primarily working with overcomers of homelessness, addiction, and incarceration from the Sunday Breakfast Rescue Mission, which is a center right down

the street [from AAI]. By getting to know the men there and building relationships with them, Aletheia and I learned about this thing called *chee chee*. Some of the previously incarcerated overcomers had made it for themselves in prison. And essentially, chee chee is ramen noodles, cheese doodles, Swiss or American cheese, some type of vegetable or two, and some type of meat. It kind of piqued our interest, and we asked, "What does that represent for you? How did that factor into your prison experiences?" And most [of the men] said that it meant unity for them, or the anticipation of something better. Or it was like a soul food that brought them back to their culture, because they were able to create it for themselves, instead of being served substandard food from the prison. We worked together on trying to create recipes that are modifications of chee chee, so we could use them as vehicles for the guys to tell their stories to surrounding populations who often didn't really interface with the homeless population. It ended up being a really interesting exchange.

Danny and Fred had never been incarcerated, but Anthony had. [In this photo] he is introducing these other guys who he works with in the program to this food, and everyone's sharing their experiences over food and breaking bread. I'm just going to go through some more photos of when we actually launched the event. We ended up calling the work *Kitchen of Corrections*.

I also want to touch upon how as an artist, I've definitely shifted from working in my own community to working in a community that is not my own. Pretty much none of my identities overlap with that of the men: I'm a woman; I'm

Emily Chow Bluck speaking at Asian Arts Initiative, Philadelphia, 2016.

Asian-American; I've never been incarcerated or homeless. That becomes a complex issue. By jumping into a community that I didn't know, I had to learn a lot. I had to listen a lot. And there are definitely ethical questions around how . . . it's not always the case that you have a person who is willing to listen to the community. Some people have their own agendas, very outright. As a mixed-race person, community—what is considered my "own"—has been a really nebulous topic throughout my life and on my path as a socially engaged artist. Many people would think that I'm white, and so working in my own community as an Asian-American—maybe that's an Asian-American community, maybe that's a white community—but in every community, I'm also marked as an outsider. Many people don't see me as a part of the community. That becomes a very interesting tension, and I think for myself, it's been an amazing learning experience to really work outside my community—not within Asian or white communities. It definitely aligns with my political upbringing. I was essentially raised around multiracial organizing, with the understanding that not only should African-Americans care about mass incarceration, which primarily affects African-Americans, but Latinos should also care about that. And Korean Americans should care about undocumented immigration issues that affect primarily Latinos. And African Americans should care about Korean reunification. It was this amazing experience when I was in LA—people coming together across difference to really try to work together toward [a more just society for all]. And I think that has really shaped my understanding and the way I approach organizing in my own community, *or not.* Thank you.

ALETHEIA SHIN: Preparing for this talk, I reflected on what community means. And when or how does a community become or [come to be] defined as your "own"? Community can be defined as "a group of people living in the same place or having a particular characteristic in common." "Own" can be defined as "someone or something which belongs or relates to the person mentioned." I would like to focus on the word "belonging." When do we feel belonged [enough] to call a community our own? Or, how do we define where we come from or who, what, or where our communities are? In my journey in answering these questions, I start from how I worked in the community that I identified as my "own" and also how I worked in a community that I, at first, identified as not my "own."

 I've grown up half my life in the United States as an international student and half my life in Korea. When I started my MFA in community arts in Baltimore, we learned much about how Baltimore's historical, racial, political, cultural dynamics, etc. shaped the communities I entered as an artist. Understanding the history of the city we would be working in, and recognizing the privileges we bring with us as students of

an institution. As a class, we also grappled with the questions, "What does it mean for an outsider to enter a community, and how do we as artists shape our practices to be equitably exchanged?"

I realized in the dialogue about seeking equity in race, power, and privilege, the conversation was contextualized by the black and white dichotomy. As I struggled how to place myself, as an Asian person, in the dialogues I was having, I realized the city wasn't so black and white. I found public markets, corner stores, salons, and restaurants run by Asian business owners, in particularly Korean business owners. I began to spend my mornings, lunch times, and dinner times at their workplaces and came to know them through the rituals of spending time and breaking bread.

I was moved by the many stories the business owners shared with me, and I realized there was a need to make these stories recorded and known. I began working at a Korean senior center, where many were first generation Korea immigrants. So, coming from a ceramics background, I designed a curriculum around creating an Onggi form. Onggi is a unique Korean ceramic form used to contain and store kimchi, which is a very traditional pickled dish in Korea. Onggi pots are cultural archetypes created from our ancestors' wisdom that are still widely used today. We use this ceramic form as a symbol to contain the Korean immigrant story made by the seniors whose own stories will fill the Onngi pots. At the end of each interview, I asked them, "Can you share one thing that you would like to say to future generations?" Truthfully, when I began my interviews, I expected to hear horror stories and comments based on stereotypes, but I was surprised. Every senior talked about the importance of relationships. They talked about how their lives had changed so much when they met that one person in their community, often Black, [who was able] to open the doors for them [in order] to accept them as the business owners in their communities. This project was transformative for me and the way I began to map myself in the world. The seniors taught me that the sense of community is not only defined by race, but by love, ties, and seeing humanity in others.

When we ask questions about organizing your "own," I think going deeper, we are really thinking about the ethics as practitioners in this practice. In community art, I often question myself: as a person, "Who am I?," and as a foreigner, "How do I enter into communities?," and "Is this okay?" So I looked up the definition [of "ethics"] again. And I found it was interestingly defined as "a belief that characterizes a community. It's something that involves systematizing, defending, and recommending concepts of right and wrong." Because it's belief that "characterizes a community," ethics are not created by one person, but communally defined. It's a collective effort, and a collective building of cultures or histories.

From here, I found the community-based art practice, in a sense, a collective practice of "truth building" that is real and authentic to the community of people whom [it has] gathered and created together. It takes a diverse pool of people to speak their truth through their personal stories, to find themselves reflected in others, and to find the collective truth or belief that brings us together. This is where I relate it to one of our experiences in the Consumption Residency at AAI. As I mentioned, community can be defined not only by race but also by love, ties, and seeing humanity in others, yet it is also crucial to be aware of the historical context of oppression as a truth that exists in the community, as we enter into it. Chaplain Jeff, who is a chaplain at Sunday Breakfast Rescue Mission, came in as part of our core committee, and he played a crucial role in educating us as outsiders coming in about how we should present ourselves to the men, and also educated us on what's the best way, what has been done wrong, what has worked. One of his recommendations was just to join what the men were doing every day. Every day, the men at Sunday Breakfast clean Pearl Street. So from that recommendation, we cleaned with them every day. It was a great way to get to know them, but also to hear stories about stereotypes that they have to hear, about how they're seen as people who are dirtying the streets, when in reality, they're the ones who clean the street every day. In that way, it was also [a form of] their own activism in the journey of reclaiming and taking ownership, a gesture countering people's perspectives on how they occupy Pearl Street. To make known the counternarrative to the negative stereotypes the men are categorized by, we decided to do the "before and after" photography series as a portal for new "truth building," to leave evidence of what we did every day together. We had an exhibition at multiple venues, including here at AAI, and the Sunday Breakfast Rescue Mission administrators came to see it. The series was also shown at Chinese Christian Church. As a result, the photos were used to fundraise money for the Men's Learning Center, and they also shifted the way in which the Callowhill Neighborhood Association will design their annual neighborhood clean-up, starting their clean-up with the men, honoring their everyday contribution to the community. The photo series will be shown again at Cafe Lift in June.

I wanted to end this presentation with a quote from our mentor Rick Lowe that resounded throughout our time here in this residency. He said, "What we are dealing with is not a design problem, but a relationship problem." I believe design and aesthetics do matter, but I learned that for an artist who works in a community-based practice, the center of the practice lays in the people we are working with. The "art" in a socially based art practice lives in the people, the social ties, the intangible that is created in the process using creative making as a portal to shape what lives in our everyday. That has been the sum of my experience here. Thank you.

DAN S. WANG: I contributed a project to the *Organize Your Own* show that's up now. I am going to break down one element of that project. The project included me compiling a reading list of and about American counterculture, in an expansive sense of what American counterculture is. The list includes 313 titles. I want to say something about where I got that number, 313. This comes from the area code for Detroit. In 1947 the original area code map was devised by the FCC, or whatever the precursor to the FCC was at that time. These original area codes have never gone out of use, just new ones added. The old ones still apply to their original geographical assignment, only the physical areas are smaller than before. Back when rotary dial phones were standard, the way that these area codes were assigned had to do with the speed of the dialing and the locations to which people dialed most frequently. 2-1-2—New York. 2-1-3 was Southern California, including LA. And 3-1-2 was the Chicago area. After that, 3-1-3! This number itself bears evidence of the

Dan S. Wang speaking at Asian Arts Initiative, Philadelphia. 2016.

prominence that Detroit once had in the organization of the national infrastructure. This is all to say that something as seemingly natural or divorced from place and territory as area codes have a history linked to the place-specific industrial world that is in many ways obscured by the digital world we live in now. As for Detroit, Mario Tronti, an Italian labor and post-Marxist theorist, said that if you want to understand Marx, one looks to Detroit. "Marx in Detroit," that became his phrase. His point was that if we want to see the story of capital—the way the dialectics of class exploitation and class struggle proceed, the problem of a division of labor creating efficiencies that lead to overproduction, and then where things go from there—look to Detroit and all that happened there.

But unaccounted for in the writings on the political economy is the endemic counterculture that came out of Detroit. I'm projecting an image, a canvas painted by the art and music group, Destroy All Monsters. In the center is John Sinclair. He was the manager of the rock group the MC5 and a figure in Detroit's poetry and radical political scene. Painted on the sidebars are other figures: "Maggot Brain" and Funkadelic—George Clinton lived in Detroit while songwriting and arranging for Motown; and Ted Nugent, who was part of that music scene, a sort of libertarian hard rocker who, of course, went on to become a right-wing whackjob. A European avant-garde entered into North America and into the English-speaking world through Detroit, via the translation and publishing of *The Society of the Spectacle* by Black & Red. Detroit is what Grace Lee Boggs called a "movement city," and there are many different episodes of tension boiling over into serious flashpoints; this is a picture from the 1967 riots, an event that a lot of people in Detroit still refer to as "The Rebellion." This is a place of contradictions: here is a picture from around 1980 of a UAW rally in Detroit where there is a literal Japan-bashing going on, a demonstration where autoworkers took sledgehammers to a Toyota.

What I just showed you were the conditions out of which a person like Grace Lee Boggs evolved politically. She did not think of herself or call herself an Asian-American. She rarely called attention to her own identity, and it is interesting to me that retroactively, all of us, including myself, assign to her this identity and membership in something we call the Asian-American people or community. How did that come to be? How did that happen? My argument is that the term "Asian-American" came out of a political moment, a moment where a then-novel political coherence emerged. This was in 1968, the San Francisco State University Third World Student Strike, the first in a wave of campaigns that took hold on campuses all over the country. This is a picture from Sacramento City College. I grabbed it off the Google search because of these words: "*ten demands*." This is what I mean by "political coherence," having a set of concrete demands by which we can measure political achievement. It was that coherence that required the construction of an identity that became known as "Asian-American."

[another photograph] Duke University—same time period—demands. This is something that is not really talked about as much as it should be—the establishment of fully accredited departments of Black studies. Almost all of the ethnic studies programs in the United States that exist now were originally concessions in response to militant student demands. That is the political coherence that existed at that time.

Philippine American Collegiate Endeavor and Intercollegiate Chinese for Social Action were student organizations that existed on the campus of San Francisco State University when the Black Students Union started organizing and making their demands. This is in the beginning of the year, 1968. By that summer, a new organization, Asian-American Political Alliance, joined with the Black Students Union and the other ethnic-specific organizations, forming what they called Third World Liberation Front. According to some, this was the first public use of that term "Asian-American." From winter to spring to summer of that year, two things happened: one, the My Lai Massacre, which dominated the news, and presented for all to see the violence that was being visited upon what in racial terms could be described as a poor yellow, Third World people—but Vietnamese. Not Filipino and not Chinese. Another thing happened in those months: there was the mass eviction of elderly residents in an international hotel in Japantown in San Francisco, but the residents were all either Chinese or Filipino. So the new terminology and the consciousness it represented came out of a need to develop an analysis and an organized response, i.e., a political coherence, that would serve the common interest of these formally nationally identified peoples. About a half generation later this happened again, this time in 1982 in Detroit. A young Chinese American, Vincent Chin, was beaten to death by two white unemployed auto workers. They slurred him as a "Jap" and attacked him as if he were responsible for putting them out of work. This again, as a response, created the necessity to build a kind of political coherence, because it bound together in racial terms Chinese and Japanese. And again, the incident and the analysis it demanded spoke to the geopolitical condition as well. My last slide here, I'll let you read it:

> Crises of yesterday are not crises of today
> Political coherence of today will therefore be different.
> Without a political coherence of a sort, the term Asian
> American turns ahistorical and therefore hollow.

My point is that this term or identity "Asian-American" is not an ahistorical thing, not a natural thing, not a self-evident thing. It is a political formation that is always under construction, always in process as a project of consciousness-raising. That's basically what I'm arguing for.

ROSTEN WOO: I am the child of a white woman and a third-generation Chinese man who speaks Chinese at like a 6th-grade level. And I took some language classes in college, but I've always had an identity as someone who didn't particularly fit in as a white person or as an Asian person, and couldn't ever claim any specific or hardcore Chinese identity in any meaningful way. So I've been used to working always in a role of being not quite anything. You'll sort of see that subject position I think reflected in different ways throughout these projects. I should also say that, for a lot of these things, I think I approach these projects without a clear problematic about whether I was organizing my own, or organizing someone else's, at that particular time.

So here are some projects I did for people who are undocumented and uninsured. I'm a graphic designer working with community organizations in collaborative processes to produce different kinds of materials. Not exactly agitprop, but pieces that hopefully change dynamics in different ways. This is a straightforward and educational thing, like, "How do you sign up for different kinds of medical care? What are the problems with Medi-Cal?" Even though I am an Asian person, I am in no way in similar situation to those who are undocumented and uninsured in California, even as a Chinese speaker. This is a project I did with the Black Worker's Center; it's about discrimination against black people in the construction business. Again, I'm obviously not a black worker. This is a project about vendors in New York City, produced with the Street Vendor Project and a designer named Candy Chang, and this is a tool for interactions between vendors and police, for them to be able to articulate their legal rights as vendors. Lastly, here's a project whose audience is employers of people. It was produced in collaboration with the designer Sarah McKay and the Fortune Society, and it's about helping employers understand the law regarding employment discrimination against people who have criminal records. So that's one example of a project where I'm entering a situation as a person with a particular skill set, working with another community that has already organized and structured to some extent, and producing projects. I find that relationship really satisfying.

Here is another kind of project where I think that there's a sort of reversal that happened. I was asked by the Los Angeles County Arts Commission to produce work, a community design project, where people do a community vision process in Willowbrook, which is in South LA, between Watts and Compton. These are the sorts of images that I think people around the world have when they think of Watts and Compton, including many people who work for Los Angeles County Metro. Even for people who work in the neighborhood, I think this is the sort of optic by which they see the neighborhood. And in doing the project, it sort of became a project of refusal. It was like, actually, these people don't really want to do another community design process and create a vision.

This is a plan from the '70s in Watts; the first line is: "Let's be honest. The last thing the residents of Watts want to see is a plan for this nationally known community. Plans and studies have a way of wearing thin over the years." So this is done in the '70s. I was asked to do kind of the same thing in 2014, and I was like, "That's terrible, I don't want to do that." They had just actually done a whole community planning process that led nowhere. So what it ended up being was a project that refused the request, and instead was a tool to organize and educate the people who were working at the Arts Commission, working at the County Planning Department, working at Metro, and they became the target of that project instead of the residents of Willowbrook. So it's like, "Here's something to help you kind of think about this place in a different way." That's another form of a project that I think is an alternate mode of organization.

Rosten Woo speaking at Asian Arts Initiative, Philadelphia, 2016.

The situation that I'm interested in talking about right now, that is the closest to when I'm really organizing my own, is something that I don't do very often, which is when I make a work for a gallery space. Typically the things I do circulate in places far outside of an art context, and to some extent, to be asked to be in the show and produce a two-dimensional work for a space, it's like, "Oh, I don't ever do that!" So it got me thinking specifically about the idea of who's my own, and that in some ways, my own are probably the people who go to something like an exhibition space. In that way, I'm often avoidant of working with my own community, if you define it in that sense. This is a little side route that will connect back: in another hat that I wear, I do interface design and data visualization, and for a

while I was a consultant to Esri (Environmental System of Research Institute). They are best known as the creators of software called GIS. And that software is a very power-ful database that's connected to a map. People use it throughout the world to make all kinds of decisions, whether it's an activist agenda, or more often, like, where should I lay this oil pipeline? Where should I open a Starbucks? Where should I close a Petco? So they specifically use this tool in that context, the business context—it's called tapes-try segmentation. The way that tapestry segmentation works is ESRI has created 100 categories of people. You can see: these are the life modes. These are the ten largest categories that go from "high society" down to "American quilt," and within, they have more specific demographic segments. This is the Social Security Set: these are the people that have this sort of age, this sort of race, things that they like to buy, here are things they like to watch on TV, here's the median income. So they create these [sets]— here are inner city tenants—and this matrix is something that's used in planning, like where should I site a Starbucks? Where should I close this subway stop? All those sorts of decisions are really driven by these kinds of abstractions, an abstract model of who these people are. A quote that I like to use is that "you might not care about demograph-ics, but demographics cares about you." Every day, all the time, whether you're being hailed by the US Census or hailed by a marketer, it would be constructed as these digital representations that then drive policy decisions. I'm an advocate of this idea of statistical citizenship—that it actually matters more how you fill out the census than it matters how you vote, in terms of what kinds of resources are going to come to your community and what resources will be taken away.

Working in this type of project and being adjacent to all this market segmen-tation, I became really interested in these sorts of categories. There's this transmis-sion that's very literal. These people actually live somewhere; they have these kinds of houses, maybe, but they get put on some kind of grid or filter, and then abstracted into this database, and that actually returns back to that world. Like, if there are not enough people who fit the criteria of "Laptops and Lattes," you will actually see busi-nesses make decisions based on that demographic scale. So that abstraction returns back in a brick-and-mortar way, back to your world.

There's a knee-jerk idea, like, of course we would reject this sort of absurd flattening of a human into these categories, and yet there's not really a way out of that system presently. Whether or not you want to be involved in this kind of matrix-ing, it's happening all the time. The thought of this installation at the *Organize Your Own* exhibition is to proactively enter in these categorical questions and get people to think about how they see themselves fitting into a matrix of identities that are gener-ated by their answers to these various questions. So the piece asked people to put

pins into terms that best describe them. You have these things that are very common, obviously there are critiques to be made about things like the Census demographic categories of race, marital status, or sexual orientation, and so on, but these are still pursuant categories. Then you get deeper into it, so there are categories that come from community health surveys and mental health surveys. So things about how long you have lived in a neighborhood, and what you think about that neighborhood and the social networks that are there—taking things that are your general attitudes. "I like to shower my loved ones with gifts." "I like to give the impression that my life is under control." These are all questions that come from the Survey of the American Consumer. The idea here is that we can both use this to collect actual information, and give people a sense, like, "Here's who's going to this exhibition." "Who is the 'own' of the Kelly Writer's House?" But also provocation—what are other questions that we would prefer to be hailed by? Interpolated by someone asking these questions and then entering this matrix of "this is my identity," what are the things we would prefer? I think these are the ones that very commonly form the matrix of identity in our society. Even though this is what you typically think of with political organization around specific racial or economic identity, I think there's always this other identity that's being put onto us that we probably aren't really thinking about that often; that's this marketing, statistical demographic identity that people are using all around us all the time.

DT: To start it off, I'm curious if any of you all have direct response to things you introduced before we bring it to the audience.

RW: [To DW] Your last slide was very interesting and provocative, about the potential of a hollowing out of the Asian American identity, and the need for a continual—I don't know what that is—supplementation or reinvention. . . . I guess I'm asking you to elaborate that. What are the things that you think would constitute the actions necessary to prevent a hollowing out? Is it inevitable, or what would have to happen?

DW: To me, the most important thing is to not divorce the term from its own history because once that happens, it becomes static—it becomes an identity rather than an identification. That's the thing that I'm always trying to push: the process. It is a process. I like to think of the historian E. P. Thompson, who wrote a classic called *The Making of the English Working Class*. He emphasizes that word *making* because all of these kinds of identities are *made*, and then they are reproduced. I think that when the making part of it is left behind or neglected and not actively engaged, practical projects having to do with organizing around identities become really problematic and full

of contradictions. Who belongs and who doesn't? Who's allowed to say this and who's allowed to say that? Who's allowed to wear this and who's allowed to wear that? It's interesting here, like, on some level, all four of us are living examples of living as our own, as we problematize this question of belonging. And it is for exactly that reason that it is important that all of us sit on a panel having to do with Asian-American organizing, or cultural worlds and spheres of action.

DT: Im curious if there are instances in which you are compelled towards something that is specifically, even in a nuanced or critical way, identifying who are your people, and doing work that is targeted at them. Or, are you at a place where you think that *this is not possible*? "There is no my people; that is not the way that I am going to approach the world." You all kind of hinted at this, I just wanted to give you an invitation to say more about it, if you care to.

AS: As I talked about in my presentation, going into a community, for anybody who does that kind of work, I think the first step is reflecting on who you are. Just knowing who you are and reflecting on what you're bringing to the community, how you're taking part in the community. That's what I was trying to present. I had to really work through [thinking] about myself and acknowledging where I am. And that work translated into what's in the community. My direction in the work almost became: "It's going to be about empowering Korean communities, and I'm going to make them more present. It's going to be about empowering Korean people." But as I started [going more deeply] into the complexity of community and movement building and social change, I realized it's not just about Korean community. I had to think broader [and ask] how I can be part of the bigger picture and understand other people's struggles as well, and what it means to be in solidarity.

NANCY CHEN: I have seen Rosten's piece, and I really liked the piece, because it's so simple, but it's like, "This is so clear. These are the criteria by which I can consider myself and the different communities that I could or do see myself belonging to." That doesn't have to be Asian-American or Chinese American only, in my case, but it can be that I live in South Philly; I live in East Passyunk; I ride my bike to work; so on and so forth. I think that we're approaching this panel from one lens, which is definitely the Asian-American, socially engaged artist lens, but I love that piece for just so simply making a map., "Where would I put these pins? What are my values and to whom do I feel most connected?" And that doesn't have to be a racial or ethnic definition.

RW: I have an answer to your more direct prompt. I think there is something that for me is relevant about Asian people and mixed-race people and half-Asian people, who don't fit into the white/black dialectic in American politics and American history. There is a way it seems to play out as an advantage for me in certain projects. I feel that there's a certain set of questions that it short circuits. There are very obvious questions sometimes like, "What does it mean for a white person to be doing this project in a Black community?" And the answer has a heavy implication toward what that means. But I think that when it's like, "What does it mean for an Asian guy to be doing this thing in this Black community?" It's like, "I don't know!" That's just a weird situation. I think that there's a certain set of channels that for Asian-Americans . . . it's easy to run out of it and fall into different places. There have been times in life where I was very proactively trying to find more organizing within an Asian-American context and doing that work there, and for many years volunteered with the Chinese Staff and Workers Association in New York. And that was a situation where it was great, but as someone who doesn't speak Chinese well and has almost nothing in common in terms of my experience with someone who is a first- generation garment worker, I might as well be working in South LA with Latino and Black communities—it's as wide of a gulf and there's as much stuff in common and not in common. That's just something for me in my experience. I don't know if I can necessarily characterize it as an asset, but it's characteristic of my particular subject position and the way that I do these kinds of projects.

ECB: To piggyback off of that, I think the context that inspired *Organize your Own* is not entirely relevant in an Asian-American context, simply by numbers. White people are in abundance; white people are everywhere. You can go anywhere, any city, anytime, and find a large number of white people. Asian-Americans make up six percent of the population, generally, across the United States. Numerically, in rural areas we're pretty hard to find. That said, I agree that if we're talking about organizing from an anti-racist perspective around specifically Black issues, then there is a need for Asian-Americans to educate the Asian-American population about anti-racist issues and where to place themselves within that context. That said, I think it's a fairly different case than being a socially engaged artist and engaging in a project. It could grapple with anti-racist issues or not, but speaking to what Rosten was saying, I have felt that there was an advantage in being mixed-race or Asian-American working in non-white, non-Asian communities because I do approach it from a standpoint where I know what it's like to be different. I know what it's like to be excluded, and I know that I have to listen first before approaching a community with my own agenda. I am able to place that there is historical trauma from white people (as outsiders) coming

into neighborhoods and putting forth their own agendas, and that's not what I want to perpetuate. Having that context, being a person of color, though not Black, can be an advantage.

Rosten, I was really fascinated by the idea of this anti-democratic demographic hailing that affects people's lives significantly, and it seems like a very specific space to organize and to ideally democratize. I wonder if there are projects that you think of as doing that work which already exist or if there are ideas about how to do that work that you've thought of?

RW : The answer is yes. There's a political theorist and writer who coined that term, "statistical citizenship." That was around the time that there was a lot of politics around whether the census should be direct count or sampling, and whether or not that would count or undercount various populations that are hard for the census to get to. If you use a sampling method, you're very likely to undercount the number of undocumented people. You're very likely to undercount people who don't speak English, so marginalized communities get pushed out of the census in that way. He wrote a series of papers, like here's a) how the census should be done, and b) if you're a white ally who receives a census form, here's how you should fill it out to best tip the odds toward counting the population most accurately. So those are some of the things I can think of that I know of as specifically demographic activism projects in a nongovernmental space but civic space. Of all the ways we're being turned into data all the time, and our world is kind of constructed by that—you incorporate algorithms—I don't know of a lot of projects that are in that field but it seems really important. There should be some!

DW : To the earlier question, about organizing your own ... when I was a graduate student in the early-mid '90s, 100 percent of my art school output was about identity themes and Asian-American themes, Chinese-American themes, Chinese motifs, Asian motifs—trying to figure out how to use those languages of culture, thematics and motifs, imagery, etc. I left all that behind after graduate school because I felt that the missions of Asian-American-identified cultural organizations were fairly narrow and did not speak to my larger political commitments. In the early 2000s and late '90s, I started paying attention to what was going on in China—a lot of reading, talking to people, starting to visit. Then I made a commitment to go there as often as I could—about every other year. I started to realize that the changes in China were so momentous and the upheavals so fundamental that there were many people in China also asking themselves, "What does it mean to be Chinese?," but from this entirely different starting point. That's what got me back into this. I am trying to understand the shifts in the geopolitical economy, and how

they are negotiated at a deeply personal level, where people begin to question who they are. People in China asking those questions—"Who am I? Where do I belong? What's my identity? What's my relationship to this land?"—is interesting because they don't have the experience of a couple generations worth of identity politics and consciousness.

RW : Can I actually ask a follow up question to you and everyone else? What made you decide like, "That's obviously where my focus would be, with working on issues in China." Obviously you could claim a strictly Asian-American identity in a way that maybe I have. I don't have any particular national connection to China whatsoever. I've got no impulse to be, like, I've got to be doing projects in China. I'm curious what led to that, and by extension, I'm curious about your [Aletheia] project with store owners: how you chose that community. Like, "These are the people I want to be working with." I'm interested in where you make that leap of like, that's why I did that, chose these people.

DW : I had an earlier experience in China. The first time I went to there was 1991, only two years after Tiananmen. There were not many foreigners there; it was still under deep chill. Then I went there for eight months starting in 1993. I went there to study woodcut. My language skills were very poor, so I spent a lot of time just observing the social landscape. I could receive more than I could express at that point. So I had a point of reference, a strong memory of pre-economic boom China. My curiosity led me to go back to see developments on the ground, to compare with what I had seen before. After my early trips, during which I was mostly mute and only observing, I devoured a lot of books about China just to figure out what it was that I was seeing. That self-education was a springboard. Another thing about my access to China is that I am a child of immigrant parents, so my parents had some direct links to East Asia and belonged to networks that I have benefited from—and now I feel some responsibility to nurture and keep alive those networks. Also, while growing up we constantly had new arrivals among relatives coming, periodically refreshing this whole immigrant element within my family. But that to me is my question for both of you. As biracial, when do you choose to identify which way, or is that a choice, or did you come to see it as a choice? That would be one question I have for you two [Emily and Rosten].

ECB : My parents are in the crowd right now. [laughter] I guess as a mixed-race person, I think, at least for me, it's had a lot to do with my upbringing. I was generally closer to my mom's side of the family; my mother is Chinese. She came here when she was eight years old from Hong Kong. [She] also doesn't speak the language that well, so I didn't have too much connection to cultural heritage or linguistic heritage, and apparently my grandparents didn't emphasize a lot of the culture. I would see my mom's side of the

family much more often. My dad's side of the family is in Louisiana; I grew up in Jersey; and my family's been in the mid-Atlantic area. All of my cousins are mixed race. All of my mom's side of the family married white people, and so all of my cousins, we all look very similar, and that was normal as mixed race, and normal to identify as Chinese in that context. Once I became politicized, it definitely was a strong choice. It felt like, "This is where I am. This is how I feel. This is politically where I see myself."

I also want to answer [Rosten's] question about choosing the people you end up working with. In the program I went to for graduate school at Maryland Institute College of Art for Community Arts, a lot of our advisors pushed us to work with our own people. In Baltimore, my "people" didn't exist. It's like, 67 percent black, like 33 percent white, and maybe some small percentage of *other*. In terms of a Chinese population, they mostly weren't there. In terms of a mixed race population—eh! I don't know! Where are we? People who are of Asian descent and white don't get together and have all their babies and then drop them off in one neighborhood and live forever, so you can't go to one specific area [Rosten: Southern California]—maybe in California! That's different! Actually, that relates to the fact that when I was in California, I did work with Asian-Americans, and a lot of them were mixed. But since coming back to the East Coast, it's just so much of a grey area. "My people". . . . I cant find them in a lot of senses. Whenever I meet people who really advocate for working within your own community, I often will sarcastically propose, "Well, who do you think I should work with? Who are my people?" And people will often say, "Oh, check the internet! I'm sure you can find your people there! They're somewhere! Don't give up hope!" But that's not the point, right? As a socially engaged artist, you don't want to be relegated to the cybersphere. I think that the beauty of socially engaged art is working with people, interfacing, building relationships.

RW: I think that I tend to identify as an Asian person when I'm in dominantly white scenarios and dominantly Black scenarios—any situation where I'm not around Asian people. Once I'm in a room full of Asian people, I feel like I'm not really Asian! I feel like I'm missing my critical knowledge to be a true Asian person. I think a lot of people who are second-, third-generation immigrants feel that. It definitely for me has always felt like a very active process of making, of like, "I'm gonna actively do some Chinese stuff this weekend, and connect to my roots." You're sort of like, "I didn't grow up doing a big Lunar New Year celebration, but I guess I'm kind of into it. I guess I'll start doing some stuff like that." But it is invented. It's not like I feel like I'm having this authentic, "I'm just this vessel that this tradition has just poured down into me." So it is negotiated, for sure, in that way.

ORGANIZE YOUR OWN?

Moderator: Anthony Romero
Participants: Eric J. Garcia, Nicole Marroquin, Maria Gaspar
Museum of Contemporary Art Chicago
March 15, 2016

Similar to the event at the Asian Arts Initiative in Philadelphia, this panel asked artists to consider what "organizing your own" might mean in ethnically specific cultural contexts. The four participating artists considered the history of the impact of the Chicano civil rights movement on their organizing and practices as Latinx artists. The panel included a screening of the film American Revolution 2, *directed by Mike Gray and Howard Alk (Film Group, 1969).*

ERIC J. GARCIA: I'm going to begin with an Aztec legend. The Aztecs believed that they originally came from a mythical homeland, north of Mexico, called Aztlán. The Aztecs were nomads at one point. They ventured from Aztlán down to Lake Texcoco, where they eventually made the capital of their empire, Tenochtitlan, which is present day Mexico City. I want you to keep this Aztec myth in the back of your mind because it will be relevant as we move forward.

　　Centuries later, specifically in 1519, Hernán Cortés and his conquistadores arrived in Mexico and conquered the Aztec empire. Inevitably, the Spaniards mixed with the indigenous people and became something new. They created a new mixed culture, a *mestizo* culture. This mestizo culture rallied against the Spanish crown and was able to cast off the shackles of colonialism in 1821, when Mexico became its own independent nation. Now if we move further north, we see that there is another nation butting up against the once very grand landmass of the Mexican nation. In 1846, the United States, President Polk, and the idea of manifest destiny arrived

in the Southwest. What we now know as the Southwest was then the Northern Territories of Mexico. Within two years, by 1848, almost half of Mexico's nation was taken. California, Nuevo Mexico, Tejas, Arizona, Nevada, Utah, Colorado—all these Indo-Hispano surname states. Do we ever wonder why most of these names are Spanish? It's because they were once part of the empire of Spain, they were once part of the nation of Mexico, and now they belong in the hands of Uncle Sam. Along with these new territories that the United States absorbed or stole, it also took with them the populations that lived there, the Spanish-speaking populations that had lived in these territories for centuries. The United States, with the Treaty of Guadalupe Hidalgo, promised these populations that their language, religion, and their land would be protected, but unfortunately this was not so. They, the Spanish-speaking peoples, became foreigners overnight in their own land, and this population had to assimilate in order to survive. Unfortunately, it became harder and harder to assimilate in a society that did not like nor want to have anything to do with the "other." For example, the term "colored"; it doesn't specifically mean Black people. "Colored" means people of all colors *other* than white—the "red" man, the "brown" man, the "black" man, and even the derogatory term, the "yellow" man.

As we move on through the decades, this inevitably frustrated the Mexican Americans, as they would now be called. They would try to prove their allegiance to this new government— they learned English—but they still could not fit in. Even though they were fighting and dying in wars overseas for the United States, they still were not accepted. They were coming back from wars like Korea and Vietnam, and they were still considered the other, foreign. This frustration inevitably boiled over during the Civil Rights Movement. In the different struggles that were going on in the late 1960s and early 1970s, the Chicanos would use the Black Power Movement as a model for their own struggle for rights, specifically with leaders like Malcolm X and Martin Luther King as their guides and role models. The Black Power Movement was asking: How can we understand ourselves and defend ourselves? How can we self-determine our situation? The Mexican Americans started to ask these same questions. They were trapped in between spaces, as Anthony was talking about, this otherness. They were not accepted in Mexico, and they were not accepted in the United States. They were not accepted on either side of the border. They were born and raised in the United States, but of Mexican descent. There was a disconnect in both nations for these people; they were people without a nation. Eventually, radical Mexican Americans started thinking of themselves in different terms and with a different understanding of being, and they developed the term "Chicano." With the help of this new term the Chicanos identified themselves as a new movement.

With that term, Chicano, they also began to understand that they needed to learn more about themselves, versus just learning about pilgrims and George Washington. They started looking at their own histories and understanding that they had their own heroes and heroines, and they had their own myths and legends, just like the legend of Aztlán. The Chicanos absorbed the specific legend of Aztlán, and they began to use it in their own way to understand that, maybe, that mythical homeland of the Aztecs way up north was actually the Southwest where they lived. And maybe they were going to take back Aztlán from the occupying nation who stole it. And this is how the Chicano movement evolved into a very radical, nationalist, and, sometimes militant, movement. Corky Gonzales, in his Manifesto, *El Plan Espiritual de Aztlán*, specifically states that art will be used as a tool for the struggle of independence and nationalism. This became one of the core aspects of Chicano art during that time—that it would be used as a tool and a vehicle for the struggle itself. You can see that in this political poster created by Malaquias Montoya, back in 1973. He is equating the Chicano struggle with the struggle that was happening in Vietnam during that time. He is equating his brothers in arms, the Viet Cong, with his own people in the Chicano movement, both of whom were fighting the United States against oppression, against occupation. I think it's really interesting that they were not looking only within the borders of the United States but beyond, to other international struggles against colonialism.

Eric J. Garcia speaking at MCA Chicago, 2016.

I was fortunate enough to have been exposed to some of the remnants of this struggle in my own life, while I was in school at the University of New Mexico. I was taught by one of the Chicano Studies professors that lived during that time, Dr. Charles Truxillo. He was a radical Chicano Nationalist, very controversial, and I was able to absorb that history and spirit of resistance from him, which I implement into my artwork. History is the galvanizing force behind my art, and I create with the intent of using this art as a tool or vehicle to share the Chicano history with others. This is what became a motivating force to create what I create. I jump between many different media. I paint murals; I draw political cartoons published around the nation; and I do site-specific stuff, as you see here at the National Veterans Art Museum. I mix media and I do different things, but all of the work has the commonality of talking about the past and what it is to be here in the present, and all the political circumstances involved with different complications of race, history and politics that are happening not only here in the United States but abroad.

MARIA GASPAR: Hi, my name is Maria Gaspar; I'm an artist and educator. I'm going to focus on one specific community project, a project called *96 Acres* that began in 2012. But before I start talking about that project, I want to look at a couple of works that really formed my political imagination as a young artist growing up in La Villita, or Little Village, on the west side of Chicago. I was really inspired by and worked with many murals as a kid. Although I never got to work on the Wall of Respect, for me, that project really represented an interesting, radical way of thinking about the way that communities can create their own kinds of narratives. Created by a group called OBAC, the Organization of Black American Culture, the mural was collectively conceived and produced by artists and non-artists as a way to highlight local black heroes and leaders. This piece by Hector Duarte is a project that he did a couple of years ago where he's portraying himself underneath these sharp barbed-wire images, his hands held out in almost a position of arrest. This mural is literally on his home, about a block away from the National Museum of Mexican Art. I'm interested in looking at the politics of space, the way that brown and black bodies think about a sort of spatial justice. What are the ways that artists can intervene in architectures of power or powerlessness? How can the body become a political space, inserting itself into a political space and then reclaiming it? But I'm also interested in the idea of legibility and the freedom to also be illegible as a space of freedom. In looking at these architectures and thinking about public space, I've been spending a lot of time with my collaborators thinking about borders and walls. This is Border Church in Tijuana, Mexico, where two communities on either side of the wall come together in a ceremony. What are the politics of space and geography? What are the psychological elements of a

place like this? The formal and informal elements that monitor behavior, or direct behavior, and the way these spaces keep people apart, spaces like the US–Mexico border.

In thinking of these spaces and the way that one kind of adapts or works against them, I started to look at the largest architecture of my neighborhood, the Cook County Jail. It is the largest jail in the country; it holds about 100,000 people per year, mostly Black and Brown people. A group of artists and educators started to really think about how communities across the street from the jail interact with such an oppressive space? But also how can radical interventions create counter-narratives around

Maria Gaspar speaking at MCA Chicago, 2016.

these places of power, and how can people collectively counter these issues of isolation, displacement, and oppression? I came across this manifesto recently, made by Arturo Romo, called *Crystal Brilliance Manifesto* from 2005. It was exhibited as part of the *Phantom Sightings* exhibition at LACMA. He's talking about a new muralism; he's talking about the tradition of poster art, of a kind of democratic artistic process. And in it, you see these really amazing tripped-out images. This is the part that I really love the most: he says, "Seek to reinterpret the flatness of the building, plow through the picture plane ... emphasize the flatness of the building as well as the illusionistic nature of the roundness that you might have taken for granted while being by your training desire. Transform the building into a crystal, into a mirror. Transform the exterior of the building into an interior space. But please, transform that building, change it into something else. Luminize it."

The jail is 96 acres of compound. It is about the equivalent of 74 American football fields. This is a view from the administration building, looking all out towards La Villita, a community of about 80,000 residents, many of them youth. *96 Acres* project is a series of community-engaged, site-responsive works that address the impact of the Cook County Jail on Chicago's West Side and communities of color. We are interested in generating alternative narratives of power and thinking of a way to create a vision of transformation and healing. This is the #60 bus going from the east side of the neighborhood to the west side of the neighborhood, looking at the jail. There are some informal things that happen around the jail every year. Every September, you can experience the Mexican Day parade comprised of floats, cowboys, cowgirls—set up just outside of the jail wall in preparation for the long walk down 26th street. *96 Acres* is comprised of lots of educators, artists, activists, many of whom are in the audience, different kinds of collaborators. We've worked on audio archives, really focusing on people's personal stories, first-person narratives, and the sharing of those stories. What we've noticed is that when we ask young people, "Who here has had a personal experience with the jail?," many of them raise their hands. But what kind of spaces or places for dialogue do we create so that we can come together and talk about these things? We organize things like educational workshops, with many different community leaders, artists, educators who are interested in engaging the body, the youth, and the way that youth organizers are organizing in their own high schools and communities, learning from them. Throughout that work, we have produced eight site-responsive of projects that have ranged from zines and comics, to photography projects and a piece by Bianca Diaz, a two-page spread of a comic of mothers who are incarcerated and their families. We have worked with other artists to produce site-specific work; this is a photo studio situated across from the courthouse where the artist took photographs of all the passerby as a way to document and share stories. I'll show you a little clip from this project by Yollocalli Arts Reach. It's a reverse graffiti project where they use stencils to remove the dirt from the walls and the sidewalk to reveal text. . . .

[video clip]

She ends with a really important point—that sometimes people don't do bad things to be in there. We're really thinking about and looking critically at the space and thinking about the issues around mass incarceration in this country. We incarcerate two and a half million people, more than any other country in the rest of the world. And she's talking about the prison industrial complex; she understands that there are private prisons that exist that are mostly imprisoning people of color and the poor. I have a

couple other pieces, but I invite you to go to the *96Acres. org* website to look at a couple of other projects that we've done, including a series of projections that tell stories from both sides of the wall about the experience of incarceration. Anthony asked two questions during his introduction; he asked, "What do we need?" and "What do we do?" And I was recently at a presentation by an artist, Amalia Mesa-Bains, who was talking about equity, organizing, and art . . . she asked the audience, "What do we have?" She was pointing out the resources that communities already collectively have. So I just wanted to put that out there as well: What do we have? Thank you.

Nicole Marroquin speaking at MCA Chicago, 2016.

NICOLE MARROQUIN: The Lower West Side of Chicago has been organizing for a really long time, and these are out takes from a film called *Mi Raza: Portrait of a Family*, made in 1972 by a filmmaker named Susan Stechnij, who was, according to Olga Herrera, a member of MARCH, the Chicano organizing group. Susan was a student in anthropology at UIC at the time. This is one of the pieces of material that I used when I was working with students at Benito Juarez High School. What I started looking at was a series of school uprisings that happened from 1968 to 1973, more or less. The main organizers of the 1968 walkouts were two Chicago Public School students named Victor Adams and Omar Aoki, featured here in *Ebony* magazine. Victor Adams was a student at Harrison High School. These walkouts happened in October, a couple of months after Dr. King was killed. The students organized three walkouts in

one month; one of them had 28,000 students; another one was estimated at close to 60,000 students.

On October 16, 1968, there was a meeting at which Latino students, who were walking out with the Black students, presented their manifesto during a meeting of the Black student organizers. I'm really interested in moments of solidarity between organizing groups, and I feel like there's so many of these moments that aren't talked about. I think that movements are led by youth, so my very first impulse was to run to the group of high school students that this would mean the most to, give it to them and see what they would do with the material. Let me read a quick quote from a student named Salvador Obregon who was in the 1968 meeting. He said Principal Burke had threatened him with deportation as an "undesirable alien" if he participated in or led the walkout. This was at a school that's at 24th and California, which is now Saucedo Elementary. I found this picture [projected], about a month later, of a 1973 walk out. It was all 9th graders who led this. This is a map from 1968, so Juarez is where the heart is but it hadn't been built yet. I'm talking about Harrison High School and Froebel, which, in 1964 was converted to Froebel Branch—the 9th grade branch of Harrison High School—and here is Benito Juarez, which is where the students who would have gone to Harrison and Froebel before, currently attend.

I started to work with Paulina Camacho and her students; she's the head of the art department at Benito Juarez. I've been talking about this with her for a couple of years, and, over time, students have really taken to this project. We got accepted to a conference to talk about the outcomes of the work, which I'm going to show you. This [projected] is the timeline of events, and interestingly I found a picture from 1968 of students marching on the Board of Ed. with a coffin with a cross on it, and then, in 1973, the same community of students having a march with a coffin symbolizing the death of education. The marches were called Liberation Mondays in 1968. The thing I found so exciting about these *Tribune* articles and the photos, is that it's similar to what's happening now, when people say, "It couldn't be these students; it must be outside agitators." There's a bunch of people saying, "This doesn't have anything to do with civil rights," and calling the marchers hooligans or pranks. But then there's this really elaborate performance, and all these props, and the students are organizing in these huge and phenomenal performances!

A lot of what I'm talking about here is coming out of a dissertation by Jaime Alanis, who was looking at Red Squad files, currently housed in the Chicago History Museum. The police were the ones who were recording a lot of this information, just so you know. [The students and I] spent a lot of time looking at pictures and investigating what they are; you can't take it at face value. This is another one [projected

image] that I found on eBay. It was actually published in newspapers around the country. This isn't, like your romantic, righteous civil rights moment, where you hear electric guitars blaring in the documentary, like in the documentary, *Chicano!* People were injured and arrested. We can only see what the *Tribune* printed here. There were four Spanish-language newspapers that followed the story that are not archived at all. We had a lot of other sources, like the 1973 yearbook. Students at Benito Juarez High School started to work with these images and I thought, "Who is this most important to? Who has the most at stake?" And it would be the 9th graders who attend Benito Juarez High School, which is the school that was built as a result of the uprisings. They know more than I could ever know by digging in any boxes. I realized that staring at the yearbook photos at the faces of the actual people who led the walkouts, who were there, who were either the witnesses or the leaders, that the students would intuitively ask the questions that needed to be asked. The students were thrilled to work with primary sources. I asked them a couple questions: What do you think happened? What would you have done? And what would you ask them? And these people are now around 56 to 60 years old, we figured. Students have been working with the images, and they've made hundreds and hundreds and hundreds of collages. The students had all my material at their disposal, at one point, and we were all sort of deducing what had happened. There's the staircase, there's the police . . . the riot cops showed up. One student was pretty much on the same page as me, really just wanting to know what happened on the stairs, that day in 1973, and so he animated it.

Another student is organizing her own archive, with images that she thinks are the most precious and that need to be saved, putting them in an order that reveals how she is interpreting them. Another student surprised everybody at a critique less than a week ago with this little tiny 2-inch sculpture of Froebel that fits into a box where you have to peek at it through these tiny, itty bitty holes. It's about a 3- by 4-inch box, which sort of meant that this is all you are able to understand of the story of Froebel. Other students took it into their own hands and did a site-oriented burning piece where they took a giant photo of the riot cops and burnt it at the site where the school was. I'm just going to show you a little part, but they showed it in reverse so that the history would then begin to be revealed. And it says on it, "The truth always comes out in the end." 64 students are currently proposing their own individual projects. While there's so much that they've seen, there's so much they haven't seen. We just got cutting room floor out takes from this film, 100 minutes of them. There's no sound; it's just bits and pieces from the lives of the people that lived on the same block as the school and some of the kids that went there. We've just started.

Anthony Romero: I work in a lot of different ways, but for the purpose of this panel I'm going to focus on projects that have to do with organized interventions into institutional spaces. A few years ago, myself and an artist named Josh Rios were invited to Texas State University, which is in a small town called San Marcos in South Central Texas. For this project, we decided to create a temporary space that was attached to the art school. We asked all of the art professors who were teaching classes during that semester to give us their syllabi and any lectures that they might have for the week of our residency. We chose a number of courses, one course from each day. We invited a group of students from across the school, so these were not just art students; they were also biology majors and other kind of science majors, mathematicians, etc. Each day we would visit a different class. Students were asked to pay attention to three things: one was the way the architecture of the room impacted their learning. This could be the way that the chairs were arranged, how big the projection screen was, the kind of media the professor was using, etc. The second was the performance of the lecture, how that professor was communicating the information. The third was the larger context of the university. The university was funneling money into a lot of sports activities and was defunding other things. At the end of these class visits, we would all get together and we would share our notes with one another and build performances out of the experience in the classroom. These performances were all open to the public and took place in the main lecture hall.

Another recently completed project was that last summer, another collaborator, J. Soto, and I were invited to teach at Oxbow School of Art and use the opportunity to collaborate with the school to create a scholarship for Latina/Latino people to attend the school. I like this project very much because it sits just outside of my artistic practice and has a relationship with these kinds of activities, but maybe more directly impacts the institution and opens up the opportunity for other Latinx artists to occupy similar spaces. The student on the right is the first recipient of the scholarship, which was given out last year; this coming summer will be the second year.

The final project is something that I'm working on with a theater company in Mexico City called Teatro Linea de Sombra, a socially engaged theatre company based here. For that project, we've connected and will connect with artists in Chicago, as a way to think about the relationships between places like Juárez, Mexico City, and Chicago. I just spent the last week in Mexico City: working with these artists. During that week, I was thinking about this quote from the artist Bas Jan Ader: "Who will fight the bear? No one? Then the bear has won." When I think about the projects that the other panelists have talked about so gracefully, and I think about my own work, I think in part that it has to do with identifying these troubles, the "bears," let's call them. And in

creating the conditions in which we might return the pressure of that force that is bearing down upon us. As a group, we've been talking a lot about the possibility of creating a Latinx Artists Retreat, in a way modeled after the Black Artists Retreat that Theaster Gates has been doing with a lot of other collaborators for a few years. This, I think, emerges from a similar place of both wanting to create the conditions for establishing stronger networks amongst ourselves—creating a kind of political cohesion across our practices and our regions and territories—and also to begin to think about how we might negotiate our entry or reentry or disavowal of pre-existing institutions and organizations.

Anthony Romero speaking at MCA Chicago, 2016.

I'm thinking about how nationalism for Black Americans, in particular citizenship, has always been an ongoing struggle, a little bit in a different way than I think Latino Americans sort of deal with. I'll speak for myself instead of on behalf of all Black people, but I will say that [I understand] this question of not really feeling as a Black individual that I can entirely claim my citizenship to the States, nor can I really claim my citizenship to Africa. I'm wondering if you guys can speak to maybe how that pertains to your coalition. I don't know if everyone is from the same place; how does that work? How is nationalism maybe or maybe not informing the retreat that you're talking about?

EG: I think that's super interesting because when we started meeting about this panel talk, we were talking amongst ourselves about where we come from and how each one of us has our own unique places and terms that

we identify, even though we're under the umbrella of Latinos or under the umbrella of Mexican-Americans. I still consider myself a Chicano, from the Southwest. I am originally from Albuquerque, New Mexico; I'm Nuevo-Mexicano, I'm from the other side of the Mississippi. Versus my comrades; some are from the Midwest, some are Tejano. There are all these different labels, even though we're under some sort of umbrella.

NM : I actually was thinking about this concern that I have through the project that I am working on. For example, in 1968 when the organizing was happening, and there was all this solidarity, it was invisible in the news. In the Tribune it would say, like, "the 300 Puerto-Rican students and Black students and 'others' march" because they didn't have any statistics on the Mexican or Mexican-American students because they were categorized as white. My birth certificate says white—that's how segregated schools were desegregated without having to trouble the waters. All of this changed in '72 in the case of Cisneros vs. Corpus Christi ISD, when it was determined that discrimination was occurring, and Mexican-American students were re-labeled, and could not be used to desegregate black schools. It's still a difficult set of terms and we are all coming at it from different ways. I'm from Texas, and I didn't know anything about this. My birth certificate says white. I didn't find anything out about this until I was figuring out this history in the process of working on this project. And I'm relatively new to this history situation, and it's really unlocking a lot for me around these topics. My parents were involved with Chicano movement people in Ann Arbor, Michigan, which is really different; we all are coming from really different places, which makes it difficult to define.

MG : I think a lot about how displacement and placelessness, or lacking space, is also really central to being able to unionize or form community. These are just things that are on my mind; I guess I'm just seeing some of the bridges between these two different constituents, groups of people.

I have a question that piggybacks off the quote that you ended with, about the bear. What is the "bear," in the context of providing an interior cohesion of Latinidad? Or providing exterior pathways for alliance that we saw through the documentary? What is the "bear" in your own work, in the sense of the communities that you work in, and in your sense of working across community towards a shared antagonistic frontier, or however you imagine it?

EG : I don't like that animal, the bear. I would say the *bald eagle*. That's the one I'm fighting against. And when I say that, I do mean specifically, Uncle Sam. That's what

the Chicano militant movement is talking about, this government in itself. The Chicano movement was fighting back in the day against poverty, healthcare, foreign wars, domestic wars. The work that I'm creating right now is about those same damn things! This country hasn't changed very much. I was at the rally the other day against Trump, and it was disgusting. It was ugly to see a new generation of white supremacists out there, young, teenage youth. It was ugly.

MG : To add to that, I'm thinking a lot about how do artists or educators, activists, create moments or spaces for liberation. What are the ways that these artistic projects, at least those that I've been engaging in with collaborators, how did these projects become spaces to reimagine *96 Acres*? Can we collectively reimagine what that space could look like? A lot of the time we can't imagine it; we don't have the ability to do that. But as soon as we can start to challenge each other to rethink that and really identify those spaces of oppression—and the jail is in fact one of them—that maybe we can transform that space in a new way through collective action.

AR : I think that for me, as a person in the world who happens to be an artist and a person of color from a working-class background, that this sort of confluence of what we might call blessings, has put me in a position in which I encounter lots of different kinds of bears. And lots of different forests. So it's more difficult to identify what the bear is and where it's coming from and how we might fight it. As we walk into the forest, we might find that we are lost amongst the trees and are surprised to find the beast in the shadows. This idea of identifying places, or opportunities, in which resources have been evacuated, allows us to create situations in which we might reinvest resources or divert resources into other places. It's not so simply a question of representation, but rather about the distribution or redistribution of resources.

[I have a question] about how the idea or definition of the word Chicano came about. I was born and raised in Little Village, Chicago, and one thing that always sparked me growing up was an identity issue. When I went to Mexico, I really wasn't part of Mexico, so I wasn't part of the people there and they noticed that and saw that. And the same has happened to me here in the United States. So it's kind of like you're out of tune; you're just this guitar that's been played out of tune and you're just not ever really understood. Does that affect you? Because I really didn't think of that Chicano word, until you just mentioned it. And it makes sense. But how does it influence your work, your work of art, and how you try to find or evolve this aesthetic?

EG: I think I use the word as an advantage to me; I don't use it as a disadvantage. I am able to pick visually and historically and philosophically from Mexico and from the United States, because I'm from both worlds. I have a foot in Mexico and a foot in the United States. Even though I straddle this border. I use it to my advantage. And then along with that, it comes with this baggage of politics of radicalism, and I accept that as well because my artwork is all about history and using it as a way of challenging, but most of all questioning. I'm not giving answers; I'm just posing questions. And hopefully someone else who looks at my art can find some answers from it. Hopefully, I'm praying! If nothing else, at least get you thinking or have a dialogue about these bigger issues of who are we, where we come from, and where we stand in the present state.

Organize Your Own Panel Discussion, MCA Chicago, 2016.

ORIGINAL RAINBOW COALITION

Moderator: Edward Onaci
Participants: Amy Sonnie, Hy Thurman, James Tracy, and Jakobi Williams
Slought Foundation, Philadelphia, PA
January 15, 2016

This panel asked historians of social movements to consider the history and historicization of the Original Rainbow Coalition—a unique example of how those groups negotiated race and class across self-determination movements by bringing together organizations such as the Young Lords, the Black Panther Party, Rising Up Angry, and the Young Patriots Organization. The panel included a screening of the film American Revolution 2, *directed by Mike Gray and Howard Alk (Film Group, 1969).*

EDWARD ONACI: We've heard of this Rainbow Coalition, and we know that the Panthers and the Young Patriots Organization were a part of it, but what were some of the other organizations who participated?

JAKOBI WILLIAMS: The original group to join with the original Rainbow Coalition in Chicago was the Young Patriots, followed by the Young Lords Organization, and that was pretty much the nexus. Later, you get Rising Up Angry and some other groups that were in coalition with them, like the Latin American Defense Organization (LADO), a lot of former members of SDS, a lot of community groups, and even some of the street gangs. But the nexus were those Southern whites, those African Americans in the Panthers, and the Puerto Ricans of the Young Lords, at least in Chicago. "Preacherman" from the Young Patriots and Bob Lee would eventually travel the country, beginning in the South, on a multi-city tour to try to organize other branches of the coalition in other places.

AMY SONNIE: Aside from the origins [of the Rainbow Coalition] in Chicago, the "rainbow politics" and the concept of the coalition really expanded beyond Chicago. Fred Hampton and Bob Lee's work inspired a lot of other chapters of the Panthers to grapple with the question in their own cities and in their own chapters. It also inspired a network of organizations that James and I write about in our book, who were already, like the Patriots, in motion around their own community organizing efforts around issues of poverty, and racism, and gender during the early parts of the feminist movement, including here in Philadelphia with the October 4th Organization.[1] I just want to give a nod to Dan and Sharon Sidorick who are here [tonight] from the October 4th Organization, which is part of the spirit of this coalition-based politics around white working-class communities working with natural allies in other ethnic-based communities. Another one of the groups that we write about in our book, also part of the spirit of these politics, working with the Lords and the Panthers in New York, was white Lightning, an organization based in the Bronx.

JW: I wanted to clarify that racial coalition politics was not the baby of the Illinois chapter of the party. The Black Panther party, as a national organization founded in Oakland, had always been involved in that kind of coalition politics. What makes Chicago so unique and so rewarding is that Chicago [was] then, and still is today, the most racially, residentially, segregated city in America. In the '60s, we had three or four different race riots, dealing with issues like desegregation of schools and others. The fact that a coalition and that kind of politics can take form in a city like that, with that kind of turmoil, especially between two supposedly competing racial groups to spearhead it, was remarkable. At least in Oakland, you had other groups like the Peace & Freedom Party, the Brown Berets, and a whole host of groups—I'm leaving out all the other Asian-American and Native American groups that were involved. So that was the philosophy of the organization as a whole. I don't want to give this misconception that Chicago started this trend, but the way in which it transformed politics is a Chicago phenomenon.

EO: As we saw in the film, and as Hy Thurman alluded to, and as you all have alluded to, this was something that people were attempting to do. I'm curious to know if there were any, or what types of obstacles they had to overcome in order to make something like a Rainbow Coalition effective?

JAMES TRACY: I remember when I interviewed Bob Lee over the phone two or three times, the thing that stuck with me about what he had to say was that the Rainbow Coalition was a "code word for class struggle." Because not everybody and

everybody's community were ready for a class struggle, it was a strategy of dealing with racial fragmentation in the movement at the time. It was a very specific response: to organize your own but work together. And so I think that was the biggest obstacle, that while you had people like Hy, and Junebug, and Bob Lee, and Karen, who were absolutely ready, and probably had the temperament to be in a multiracial organization and not a coalition, not everybody was there. So they were coming up with a theory about what might work and what might reach people where they're at, and then pull them over a few steps into actually laying the ground for the unity. They knew from the start that that unity wasn't there in all of their base, and that went for all three of them.

Notes:

1 Sonnie, Amy and James Tracy. Hillbilly Nationalists, Urban Race Rebels, and Black Power: Community Organizing in Radical Times (New York: Melville House, 2011).

(L to R) Edward Onaci, Jakobi Williams, Amy Sonnie, and James Tracy speaking at Slought Foundation, Philadelphia 2016.

JW: In Chicago, individuals like Fred Hampton, and even Bob Lee, were already engaged in this kind of interracial organizing. For instance, Fred Hampton, as a youth, was president of an NAACP youth council; he was already involved in that kind of struggle. He worked with King and the Chicago Freedom Movement, when that organization came north. And Bob Lee, in his background from his father and grandfather, worked in the Longshoreman's Union where he was born—he was from Texas—so he was bringing that activism forth. The irony is, in all of this, that segregation actually helped the coalition. It was actually the glue of the coalition. What do I mean by segregation? These groups were already segregated in all these various forms—the Chicago city of neighborhoods. The key, which was the theme of the *Organize Your Own* exhibit and panel, was you organizing your community and we're organizing ours. And that was a front for groups like SDS that were trying to come into and organize people in the Black community. So you have some ideological differences between the SDS and the Panthers in that regard. And then, when those issues [arise], whatever issues they are—say it's housing in the Puerto Rican community, or in Uptown for others—you don't fight those problems on your own; we all come together as one solid force. And we skipped a key part of the documentary, when Bob Lee was talking about these issues, about writing about what you have in common, and your poverty. What they were able to do was transcend these racial differences. He would highlight these particular instances in the film: "Do you have dilapidated schools?," he was asking these Appalachian/Uptown communities. "Of course we do!" "Police brutality? Really? And you have no healthcare? Hmm, neither do Black people! Getting drafted into the Vietnam War? Well, so are we! You're unemployed? We are too! Why do we hate each other again? Cause we're Black and white? It's stupid!" This is happening in all of these communities. So the separation was actually the glue to keep those groups working on their own and then coming together against the city, Mayor Daley, on a collective front.

AS: The only thing I would add: You can't underestimate the intensity of the period as one of the obstacles, right? So you're in a point where you've got this incredible pace of change, national liberation movements all over the world lending inspiration to movements here, you've got a war, you've got intense racism and poverty at home. All of this stuff happening, it's like a pressure cooker. If we all reflect for a minute on our own moment that developed our consciousness or politicized us—we're all in that process—it doesn't always happen overnight. Sometimes we have these moments that crystallize things. So we're talking about people who were trying to organize folks who were having these crystallizing moments, but sometimes that kind of education, that kind of coming to consciousness and politics for people is slow. And it's happening at

this incredibly condensed time period of so much change, and then you have an equal and greater weight of oppression from the state on top of that. That mix was both what makes this period so fascinating and important, and why we're still talking about it today. But it was also a part of the challenge. How do you get this coalition off the ground, find the campaigns you want to move, design the campaigns, start working on them? We all know, as organizers, that campaigns sometimes take time, and splits and disagreements start to happen, and these organizers were operating in that context with very little time sometimes to hash out disagreements. Because at the same time, you've got people asking, "What are you gonna do? Tell us what you need. Tell us what your campaign is. Tell us about your project." And then you also have the state being like, "They're going to take over the world; smash them now." And you can't underestimate the challenge that that presented for these groups.

EO: Thank you. I have a hunch that at least a few of the people in the audience are interested in this history because they think that there is something to learn from it about organizing today. So that's the next question I want to ask: what can we learn from the Rainbow Coalition about organizing around radical and revolutionary ideas? What does this coalition have to offer that we might not see in other places, or that they might help us see from some other peers?

JT: Your question reminds me of an interview that I once read with Saul Alinsky, where he said that his biggest fear when he wrote *Rules for Radicals* was that someone would be at a protest, and be like, "Oh, shit, what do I do?," and then run into an alley and look at his book, and say, "OK, point number eight, right?" [laughter] I think that there's such a thirst today with the amount of white reaction, with the amount of conservative reaction going on, people are looking for quick answers. I think that the last thing that anybody should do is say, "Read either of our books," and say, "We're gonna do a rainbow coalition exactly that way." But there are values that you can take, the responsibility to reach into your own community and challenge people to work in solidarity. . . . We talk so much around the holidays about how you have to have those kitchen table conversations. Peggy Terry was really good at the corner conversations, convincing people, "Hey, get rid of that racist junk. Come work together." And those are good. We should always have this conversation with that mythological racist uncle (or non-mythological racist uncle). But how do we build organizations that can collectivize these conversations and make political projects? You can read a thousand alternate articles on the Bundys [Ranch and their 2014 occupation], but the only way that you're going to defeat the Bundys is by organizing, by stealing the people that they think are gonna be their base, and that's it.

AS: I'll say that the question is a good one, and we could have endless conversations about the lessons to take away from this history. I'll just focus in on the theme of this *Organize Your Own* series. Particularly as a white woman, as a white organizer, what drew me to this question is, as an organizer and as an activist, what can I learn from moments in history . . . where coalitions were attempted, if not successful? If they weren't successful, why? And I think James hit on some of those takeaways. I think a lot about something we wrote about in the book, which is that when Peggy Terry—who was organizing with the Congress on Racial Equality (CORE) and involved in the Civil Rights Movement [in the early '60s]—was taken by her mentor to her neighborhood, he said to her, "You can't know who we are until you know who you are. You need to know who you are." [His point was] you need to organize your own. And this was years

2 Williams, Jakobi. From the Bullet to the Ballot: The Illinois Chapter of the Black Panther Party and Racial Coalition Politics in Chicago (North Carolina Press, 2015).

Edward Onaci speaking at Slought Foundation, Philadelphia, 2016.

before Stokely Carmichael put it into that phrase. This concept is not new, you know—DuBois—so many people have talked about this concept. And it was scary for her, and it was hard for her, and she didn't want to do it. She writes in her journals about it. And I don't want to do it. When I think about it, I'm like, 'Oh, God!' those conversations with my uncle. Or even thinking now, what is to be done in the Bay Area, which is like this multiracial whatever? It is hard and uncomfortable to think about what it looks like to do this work, to really do this work, to build these organizations, to plug in, and to have the hard conversations and to stay in motion . . . but that is what we have to do. And if we're not doing that, then the coalitions and alliances and the bigger victories in the long-term struggle aren't possible. Peggy had to be told to go do that, and my hope in writing this book and in unearthing this history and talking to you all is to continue to remind ourselves, and not always wait for someone to tell us to go do the thing that makes us the most uncomfortable. Because that is where the most work is to be done.

JW: To piggyback on those very enlightening points, one of the reasons I wrote this book was for that reason. What do we do now? What do we do in our current context? How do I learn from the past as a historian with two young kids? What do I want my children to be doing in the future, and how do I give them some ideas or a roadmap or at least some highlights to look at? This book is an academic work.[2] It's published by an academic press. But if you read it, you're not going to find any theory, jargon, huge words where you need the Oxford short version of the dictionary—none of that stuff! Even though it's published by an academic press, it's very much an activist work. A lot of my colleagues have tried to diss me by saying that, "Oh, this is not really the scholarship that we historians were looking for. It's more of an activist piece." And I always say, "Well, thank you!" [laughter] "Because I didn't write it for you!" It's academic enough where it's appreciated by the academy, but you can drop this book off in a church, a community center, a YMCA, a barbershop, beauty salon. Folks can read it and get it—it relates to them, it relates to the critical issues we're dealing with now, ideas for how to deal with those issues. And in my opinion, the organizing came out of two things: you have the chief organizing by not only Fred Hampton, but Bob Lee was a chief organizer. The Panthers became a model for others, as Hy and others mentioned earlier, how they developed from gangs, for instance, to become organizers, and many of the founders of the party were organizers. They were students, and organizers—not criminals and thugs. The two founders, for instance, Huey Newton and Bobby Seale were law students at Merritt College. Fred Hampton was a student as well, who came from the NAACP. Bob Rush, who is now Congressman Bobby Rush, was a student at UIC, University of Illinois at Chicago, and a leader of SNCC. These were not

idiots, is what I'm trying to say, so they became models for a reason. Even people like the Young Lords and the Young Patriots and others began to see them as a model of organizing so we can do that today.

The lesson that I try to tell folks is, don't be naive! Because what these folks did was stay within the bounds of legality, and it was the state that stepped out of bounds, and used illegal means to repress them. So now we know that when we're doing good work, don't think the state isn't watching you, don't think they won't murder you the way in which they did Fred Hampton and others. Don't think you won't be incarcerated like so many political prisoners are today, and so forth. Let that be also a lesson, that as some scholars have argued, if you weren't doing good work back then, you're probably alive today with no scars. A lot of those activists around today have a lot of post traumatic stress syndrome. Folks have a lot of scars from the struggle, so if you don't have those scars you probably weren't effective organizers, and you probably weren't doing your job during that period. Of those who were really effective, most were incarcerated, exiled, or assassinated. Keep that in mind, that when you do this kind of struggle, expect the state response, especially if you have an anti-capitalist tinge, which these organizations did.

EO: Jakobi anticipated, he knew that I was about to turn the focus on them. . . . I would love to know for you, Amy and James: what drew you to your research? For all three of you, if you could: what responsibility do you feel comes with taking on this type of research that is so relevant to a lot of political activism that is taking place even today?

AS: I kept laughing under my breath when Daniel [Tucker] was like, "the historians will talk about their work as historians!"—because academics carefully police the term historian! We are not historians. We are activists. Activist-scholars . . . I mean, I'm a librarian. And I'm an activist, and I'm a writer, and I'm a person in community, and I'm curious about questions in history. I'm not a historian. And I don't feel like I need to aspire to that carefully policed kind of term. I came to the book and the research in a study group for organizers, the Challenging White Supremacy Workshop in the Bay Area, which then turned into the Catalyst Project and the Anne Braden Training Program that still exists there now. It was a study group looking at questions in the past and moments in history [where multiracial coalitions succeeded or failed], like I said before. What drew me to it was the curiosity, and wanting to learn the histories that were not taught anywhere else. Through that process, I felt like I had a responsibility to be in dialogue with my community and with people who wanted to know the history. So the study group turned into discussions, and dialogues, and trainings, and writing, and

meeting James, and working on the book. Long story short, my responsibility is to continue to do the work, and to show up and talk about what I know, and ask people questions about what they know, to keep the conversation going, to turn over pieces of research and information so that people can work on new works.

Hy and I didn't meet until a year and a half ago. We didn't get in touch until a couple of years ago because of exactly the kind of stuff Jakobi is talking about. Folks that are involved in these movements have a lot of hesitation around wanting to talk to folks who are just curious. Like good organizing, doing this kind of work and doing this kind of research means building relationships over the long term. So we've built a relationship over the long term. The book came out before that relationship was fully formed, and so now my responsibility is to work with Hy to get his story told. And to work with anyone else who wants to continue to do this work and tell these kinds of stories and unearth these histories. Whether you're in an academic setting, or a study group, or going to put out a zine or a website—whatever it is, it's valuable.

JT : I came into this research initially because of marijuana [laughs]. I was talking with one of my mentors, Malik Rahim, who was a member of the Black Panther Party from New Orleans. He had lived in San Francisco for a bit, we were doing really good housing organizing together as part of the same very loose organization. We were smoking pot on top of Bernal Hill, and he said, "You know, I used to hate white people." And I said, "Well, you seem to work pretty well with us right now." And he goes, "Oh yeah, well, I went to this conference one time and there were these guys that had the confederate flag on their uniform, but also the Free Huey button, also the Black Panther, and they were running armed security for my brothers. So I figured if these guys could get their act together, there's hope for the rest of you guys." So I became obsessed with finding out about this Young Patriots thing. Then I found out about the October 4th Organization and White Lightning and Jobs or Income Now, and found out through a friend that somebody cool over in Oakland was working on similar stuff, so I harassed her for six weeks until we started working on this book. (AS: "It might have been six months." [laughs]) It might have been six months, yeah. It's all a blur but I think ultimately my responsibility is to be part of building a movement moving forward, making usable scholarship, having it be something that people can read and consider and say, "OK, what ideas can I leave? What do I have to take back?"

But I also believe there's a responsibility that's always in tension with the deep amount of respect that I had for the people that we were interviewing. Respecting and loving the stories that were being given to us, and owning the fact that at some point, Amy and I had to make choices about what we put in the book

and what we didn't. And having that dialogue and having something that both owns those decisions, and also shows the amount of love and respect for people who made just massive amounts of sacrifice. I'm one of those very vilified characters because I have a nonprofit job, right? I actually get paid to organize. I think we do a pretty good job at it, but guess what? These folks didn't. These folks, all of these groups, rose up because they felt that revolution was necessary and possible, desirable, and there's some mistakes made. Like sometimes, they thought that socialism was going to be in the United States by 1984, and it was gonna be rad! [laughter] That didn't work out so much. I think that they are examples in willingness to share whatever they could share. Knowing that was entwined with personal relationships and questions about their own roles in history [and it was] just an amazing gift, and I want to respect that gift by passing it on, but also encouraging everybody else to share their stories, especially people that are being activated now. Don't wait forty years for somebody to come ask you, "Well, what was that like being part of Black Lives Matter?" Start writing and start seizing the means of information right now, because we might not even have the luxury of this debate in twenty years. The earth is getting very hot; we have to organize.

JW: Unlike my peers here, who seem to come to their projects in very organic ways, which I'm quite jealous of, I was very much in the academic, very structured environment. Some of you students in the room, or graduate students in the room, might understand what I'm talking about. . . . I was actually writing my master's thesis, which I published as an article on Nat Turner and African religions and Christianity—I was trying to be really philosophical and stuff, right? And as a graduate student I was working for the Bunche Center at UCLA where I went to school, and David Hilliard, the Black Panther Party Chief of Staff, was shopping the Huey P. Newton Black Panther Party Archive. He was shopping it to UCLA and some other schools. So I had the fortunate opportunity to get my hands on all that material to decide if it was a so-called "definitive archive." Who am I to know? So in looking through all that material, almost all of the material was on Oakland and maybe a small, not equal, but similar amount on New York. And born and raised in Chicago, the two martyrs that were instilled in us growing up, the first was Emmett Till, and then Fred Hampton. These people who died in the struggle, died in the movement, at the hands of white supremacists and the state. And it's like, where the hell is Fred Hampton?! So I get angry, and um, we didn't get the archives; Stanford outbid us.

But then it turned me on a different way. People were writing about Nat Turner, at that time, for about 160 years. I'm struggling to find something new. No one is talking about Fred Hampton. I start looking for books. Where's Chairman Fred? Where's Chairman Fred? I couldn't find anything. I found one dissertation, from Jon Rice, I think

he wrote for Northern Illinois University—but that was it! So I started this trend, that this is my life's work: I'm gonna start the biography of Fred Hampton! I set out on this goal, but there were no records! Where do I find these records? I have to find Panthers. And I have all this information, but they wouldn't talk to me. You have no idea how many times folks accused me of being an FBI agent. "You are too young to have this much information about me and what we were doing at that time; you're an agent!" And I'm trying to convince them, "No, I'm just a graduate student trying to research what you're doing"—"You're a fed!" It took years for people to trust me. In that regard, I came across these sealed secret Chicago Police records. I got ahold of forty COINTELPRO files, but I had never heard of the Red Squad.[3] And I'm not sure that many of you folks here have ever heard of the Red Squad. Every city had a Red Squad. It came out of the House

3 COINTELPRO stands for COunter INTELligence PROgram.

Hy Thurman introducing *American Revolution 2* at the Slought Foundation, Philadelphia, 2016.

Un-American Activities Committee. I wrote about this in the book as well. It was supposed to thwart communism in the Cold War. The only problem with it is that the Red Squad, Mayor Daley's use of the Red Squad, was in the exact same way that J. Edgar Hoover used COINTELPRO, to stifle any dissent. If any group or person expressed any dissent against Mayor Daley, he sent the Red Squad after them. I mean anybody. I found out the Red Squad went after the Boy Scouts of America, nuns' book clubs, so imagine what the Red Squad is doing to groups as controversial as the Party. So I'm looking to get my hands on records. Most of the documentation I use in this book comes from these sealed police records. And that was how I got some of those Panther members to trust me. In doing that, I found out about this Rainbow Coalition, that the Chicago Police argued that Fred Hampton was the most dangerous individual of the period, more dangerous than Martin Luther King or Malcolm X. This 21-year-old kid.

Why? Because not even Martin Luther King or Malcolm X could get confederate flag[-waving], Southern whites to organize with them, to form a coalition and even do security for them? You see these confederate flag brothers doing the security for them—it's serious. So I'm like, this is why they killed this man. Who are these Young Patriots? Who is this Rainbow Coalition? When I think of a Rainbow Coalition, I think of Jesse Jackson. Wasn't even involved! That's how I came to the project. It was an 11-year struggle getting those individuals to sit down for interviews. I will say for the students in the room, it's very difficult to write histories about people who are still alive. The dead do not struggle against you. But those people who are alive, you can interview twenty different people about the same event and get twenty different stories. And you've gotta tease out the truth in that and someone's gonna be pissed off. Just keep that in mind. But that's how I came to the project. It's a life blood of mine. I call this Volume 1. Of all those Red Squad files, all those sealed secret police records that I wasn't supposed to use but I did, I used a small portion of what I collected for this volume. I had to stop at about 400 pages, so this is Volume 1 of more to come. [The book]'s for sale for those who are interested; I take credit cards, discounted rate, $25, eleven years of my life, and my wife's money.

EO: We can move on to the question and answer section.

To Hy, have you sought your FBI file? If so, what did you discover? And also, did the Young Patriots have a women's department or a women's wing? Thank you all very much.

HY THURMAN: Speaking first about the FBI file, I don't have it although I tried to get it several years ago. They said I had to get three different lawyers to OK it, specific

lawyers you had to go to. You had to list the organizations and the people that you wanted information about. I did that, I got the date set, and when I got to the Chicago Historical Society, they said it would just take too long to collect that sort of information. So I never did get mine. Other people have. They've told me about it. For those of you who don't know, they boxed up our history and everything after the trial, Fred Hampton's trial. The Chicago Police Department and the FBI were found guilty of conspiracy to commit murder on two accounts. Of course no one was ever prosecuted, but at that time they sealed our records for twenty-five years. They took all of the information that they had. The FBI, the Red Squad, the Chicago Police Department, the Illinois State Police, and anybody's other records that they had and sealed them, and sent them to the Chicago Historical Museum. It's open now. You can get some of that information, but very little of it exists because they blanked out every piece of good information you want. So it is available; I've only seen a couple of mine, in which, you know, they have branded me as a communist revolutionary. It's fine, I am. They're not really telling me anything else that I don't know.

Concerning the women's role in the Young Patriots, and as you know, at the time, the traditional role of Southern women was be seen and not heard or sometimes not even be seen at all. We fought against that belief, that behavior. The woman that stood up in the film, her name is Marcela Gary. She was very much involved with the Young Patriots. She led a couple of committees. She's no longer with us. Although the child that was in her lap, I'm in communication with now. So they're still believing in the cause. We had other women involved. Kit Komatsu was one of our people. She was a Freedom Rider, went into Mississippi. And there were a number of women involved that had the same equality and status as the men that were involved. There wasn't a separate group of women; everybody was just equal and had equal say.

Going off of your last answer, are there any women that were involved directly with you that are still alive that could speak on that? Because you're saying that everyone was just equal but are there any women that were with you that could say that? Are there any women around that we could hear from?

HT : Gotta look at the age, for instance. Most people are gone. Um, there are still a couple of women around who will be involved if we need to get them involved, yes. What we are doing is rebooting and reorganizing the Young Patriots. We used to have an 11-point program and now it'll be like a 7- or 8-point program. But yes—Amy wasn't around when we did this, but Amy's certainly a member of our organization, so she can speak to that. Just by the mere fact that people have passed on, it doesn't leave a

lot. There are a couple of people in Uptown that are still around. There's another one, Andreana Belcher, who lives out in Virginia. A couple of others. But we haven't gotten to the point that we're organized enough for everybody to become involved. But when we do, these people will certainly be involved, as well as new people.

AS: I just wanted to add that your question is a really good one; it's one that James and I tried to dig into when we were doing research for the book. We wrote about five organizations, some of which started before the women's lib movement really took form . . . and some of which were right in the center of that. The things that we found the most are that in all of these organizations, women played leadership roles. And in different ways, struggled with the question of whether to go the way of some of their friends and some of the women in their lives, in forming separate organizations, or like a women's caucus for women's leadership group. They tried different forms and fashions—not wanting to do too wide of a brush—but a lot of the organizations we wrote about really took the approach that feminism was a women's issue and a men's issue; it was everyone's issue. Their work was about community. Their work was about intersections, even though they weren't using that language exactly at the time. It made no sense to go over there and form a women's organization separate in the community, when what you were trying to do was organize your community around issues of poverty, around issues of racism, all those things. But that doesn't mean there weren't struggles. There were some pretty notable struggles in the different organizations. I'd say of all of the organizations we wrote about, the Patriots was more male-dominated than some of the other ones [like JOIN and Rising Up Angry]. But you also have to look at where it came from, and you also have to look at the fact that some of the historical record is missing women's voices, because that's also part of how sexism works. Unlike some of the other organizations, we had a harder time getting folks who had been part of the Patriots to talk, because the intensity of the repression was so much more focused on the Patriots, because of their direct connection to the Panthers. We interviewed a number of women for the book, but there were a lot of people, both men and women, from the Patriots who didn't want to talk. Some have since come forward with their stories. So there's a bunch of different reasons that I think your question's a good one and also hard to answer.

JT: I'd say that the two organizations that I was impressed with personally, as a guy who made the most inroads in incorporating women in a feminist analysis, were Rising Up Angry and the October 4th Organization.

I think one of the narratives that was a part of my education about the 1960s and '70s protest movements was to cast the Civil Rights Movement and Martin Luther King as if they changed policy on a really national level, and Black Power as if it changed culture and society on a pivotal level. What are some of the material policies that came out of this coalition to sort of counter that kind of narrative, that dichotomy? Because I think a lot of people in that clip were all sort of like, "What can we do right now? What kind of political instruments can we put in place to change our communities?" What are some of the achievements of this coalition in terms of changing policy?

JW: Everyone's looking at me! I write about it a lot in the book, and it deals with a lot of the issues you raise. For instance, in Chapter 3 of the book, I focus heavily on gender dynamics and the survival programs. One of the misconceptions about the organization is that these were just some Black men armed for self-defense. But what made the Black Panther party so revolutionary in this period were their survival programs. They were very much anti-capitalist. They're social, socialist products—in other words, taking the profit out of things that people should have. For every issue or point from the 10-point platform, the party would call that "putting theory into practice." "We're not just going to bitch and moan about it. We're gonna actually get out and do something about it ourselves, for free." You don't get Appalachian Southern white migrants joining forces with the Party because they're just some cool brothers! No! One of the large issues they were dealing with in Uptown, for example, was that they had babies dying at young ages, so they needed a clinic. And everyone was suffering from, at least in those communities, hunger. So two number one programs, in Chicago, at least, they had a whole series—I can't go down all of them with you even though I'd like to with you today—were the Free Breakfast Programs and their free clinics. What made the Rainbow Coalition so important is that when a party would go and ask you to join an organization, it was not just out of rhetoric. What are your problems? What are your issues? We have a program to solve that. If hunger is one, we meet a party with training in these processes of how to empower yourselves, by using these programs, and it's community run. So here's the Free Breakfast Program, then we leave, 'cause we don't want to control your community. But if you need us, we'll come back in solidarity. Here's a free clinic, where you see real pediatricians, gynecologists, whatever the case may be, from the University of Chicago, Northwestern. We have free legal clinics. All these things are set up. These survival programs are the key to the coalitions. The Party would go in and help train and set up these programs for them, but these communities would run them themselves.

I don't want to give too much credit to the Party; the Party's a springboard but the Party learns as well. For example, we go back to some of the gender problems or

dynamics of the organization. The Black Panther Party was late in getting a daycare, for example. Whereas the Young Lords, the Puerto Rican community, from the first day, they organized a daycare center. Then their free lunch and breakfast programs, clinics, and so forth. So they ended up learning from them in various ways. Rising Up Angry, for example, one of the first things they started was for Vietnam veterans, these psychological programs and free clinics that the Panthers didn't have. [The Panthers] learned that from them. Then others started acupuncture and so forth. These survival programs were the key to these coalitions.

Now to answer your question, a lot of those programs that did not exist then, are now staples of our society, are backbones of our society. For instance, if I just look at something like the Free Breakfast Program, because of its successors. Here we are as the so-called "leader of the free world," a beacon of democracy, this example of the world to see in this Cold War context. Communism and all that, we have these so-called enemies, but we have more poor people hungry and starving in this capitalist structure, than these other places. Why are these people coming together, these poor whites and Appalachian whites and African Americans and Latinos? To feed themselves! So [the government] created the Child Nutrition Act. Now you have free lunches and breakfasts in schools that didn't exist, not because they cared about people starving, but to stop the contradictions in this Cold War context. That was something that the Party also learned from King. People forget that King was organizing these poor peoples' campaign, when he was assassinated, against the capitalist structure. These are some of the things that they learned from King and they kept that old type of movement running. The key word in all of these survival programs is "free!" You shouldn't have to have money to have a decent meal, to see a doctor, or education, and the list goes on. It's a contradiction taking a profit out of human rights issues. Those programs are what mended the coalition together. They didn't exist before the Black Panther Party. I know, I grew up with free lunches and breakfast in school— wouldn't exist without the Black Panther Party!

One of the things [the Party] did was go around testing, at least in Chicago, sickle cell. Shortly after they highlighted this issue, Nixon goes on the State of the Union and gives his address about "sickle cell is this disease we've got to throw our tax dollars at, to do something about" all of a sudden. This country did not give a damn about sickle cell! Now it's one of the most prominent things studied by the CDC with all these remedies. The Panthers did that! You have all these legacies of the work that they were doing, not for profit, not for accolades, or even acknowledgement. These are just things that people needed. Free buses for [families of] prisoners—you still have some of these programs going on today. These were policies adopted by the state,

federal, and all the way down to the local level. Some people did have those aspirations for making sure that people got what they needed, but the momentum was to stop the movement. How do we stop these Appalachian whites from joining forces with these Panthers? The backbones are these survival programs, so we're gonna adopt them so you come to us and not them, for example. That was one of the repressive ways of the government, of taking some of those and using them. And the Party would say, 'Well, thank you! We should have had this all along! We're not upset that you did this, good! We can have some of these programs; we don't have to work as hard for them."

HT : In our free clinic that we established, of course the Panthers were a great drive in that. They gave us all the contacts we needed. And it wasn't easy. At every location that we went into to offer our free clinic or even our breakfast for children program, someone from the Chicago Police Department would visit these landlords and have them evict us. We were constantly moving. We were like the MASH mobile unit, all over the place. Even an establishment like Hull House, for instance, Jane Addams and all that, they even evicted us. They got pressures on their board and they evicted us. They would harass our patients coming out. They'd take their medication. They would harass even the parents going into the Children's Breakfast Program. Every opportunity they had they would harass us. We did force the Board of Health to put in a free clinic, and we even had to go take over that clinic. We went and took a whole bunch of folks over there, and kids, and said, "We want services." Their hours were very short, and when someone would come in, especially the Southern whites, they'd tell them to go home and bathe or they wouldn't take care of them, even though they had bathed. I actually got my hand broken one time—and I won't tell you how—but I had to go to a hospital emergency room. I was like 17 years old. I had no insurance. The only thing that they did was just put a Band-Aid around it and send me out the door. Two days later, two cops showed up to where I worked, wanting to know what happened to my hand. So the cops would just come in and harass you; the hospitals in the area would call if any of us came with an injury. But we forced the clinic to extend its hours, and we forced them to at least have one of our people around to supervise. Anytime someone would have to go to a doctor or a hospital, we would have one of our medical staff, be it a social worker or a nurse, that would go these appointments with these people, and would make sure that they got proper treatment.

I had a question about you guys comparing the movements you see today, Black Lives Matter and so on, to the Young Lords and the Black Panthers. What forms of political repression do you anticipate today as opposed to then?

AS : We don't need to anticipate, it's already happening. Black Lives Matter Bay Area is entirely being surveilled. There's proof and there's evidence. There's a Black Lives Matter national campaign to ensure that we can raise the kinds of funds that we need to get the files, the kinds of files that Hy's been talking about. You've got to pay lawyers, you've got to pay fees, you've gotta do all that kind of stuff to really expose the degree to which anyone who is involved with these movements and the folks they're working with . . . are being surveilled by the government. We make it easy. We're publicizing who we know. They don't have to track down phone numbers and all that kind of stuff and try to link people anymore. We draw those maps for them. We already know that people are being surveilled, and what is going to be done with that surveillance—we don't need to imagine. We've seen it before, and you've already said, the same thing will happen again. People are being targeted. The leaders of Black Lives Matter actions are being singled out for heavy charges and jail time in ways that—whether you want to use the term allies, or like, solidarity actions—those folks are not facing the same charges that we're seeing Black folks face for the same things, like shutting down the BART in San Francisco, and shutting down highways, which is happening in Los Angeles right now. The Black activists who led those actions are being targeted for charges. What we need is active, active, active movements to pressure the state to drop those charges, whoever the target is in any given jurisdiction. And then for us to be working really closely with Black Lives Matter activists wherever we are in our communities, to be doing actions alongside and drawing attention to these kinds of things. So we do know it's already happening.

These [historic] movements changed the terms of debate and conversation for their generation. Black Lives Matter and the Immigrant Rights Movement are changing the frame around the conversation that we're having now. And that is powerful and that does change policy, and we need to change more than just policy. Language matters, producing our own media matters, using the media tools that are also exposing us in some ways, but using them on our own terms to the degree that we can—it matters. Controlling that conversation, and the power of language and words and media production, is what allows us to get the message out there, to document our own movements as we go, to push things, to connect with each other. Media is a double-edged sword but it's absolutely crucial. Media and technology are absolutely crucial now just as they were then. You've got the artwork of Emory Douglas. You've got all of these movements producing their own papers. We wouldn't know a lot about them without that, and they couldn't have changed society, culture, policy or system structures to the degree that they did without it. And we need it just as much now. We need to be media savvy, both in terms of the way we talk, and the tools that we use, but also in terms of recognizing the double-edged sword and getting our own stuff on there.

JT: When movements get big, they're always imperfect. They're always collections of people who often times agree on very little except for maybe one or two things they're protesting on, and then the whispering campaigns happens. The shit-talking happens. The major thing that we have to do is when people that are activating themselves in a movement are attacked by the state, big or small, we stand up for them no matter what. No matter what. No matter if they're in your enemy's organization and only agree with your group 80 percent of the time, and you're just mad at them over the 20 percent. I'll give a really good example that I saw on social media. My very dear friend Alicia Garza was asked by Congresswoman Barbara Lee to attend the State of the Union address. People who were engaged with how you make change could actually have a very principled debate on whether that was a good move or not. I'm not going to say it was, as I respect my friend's choice. But immediately people started chattering on the activist blogosphere. "She's throwing

A question from the audience at the Slought Foundation, Philadelphia, 2016.

those who are being deported under the bus; it's showing she's just selling out to Obama," and all that type of stuff. No, she wasn't. She made a strategic choice, and the agenda behind that type of trash talking was to delegitimize solidarity with one another. I personally don't care if you're an anarchist breaking windows in the street, or you're a Bernie Sanders supporter who gets swept up—if you're under attack for trying to move in the right direction, I'm going to defend you and I'm going organize people to defend you. Then we can have a conversation about the larger politics, not on Facebook, not calling each other out, not even calling each other in. But just saying for right now, our priority is each other's safety and each other's deliverance from the clenches of the state.

JW: I hope in this current context we can duplicate the action of movement lawyers. We're going to really need them in the twenty first century. We had a whole contingent of attorneys in the past to help all of these organizations, because of the repression. You can think of all of these various cases—New York 21 case, Panther X case, Young Lords such/such case—it goes on and on. You have these lawyers, who work numerous hours around the clock, great attorneys, for free! Their contribution to the movement was that kind of legal action. Considering the way we understand the power of the state, I hope not only can we duplicate but significantly advance or increase the activism of those lawyers in our current context. We're going to need them.

Having been a long term activist myself—and I will call myself a historian but not an academic historian. I was wondering, with all of the things going on and what you're talking about, is there any work reaching out to poor and working class white communities to try to do as was done in the past? To focus on the fact they also have real problems, and make them understand again the connections, the real connections with the system, between their problems and the problems of people of color, and how many times they're exaggerated in communities of color?

James, you mentioned the "organize your own" approach from reflecting and trying to address fractures that already existed, for example, in Chicago along racial lines. I was wondering if you all could speak on what were some of the advantages and opportunities of that approach, of a more nationalist, organize your own, approach to organizing?

I'm under the impression that JOIN and the Young Patriots were really committed to organizing around material conditions that poor whites were facing and they also did solidarity organizing to support autonomous organizing in the struggle for self-determination around Blacks, Latinos, other folks. I was wondering if you could talk about what that

looked like, in the spirit of understanding the fight against white supremacy as part of waging class struggle long term?

AS: Those are big questions to end with, all three. I'm not going to attempt to do them justice. These questions are exactly what this series of events is meant to have us talk about, both over the next couple of months in Philadelphia and Chicago, and going forward. We need those conversations; we need those questions. I think that in the work these groups were doing, it was a really different political moment than the one that we're in now, when it comes to things like organizing around the national question. I don't personally know that I think the idea of organizing white folks around the national question makes sense for us in our current moment. It made sense in some way talking about Appalachian whites, poor whites, as an oppressed class, in a region in which they were forced to migrate for particular reasons, in that moment. I think we need more discussion about what that means now, but I think the idea of "organizing our own," whatever that looks like—whether it's your neighborhood, whether it's your school, and white folks organizing white folks, and having conversations with white folks about reclaiming and reconnecting to the ethnic histories that we've been forced to lose in order to opt in to the benefits of whiteness in the United States—that is work that we can continue doing now. That does have us still talking about the idea of a national question. You're asking about who's doing this work now? There are some organizations that I would lift up as doing good work, some of them have come and gone, and some of them are still active, like the Rural Organizing Project has been talked about a lot lately because they're in Oregon organizing against militias. There are organizations in West Virginia and Kentucky, too. Kentuckians for the Commonwealth has been doing really great work. Vermont Workers' Center does good work. And then there are white folks working in multiracial organizations, but dealing with these questions with the white folks that they organize. So it is there. We need more of it, and we need to be continuing this conversation and figuring out where and how to do more of that work with white folks, poor and working-class white folks in particular.

HT: I'd like to say to the students that are here, if you're wanting to get involved and not sure about what to get involved in, there's an issue that's facing everyone here and that's your tuition. There is a way that you can get involved and work toward getting this tuition lowered or even free education. There are several organizations right now that's working with it. And that might lead you to some other activism.

JT: Getting to your question about organizing, about the advantages of it, is that it put people in motion, and it gave people a way of building up accountability towards

one another, being able to show up. In the case of when the marches against the Attica slaughter were happening, White Lightning in the Bronx were doing the same thing as the Young Patriots did for the Panthers. They were running security and guarding their accomplices of color. I think that's a pretty big advantage because it gives people something very measurable to consider. Is this partnership working? It's not just an individual, "I'm gonna call you out because I feel you're not a good ally," but there's actually organizational discipline and comradeship, and it's actually measurable and tangible instead of subjective.

JW : As a historian I always look to the past, and look to those methods and ideas that worked. One way of doing that, at least in the way that the original Rainbow Coalition did, is finding those commonalities. Organizing around those commonalities, that's how you transcend those so-called differences in terms of race, gender, sexuality, whatever they may be, because we all suffer from some of those commonalities, especially from a class or economic perspective.

The audience at the Slought Foundation, Philadelphia, 2016.

ORIGINAL RAINBOW COALITION

Moderator: Rebecca Zorach
Participants: Billy "Che" Brooks, Mike James, Antonio Lopez,
Paul Siegel, and Hy Thurman
Columbia College Chicago, Stage 2
April 6, 2016

Organized by Hy Thurman, this panel served as a counterpoint to the Original Rainbow Coalition historians' panel in Philadelphia. It brought together activists from across movements to discuss the legacy of anti-racist organizing as pioneered by the Original Rainbow Coalition, in which several speakers were direct participants.

REBECCA ZORACH: I'm excited to be moderating this discussion this evening. I was having a great conversation with my Art and Activism class earlier today about some of the issues that are raised by these organizations and the Rainbow Coalition and the particular historical moment from which they arise. That's especially exciting for me. One of the things that emerged from that conversation is how very relevant the issues still are today, and that's something that's really expressed in the exhibition as well. I'm just really excited to be up here with this amazing roster of speakers. I thought I would start with Antonio, and ask him to set the stage and give the historical context and summary of the organizations as they developed.

ANTONIO LOPEZ: Good evening, everyone. Thank you for coming out on this really rainy night here in Chicago. We're almost out of this winter—not quite. It's always an honor and a pleasure to be in conversation with the gentlemen here, some of my heroes, who really shaped my own development, and who are also the reason why I wanted to go back to the Mexican community here in Chicago and bring my skills and take it to

the ground level. What I wanted to do was very briefly with broad brushstrokes give you a few things that can help you contextualize the importance of the Original Rainbow Coalition, which was very significant if we understand that era and that moment and the organizing that was taking place as a very important anti-racist class struggle here in the city of Chicago.

Just a few things that I'd like for you to bear in mind as you listen to the other presenters go really deeply into their experiences: the first thing to think about is that Chicago really experienced the tremendous impact of deindustrialization during this time period. In places like the Westside of Chicago, particularly where you had large factories where folks were able to get good-paying jobs at one point, the impact of deindustrialization was devastating to the inner city of Chicago. This is the history of how the white middle-class subsidized suburbanization and all of that. We have to keep in mind that this was the period of deindustrialization and how that particularly impacted Black and Latino communities but also low income folks that were in some ways trapped in the inner cities with very few opportunities.

The second thing to keep in mind was that, though we oftentimes think about the really incredible history of the Great Migrations of Black families and Black folks moving from the South to Northern cities like Chicago, also at this time period, in the post-Great Depression period, there was actually what I call the "Rainbow Migration" of all kinds of people moving into the city of Chicago. You had Native American folks and indigenous people who were experiencing what were called termination programs who were moving into places like Minneapolis and Chicago, particularly in Uptown. A lot of the Puerto Rican community, moving into Chicago after being displaced from the island. Mexicanos, and also Southern whites who were being increasingly displaced out of the South due to the transitions in the coal mining industry and were moving in large, large numbers. That combination of deindustrialization and the loss of jobs, happening at the same time that you have a rainbow migration of folks and communities moving into the city of Chicago.

The other thing to think about is that this was the period of "urban renewal," or "urban removal," as a lot of folks really think about it. What was happening in terms of city design and how people were thinking about housing, and how they were being displaced due to all the efforts to transform the metropolis, which were really shaped by a disdain for poor people, regardless of background. So this was really the era of urban removal, where you're looking at people and how the decision makers were just bludgeoning city communities, particularly low-income communities and figuring out ways to displace folks, particularly poor people. That's an important thing to think about.

Politically, this was also the era in which the Democratic Party, in its more neoliberal approach to city governance, was really consolidated under the first Mayor Richard Daley. This was a form of government that particularly thrived upon racial conflict. This was a guy whose largest margin of victory in reelection was after the riots in the '60s. This was a regime that really thrived upon people prioritizing racial politics. We have to keep that in mind in terms of how that regime was consolidated following the Great Depression era in Mayor Richard Daley's tenure. In terms of racial politics, too, there was an incredible Civil Rights Movement here in Chicago, which has gotten a lot of publicity lately, but there was also a trend where a lot of folks were actually against solidarity and against coalition work. There were a lot of people who believed in racial separatism. This was the era of the Nation of Islam, and people who did not believe that coalition politics was the right strategy for various reasons. Whether it was from a civil rights perspective or

(L to R) Rebecca Zorach, Billy "Che" Brooks, Antonio Lopez, Mike James, and Paul Siegel speaking at Columbia College, Chicago, 2016.

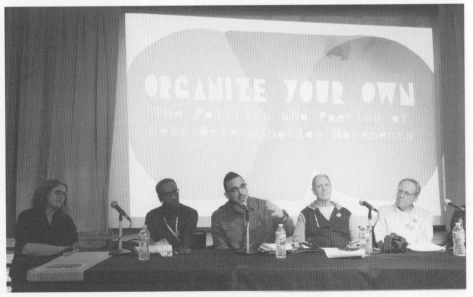

not, there were people who really thought that a more nationalistic or group-focused strategy was what was needed in their community.

At the global level, this was also the era of the very important anti-colonial struggles that were taking place around the world, beginning with the Bandung conference and with the liberation of Ghana, and then sweeping through the colonial nations which were waging incredible struggles to free themselves from the yoke of European colonialism, including the Vietnam War, which was a part of this history. That had a tremendous impact in the United States in terms of the development of what a lot of people think about as a "Third World Left" and a "Third World radicalism" here in the United States. It's really crucial to remember the learning that was taking place among folks who were interested in learning about revolutionary change, and how impactful were things like the Cuban Revolution, and also what was going on in China to a lot of people who were trying to understand the experiences that they were dealing with in their neighborhoods, in Lincoln Park or on the Westside of Chicago or in Uptown.

There were other things going on of course. The Democratic Convention was taking place; you had the Days of Rage happening and all that kind of stuff. And in the city of Chicago, there was also a very powerful and very important leadership; people like Fred Hampton, Cha Cha Jimenez, people who were witnessing all of this. So I just want to give you that picture of where the Rainbow Coalition emerged. There were other things going on, but just to give you that kind of context to think about how the Rainbow Coalition emerged, and when folks started talking about crossing and transcending racial borders and really talking about class struggle in an environment where a lot of people were against solidarity and coalition building; it was really significant. Even though it was brief, and unfortunately, it witnessed a lot of repression, there's something very significant about this history.

RZ: I'll ask the other speakers to speak from their personal experience with the organization and from the perspectives of the individual organizations that they started out working with, and how they came to work for the Rainbow Coalition. Maybe we'll start with you, Billy.

BILLY "CHE" BROOKS: First of all, I'd like to say that I'm glad that those of you who are here took time to be here. I'm really excited to have this opportunity to speak about some things that are really, really dear to me. I joined the Black Panther Party as a student, and at that time [my school] was called Wilson Junior College; it's now called Kennedy King. We wanted to call it King, like here on the Westside, Malcolm X, but some of those people that you just spoke of co-opted what we were trying to

do and it ended up as Kennedy King. My involvement with the structure of the Black Panther Party was purely coincidental in that I never looked upon myself as joining the Black Panther Party. I felt that the Black Panther Party joined my crazy ass. To this day, one of my more fortunate memories is meeting Fred Hampton for the first time and being amazed at his breadth and depth of struggle. He started out talking about class struggle, the need to develop strategies for all people who are oppressed within the infrastructure of the empire. We didn't say *empire* back in those days, but.... The importance of coalition-building preceded what we started here in Illinois with the Peace and Freedom Party. Mike out in the Oakland-Frisco area really gave us the idea of a Rainbow Coalition. When we decided to organize and strategize our first Free Breakfast Program, we started working on it in earnest, I would say, in December of '68; it really started coming to fruition January/February 1969. We did it on the coalition-based approach.

What I want to say is that I had conjured up all these thoughts that I had to [share with] young people to bestow upon them the need to learn from our mistakes. And there were many. As I look around the room I see some veterans of the struggle. To this day I feel that what we started, it is still going on. It's now on a level of what I think it should be, but when I have a chance to get with Mike, Cha Cha, Hy, it takes me back to when we were young. We were young. But at that time we recognized that we needed to work together. Mike was doing his research stuff, but we saw a need to work together to develop strategies that would allow us to recognize the true essence of a people's movement. When you start talking about social justice and you start talking about building a mass movement and putting people together, what you have to recognize is that everybody has got their own interpretation of what social justice is to them. We have to put these things on the table so that no one is left out. We're all oppressed on some level or another. We are all victimized by an economic system that uses racism and white supremacy as a tool to keep us from vocalizing on what the real concerns are. When we talk about this economic system that's based on exploitation of human beings, then we see how slickly they use racism as a tool. We used to say that racism is a byproduct of capitalism, and I still say that today.

I think one of the greatest things we were able to do back in those days was to recognize that we have to work together as a people. We have to come together as a community and throw aside all the concerns and problems that they put out there to keep us from working together. Fred used to say it all the time: "I'm black and I don't like white people...; I'm white, I don't like Puerto Ricans...; I'm Puerto Rican, I don't like Asians...; I'm a Mexican I don't like no motherfucker." He took us beyond that. And what's going to save the young people today—our struggle for social justice in this

country has been slowed down. When people talk about how the FBI and the Chicago Police destroyed the Black Panther Party, I look in the mirror and say, "Do I fucking look dead?" I say, "No! Hell no." We got sidetracked.

There are many reasons why you get sidetracked. There's money, there's sex, there's drugs, there is just miseducation, and then there's stupidity, or I could say ignorance. But we overcame all of that at a very critical point in time in a short existence and developed a strategy that I hope we can continue to develop as we grow older. Like I said, I'm just glad to be here. I'm glad you guys came out. Unless we can develop a strategy, and when I say strategy I really mean a strategy, to pull everything together. Because there's too many divisions. I sat back and watched Black Lives Matter, BYP100, Assata's Daughters, and I got excited. I got rejuvenated because I saw myself in them. I was 18/19/20 years old and I felt that by the time I hit 30/35/40, we would be seeing some very fundamental paradigm shifts in this country. I know why we didn't. That's the message that I want to give to the young people, because youth in my mind do make the revolution. Always have, always will. All we can do is be stewards at this point, and offer love, support, and compassion. Somebody gotta lead or move out of the way.

MIKE JAMES: I was teaching at DePaul this last semester a class called Activists and Activism since 1960. We went out to the Westside and we hung out with Billy "Che" Brooks, and I think that all the swearing that you did really won them over. They were really enthralled with you. To be honest with you, when you were on my radio show not too long ago, you

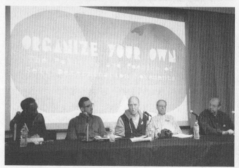

Top: Introductory remarks by Daniel Tucker, Columbia College, Chicago, 2016.
Bottom: (L to R) Billy "Che" Brooks, Antonio Lopez, Mike James, Paul Siegel, and Hy Thurman speaking at Columbia College, Chicago, 2016.

always really get my heart. Thank you very much. I want to thank Columbia College; it's good to be back here. While I was involved with the organization Rising Up Angry, I taught a class from 1971 until '77 or '78 called Organizing for Social Change. In that class I developed the idea of the Heartland Cafe. It was the idea of the mini-red econo- my of interconnecting businesses that serve the people's needs and gave them a place to go, so that they could work, so that they could then have free time to organize the revolution. I will always be indebted to Columbia because those thoughts hit me here.

I ended up by accident at Lake Forest College in 1960, so I probably am the oldest. There may be someone older, but I doubt it. I'm 74 now; it goes really quickly. It's a battle to keep in shape and keep your health, but I think it's important that all of us work at that so we can share the things that we experienced and are still able to talk about them. At Lake Forest College, lots of things happened. We integrated the barber shop when they wouldn't cut the African students' hair. We started tutorial programs in North Chicago. I met people from the San Francisco to Moscow Peace March that came through and first heard about atomic testing. One of the things that really stands out for me is that I wrote a paper for a Christian ethics class, and in it I talked about a vision of the future that has someone eating Chinese food, wearing a yarmulke in a kimono with Dutch shoes, listening to John Lee Hooker sing the blues. I had this early 'rainbow' idea going in my own life. Without going into a lot of earlier history, I think I was destined to end up at this place on the planet, which I always used to say is THE place on the planet, or certainly in our country, that has the largest concentrations of diverse racial, ethnic, and religious groups. Whether that be Latino, or black, or American Indian, or Asian, we have large concentrations of a lot of different people. That of course is an opportunity. The excitement of discovering the city was really something for me. First of all, it was coming down and exploring the south side when I was up at school.

After I graduated from Lake Forest, before I went off to Berkeley, I spent the summer mostly in the alley behind Kenmore Avenue, under the L track, working on the study of southern white migrants for a guy who was doing something with Notre Dame. I learned how to roll cigarettes, I learned how to do certain licks on the guitar, did my share of drinking out of a half-pint, learned to make biscuits and gravy, but I also was living in a rough-edged way, up-close…first time for me ever really seeing people who were poor and a little bit desperate. I ended up going to Berkeley, came back after graduate school there, and we had started an organization, Students for a Democratic Society (SDS). During the Free Speech Movement, I found a piece of paper on the ground that said, "Build the interracial movement of the poor." It was put out by the Economic Research and Action Project of SDS before the Vietnam War really took off. That early orientation of SDS was to complement SNCC (Student

Nonviolent Coordinating Committee), to work around student issues and to work in the North. That little piece of paper was pretty crucial for me. I had been trying to figure out, in my sociology graduate classes, how you would bring people together; how you would use conflict theory as a way to bring folks together. People who were divided, how do you get them to unite? Then I find this piece of paper on the ground. I sent a letter to the SDS office; I said, "How do I get involved?" They said, "You have to do it!" A group of us ended up moving into West Oakland that summer of 1965. That's when the troop trains were coming through, bringing people to Oakland to be shipped out to Vietnam. I remember it really inhibited our work in the community, which was mostly white kids and one black guy working in West Oakland over by the Southern Pacific yards. It just wasn't happening because there was so much anti-war stuff going on. The troop trains came through, I remember "Stop the War" signs hitting the sides of the train, with these guys with shaved heads kind of laughing, but freaked out, mostly white kids then.

I ran into a guy named Stokely Carmichael. I'm not sure how you say his African name . . . Kwame Ture. Stokely Carmichael and I were at the Fillmore Auditorium in San Francisco at a benefit for SNCC. I remember talking to him, and I said, "I'm going to leave graduate school. I'm going to work either in Newark with Tom Hayden and the NCUP (Newark Community Union Project), or go with Rennie Davis here in Chicago to work with JOIN Community Union. He said, "Work with white people. We've got plenty of stuff going on in the black community. We need more support in the white community." That was how I ended up back here, in the same neighborhood that I had worked in a few years before. The first afternoon I showed up, JOIN (Jobs or Income Now) was having a demonstration against the Price Brothers, who had ripped off Mrs. Hinton. She was an Indian American, from India. They were having a demonstration and I got into a pushing and shoving match with one of the Price Brothers from Kentucky. The next thing we know, a few days later, they ended up making a compromise with Mrs. Hinton. They became supportive of the organization, and I spent the next two years in Uptown, working with a lot of people, but mostly young guys.

I want to say I'm really indebted to guys like Junebug Boykin and Paul Stamper, and your brother and you [Hy] and a lot of guys. You probably wouldn't have known where I had come from. By then I was in Cabretta leather and A1 pressed pants, pointy shoes; I always slicked my hair back. We were on the street. They would tell me stories, and they would tell me about the things that they did, good and bad. We would get into hassles with the police. We ended up having rent strikes over on Kenmore in the Samson building. When people were being illegally evicted we would stand up for them. We would go into the basement and turn the electricity and the gas

back on that had been turned off. I got my sister to come out; she was going to school in San Francisco, I think. She ended up starting the JOIN community theater which worked to try to [create] the Hank Williams playground over on Clifton. Along the way we met a lot of wonderful women. There were Big Lovey and Little Dovey, two black women who were in the welfare group. There was Virginia Bowers and Peggy Terry, who had been a self-described "racist" from Oklahoma, who ended up being the vice presidential candidate on the Peace and Freedom ticket. I didn't manage the Eldridge Cleaver part; I just did the Peggy Terry part.

One of the things I wanted to say . . . you talk about "Rainbow Coalitions." Whether it's the "original," or the "early," there were a lot of us around then who were in radical organizations trying to make a difference, and we got to know each other. The distinct things I remember were around welfare organizing. We got involved with the Latin American Defense Organization (LADO), and Omar Lopez was a key person in that. And we worked with the Kenwood Oakland Community Organization, which is still around today. Someone who came out of there just became a congresswoman, I think. There were early groups that were around from different corners of the city that started working together. We had a march on the police station after Ronnie Williams was killed by the police. Hundreds of people came out, mostly Southern whites that we worked with, but there were blacks in that march, there were Latinos in that march. This is something that a lot of us grew up believing in, and I would assume most people here [do to]. In America we have people from all different places who come together, and we all have equal opportunity. Of course, we learned that that wasn't true, the way it was supposed to work. We learned about the American Nightmare. We learned about racism. We learned about class and oppression, whether you experienced it firsthand from growing up with it, whether you were tuned into it or came to know it. There were a lot of us in the country in the sixties who really wanted a different direction. The inspiration, the motor force, was the black community, and probably women, too. King was certainly my hero. It was very difficult later on, getting pissed off because King wasn't radical enough. But we all moved way to the left, and it's a challenge today. If you want to connect the Bernie/Hillary battle, and whether people will support her if he doesn't miraculously pull it off, we gotta look back at when we would not vote for Hubert Humphrey. We were very pure.

Later on in my life, I did work pretty closely with the 49th Ward Democratic party. Alderman Joe Moore has done a lot of good things but is just in the mayor's lap. I would say, "I'm in the Democratic party because we're trying to hold against the rising tide of fascism. As soon as we can hold those mothers off, then can move it to the left, just like they did when Mao knocked off the Kuomintang." They united for a time to

fight the Japanese. The war in Vietnam ended, the Rainbow Coalition came and went as we were moving out, starting Rising Up Angry. Junebug, Hy Thurman, Ralph, and a whole lot of people were doing stuff with the Black Panthers. How many people have watched the movie *American Revolution 2*? It's beautiful stuff. Whether it built institutions that lasted or whatever, it's such an inspirational model, that you have southern white guys uniting with radical black people. It was a real thing. There were a lot of different groups that were involved, certainly the Latin American Defense Organization, and the early American Indian Movement people. Some of that was just that we were forced geographically to work together. We live in the city; we're all together.

Some of us had ideological visions of being together and being unified. I study anthropology. I like pure indigenous cultures and that's cool, but I really like the crossover, the edges—the Syrians that go to Africa. There's always that happening. As much as we have to understand nationalism, and I'm talking progressive nationalism, not just, "I'm black and everyone else is bad," or "I'm a woman and all men suck," but people who understand there's complementarity and there's a progressive side to all of that stuff. *[BCB: "I'm a man and I suck."] [laughter]* I guess where I'm going with that is that now this country is projected to be more than half non-white, not too far in the future, if not already. That's a good thing. When I talk to students, I say, "The best thing that white people can hope for is that someday they will be viewed as part of a national minority that works for the good of the whole. The best thing the United States can hope for is that they're viewed as part of the world community and are viewed as a country that works for the good of the whole."

I just want to say that we were and are organizers, and that's key. John McCain may have laughed at Obama being a community organizer—I'm not sure that his community organizing was the same as what we were all doing—but I think it's a noble profession. And it's something you can practice while on your other job, whether your job is as an organizer or not. We didn't get paid for doing political work. That changed when the environmental guys would come. They got paid to go to doors and stuff. It's a long haul. I just want to say that it's a long haul. Those of us who are growing as slowly as we can down the back side of the mountain, we've got a lot to share. We still stand up and do things and be in touch and influence, and there's a lot of younger people who are—bless their hearts—just kicking ass. We couldn't ask for a better deal. We've got young people on the move. We've got black and Latino communities on the move. We've got a guy who calls himself a socialist running for president. When I talked to cops, just recently after the Laquan McDonald stuff came out, having a friendly chat at the taco place, I said, "Well, we all come at this from different places. We have different positions and different experiences." For some people

it's really hardscrabble and for some people it's a little pleasure. But we have to see ourselves as a nursery school that's made up of kids from all over. The teachers at the nursery school, what do they do? They teach people to share and they teach people to look out for each other. The buddy system. It's the early stages but I want to work on that analogy somehow. We're at a crossroads. Whether it's the environment, food production, the population, broken infrastructure, we've got a class struggle ahead of us worldwide. We have to look for people we can work with and align with. And I'm an optimistic dude, so I'm looking forward to what's to come.

PAUL SIEGEL: My Chicago-based experience really begins in the immediate after-math of the original Rainbow Coalition in Uptown. Maybe I'll just start real quickly, flash back to somewhere in the [Mayor Harold] Washington era in the '80s. We'd already been through a lot of struggle in Uptown. A lot of lives had been lost, a lot of arson for profit, a lot of kids had been maimed by lead poisoning, a lot of people killed by the police, et cetera, et cetera. We were in there fighting. We were standing up and fighting, and had built an organization, the Heart of the Uptown Coalition, that encompassed thousands of families in the Uptown area who had committed themselves to staying in Uptown for as long as they could.

It was a conversation that Marlene Barton, a fairly slight African-American woman in her seventies who still lives in Uptown today—I wish she were here—was involved in. She broke the color line on Kenmore somewhat single-handedly. Kenmore was very, very white, southern white. And there was a color line on Kenmore between Irving and Buena, and Buena and Montrose. She had been displaced from the south, urban renewed out of the near North Side. Like everybody else in Uptown, she had been thrown out of one joint after another and [since they all] found themselves thrown together, everyone really had to decide every day on a personal level—because it was all racist by that time—"Are we going to kill each other because my granddaddy was in the Klan and my granddaddy fought the Klan? Or do we have to figure out how to come together to fight for our right to be here?" Marlene broke the color line on Kenmore by calling the landlord of this building where there was something for rent and covering up whatever accent she had that would give up that she was African American. She said, "Oh, you're German? Oh yeah, me too." Then she goes and meets him, and she figures out how to shame him into renting, how to just push him around enough. "Come on now, you said you were going to rent to me!" Then she had to stand up, this slight woman with a house full of kids, to all the racism that existed there and to people who said, "We don't want a black person living on Kenmore Street." And she did, and she established herself there.

When I came around, this green kid—I'd been organizing the Free Breakfast for Children Program there, inspired by the Black Panther Party—I come around asking her to take the Black Panther Party newspaper every week. We built a base in Uptown doing that, especially with the poor whites. If you think about it, it's a pretty ingenious tactic. Home distribution of the Black Panther Party paper. That way, you figure out who's willing to take the Black Panther Party paper at their house, people living on top of each other, living in very close quarters, and people who might be hooked up with white supremacist groups. That person is talking to the Black Panthers. Then you're in the house delivering the paper every week and you sort of check things out and you learn from the people and you begin to identify who's a leader. Then you have this perfect way to hook them up with a survival program, which we learned from people like Billy "Che" from the Black Panther Party. You hook them up with a survival network and then you start moving to the level of political organization. Marlene Barton, this African-American woman, didn't want to take the Panther paper at first. She said, "People told me not to mess with them."

And just gradually, when the kids on Kenmore. . . . Kenmore Street was like a little city in itself, from Irving to Montrose, teeming with people, teeming with children. When Mayor Daley decided he was going to drown the kids in swimming, to try to cool everybody off in the summers, they built a swimming pool on Kenmore, but they didn't do anything to maintain it. Overcrowded, broken glass, and it sits there for years with all this broken glass, and all these kids are out there surviving on the street. There is just no recreation; there's no programs for them. Meanwhile Gill Park is just a few blocks away—it's from the Park District—this modern kind of center with a swimming pool, basketball courts, and everything else. So we organized people in the community and demanded that they open Gill Park up on Sundays. We started bringing 30, 40, 50 kids from Kenmore over to Gill Park to play basketball and do other activities; different age groups were there. Marlene Barton decided that she wouldn't let her kids go. There was a white Southern woman named Carrie Sue Smith. Her husband was a window washer from Chicago. Her husband, who had been so skeptical of these people coming around with this Black Panther Party, when he saw—because they had a household full of kids and they were worried about the influences on their kids—that we were identifying the stablest families, people who had the most, who had survived all of the horrors of the slow miserable process of displacing people from the community, he was a real spark plug in that recreation program in Gill Park. That's when Marlene Barton started. "Yeah, you can bring the Panther paper. Okay." Then we got her to organize her neighbors to come over; we brought the tape of Bobby Seale running for mayor of Oakland. We would do these house meetings. People would come, somebody would just invite their neighbors: "Want

to hear this tape?" By the time it was done, I had that entire speech completely memorized because I had to listen to it so many times at all these house meetings. [It was] about building a base of power, [that] was the idea. I digress.

This was in the '80s. This has all been going on for a while. I just remember that Marlene said to me, "You know, I'm used to living with all kinds of people now. I can't go back to the old way. It just grew on me. I'm just used to it." That stuck in my mind to this very day. That's what happened in Uptown, in the years after this incredibly heroic [period], starting with JOIN and moving forward with the Young Patriots, the Rainbow Coalition…. [That they were] short-lived in one way, those organizational forms, had a lot to do with the repression. You're absolutely right; it's not just the repression. It's all the ways society acts on us and distracts us. We studied what happened in Uptown, for those many years after, we studied the experiences of the Patriots and JOIN, and we studied the experiences of the Rainbow Coalition. How are we going to dig in and build something for the long haul?

Original Rainbow Coalition panel discussion, Columbia College, Chicago, 2016.

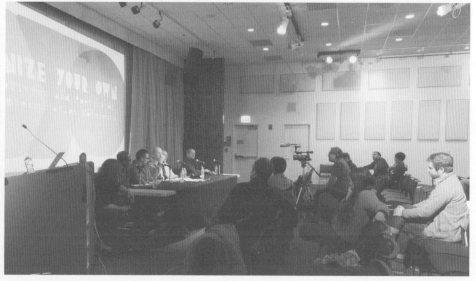

The way I put it is that Uptown became this very tenuous…. You've got to understand that the buildings are burning down around us. They're burning down the buildings. These horrible chemicals are being released. You'd go into a building that had three fires and the smell would overcome you. And there's kids living there. The buildings are burning down, peeling paint, the lead, sometimes poisoned water, police brutality, destabilization of all kinds, having to move one step ahead of the wrecking ball or the arsonist's match all the time. Uptown became the place because of the efforts led by people like Marlene Barton and Eileen Jameson from the coalfields, the first white hillbilly to put on a Jose Cha Cha Jimenez button for Alderman. A Puerto Rican ex-street gang member turned revolutionary, had to go underground, came out of hiding, reestablished the Young Lords, ran for Alderman—[Eileen] was the first to put on that Cha Cha Jimenez button. And when she wore it, her extended family of 25-30 people and all kinds of other people, started moving. Because of the struggle of people like that, Uptown became the place where those who at first couldn't fit into the post-World War II order, and then wouldn't fit, said, "We have a right to exist as a multi-racial integrated community in the most segregated city in the world. The most segregated city in the Western world. We have a right to exist."

That found its way into a court of law, through the Avery suit, which came out of the heart of the Uptown Coalition, which said there was a conspiracy between private developers, the city, and the federal government, to take the only integrated neighborhood in the city and turn it into an exclusive all-white, affluent, segregated neighborhood. Couldn't have done the lawsuit just on the basis of "You're running out poor people." Civil rights gave us the ability to do it with a challenge to racism, which of course in reality is so completely intertwined with class in this country, so that it was not only a tactic but a truth. A truth. Those who couldn't fit and ultimately wouldn't fit—that's what I meant when I referred to Marlene Barton saying, "I'm used to this. I just can't do it any other way. I can't live any other way." She is there today. There are some other things I'd like to talk about but I won't, except to just quickly say that the tradition of poor whites making a contribution to the struggle was very important throughout the seventies and eighties, and even into the nineties, in Uptown. One of the real manifestations of it was the Chicago Area Black Lung Association, which grabbed me. That woman, Eileen Jameson, with the Cha Cha Jimenez button, it was her idea. She said, "I heard about this 'Black Lung Club' in Ohio." She was a widow of a coal miner, who suffocated to death from black lung disease. People who came, they were displaced from the coal mines. They worked before federal dust control came about, so they worked in the worst conditions. The new machinery was in, stirring up the dust, and there was no attempt to control it. Then they're displaced to Chicago, where they

work, naturally, at the dirtiest jobs. Their lungs read like a map of American industry, including the coalfields.

HY THURMAN: Doesn't [Paul] look like Bernie Sanders? *[laughter]* I don't know where to start from. It's great being up here with these guys; I haven't seen Mike since the Stone Age. When I first came to Chicago, I was 17 years old, in 1967. I'll get into more of the details of the community and the organizing, and how all that came about with the Young Patriots. I came from a small town in Tennessee that was predominantly agricultural. We were very poor in that community, in that town, as was most of the South that time. Because a lot of people were coming to the north, I followed that migration. There was a migration circle that we used to talk about, which was that people would come to Chicago, or go up to parts of Michigan, Ohio, Pennsylvania, and those places looking for jobs. Sometimes they would make that circle several times, and sometimes they would hit Uptown two or three times, just looking for a job. When a lot of the southern people came to Chicago, they brought skills that weren't needed in the city. There was very little farming. Some people went to Southern Illinois. But a lot of people came with black lung and brown lung from the textile mills; a lot of the kids already had, and some of the adults had, lead poisoning from strip mining, with the water running off the strip mines into the streams.

 Uptown was an ideal place for these people to come, for us to come, because it actually used to be the 'diamond of Chicago' back in 1900. It was established in 1920; there's a street called Broadway running through it. They wanted to make it an entertainment district, the best shopping area in Chicago. We've got the Aragon Ballroom, the Essanay Studio that was owned by Charlie Chaplin and made movies. Chicago was the Hollywood at that time. Right after World War II, the movie industry moved to Hollywood. People started moving to the suburban areas, leaving a lot of vacancies. It opened up into a community for migrants from all over the world, because of the cheap rents. What came along with that was that when the community deteriorated, it became a slum, of course, that brought in the cops. The good cops that were there were replaced by very bad cops. That was one of Chicago's tactics to keep people under control—they would put all the bad cops into the poor neighborhoods and would pretty much give them reign to do whatever they wanted to do. This opened up migration for the southern people, and when we were in Uptown, there were around 40,000 people there. There were as many as 70,000 that came through migrating, and that's not even counting some of the other nationalities. I came there when I was 17; I was pretty green. I dropped out of school to help work in the fields. I was caught in a situation that was kind of unique, because I had a brother here who

Mike had been working with. He was one of the leaders of a gang at one time called the Peacemakers. Those guys were pretty rough. When SDS came in, they started hanging out in the streets with these guys. They started having some influence on them politically, and started hanging out partying. With JOIN and with some other organizations, they had a march on the Somerdale police station against police brutality, police murder. Sam Joseph was a notorious police [officer]—I guess every community has them. He was very well known for just beating people, shooting people. It didn't matter who you were. It was class hatred within the city. Mayor Daley came up through a gang. He understood how gangs worked and he didn't want any other gangs or other groups to have any type of power. Once a group started trying to get some power, he would release his gang, which was the Chicago police, on them, and they had free reign to do anything that they wanted to do. We've seen a lot of brutality, not only brutality on men but also on women. There was a woman who walked into the JOIN office one time complaining about being raped by a cop. About two weeks after I came to Uptown, I was stopped by the cops. They handcuffed me and put me in the back of the car. I didn't know what was going on at all. When they found out my Southern accent, one of the cops said, "Oh no, not another fucking hillbilly. Why don't you go home and just fuck your mother, your dog, your pig or whatever it is that you people do." That was the mentality of the police department. There had been a series of articles in the *Chicago Tribune*—somebody named Browning, I think was the name—about how we were invading the city, we were a swarm of locusts, we would fight at the drop of a hat; they were demoralizing us as much as they could. That of course affected a lot of people trying to get jobs in the city. We weren't respected anywhere. We were treated like trash, white trash. I remember the first time I met Mike. I didn't know anything about politics, but they started working with us and it had a lot to do with us turning political. After that police march, the JOIN office was raided. There was a memorial service because one of our people had been shot down by the police, and there was a retaliation on us. This cop came and tried to break it up. My brother was there, and he literally hit him with a stick and took his leg and dragged him across the street. This is the way that they were treating us, but there were also other conditions, in terms of the housing, for instance. Most of the buildings should have been turned down, burned down. They were terrible buildings. We were constantly fighting landlords all the time. It gets hard to talk about this stuff sometimes when you go through it. . . . We decided, as a group of young guys, that we were not going to take it anymore. We could have went the other way; we could have just walked off and left. We became what was called the Goodfellas, and we started working in the community a little bit more and working with people. We always looked at

organizations, groups like the Black Panthers and the Young Lords and other groups that were offering actual survival programs to the communities. How the Rainbow Coalition came about . . . you've got to understand that we were running out with Confederate flags on us. Some of these people in these organizations were racist. We had to fight through that. We had to fight through that all the way up. We're still fighting, because that's not something that you can just turn off and on, especially if you came from the south and you were raised in that type of environment. We started saying, "We need this type of a program." We were just Southern kids; we were 17, 18, 19, 20 years old. We were at a meeting one night and an organizer named Bobby Lee who was there with the Black Panthers was giving a presentation. We were given a presentation and this is how [the Rainbow Coalition] came about. And this is how the film *American Revolution 2* came about.

We had other programs within the community too, because urban renewal was coming into the area. They were tearing down our buildings. They weren't replacing any buildings; they were just moving people out. We got together with some other organizations and formed what was called People's Village, which eventually became the Hank Williams Village because of all the southern people. It was a self-determined community, basically, that would go into Uptown, the village, to replace Truman College. We actually did get funding for it. We got funding, we got backing from the banks, from a lot of developers in the city that said they would take a look at it. Of course what you see sitting there now is Truman College. So that was just Daley's way of getting his way, but the same time, as Paul talked about, there was arson for hire. There were some landlords that would hire winos and others to come in and burn buildings, and unfortunately they would burn buildings with people in them. No one was ever found guilty of that. What they would do is that they would buy the building, burn it, and collect insurance money off of it, and then they would sell it back to the city to make another profit off of it. A lot of the city officials were involved in that also. We were fighting the people who lived on the fringes, the wealthier people who were trying to get the community back into what was considered the Gold Coast.

That's what's happened now up there, with Uptown. We formed coalitions. This button that you see, we painted over Nixon/Agnew buttons. It represents every person on Earth, every color. We started wearing that, and the Panthers started wearing it too. The Panthers invited us into a coalition. We couldn't understand why because we were the oppressor. Traditionally, we had been the oppressor, people in the South. This was the genius of Fred Hampton, that he understood that not everybody is an enemy. But he also understood that we can work with racism. We can deal with that. Because if we're revolutionary, and we're socialist, we're going to all work for

the same thing. But if we're capitalist, we are going to work against each other. That was a way for us to show the city that we would no longer be divided, and that we would fight it. That's when the repression really came down on us, when the Rainbow Coalition was formed. The day after the Coalition was formed, the COINTELPRO, the FBI, started investigating us and following us around. We were just a bunch of young kids. We were just trying to develop programs for the community. But the way that they saw it, the government, was that we were a real threat. Mayor Daley saw it as a real threat. The Black Panther Party and those groups associated with them were considered to be a threat to national security because we were feeding kids. They were afraid that we were going to turn these kids into revolutionaries. Plus we were gaining power within the city and they weren't about to let us do that. There were FBI documents that state that there's a rising Messiah within Chicago that needed to be neutralized, and we knew that that was Fred Hampton.

We all lost people. The Young Patriots had a couple of people that went down south to start some programs; one person got their throat cut, the other got shot. We were constantly fighting. We had the Klan come out, and we also had the American Nazi party. We had cops all over us all the time. All of us started suffering from beatings, and there were also some other shootings within the community from cops. What I'm trying to say here is what was our belief. We could have turned around and walked away. We could have just walked and kept going and went back down south. But even a handful of people, like there was with the Young Patriots, can make a big difference in this country in fighting racism. None of us had any idea that this Rainbow Coalition would have the far reaches that it's had. We had Rising Up Angry, which did work in educating and was just a fantastic organization that Mike and others put together. But it all came down with the repression.

Some of us had to leave town. I left for a long time; I didn't come back for like forty years or something. I was still involved in other things . . . but Chuckie's back. We are trying right now to revive some of the Young Patriots programs. Of course it won't be exactly the way it was. We support other programs. And with the *Organize Your Own* exhibit, we came out with some of the things that we've published. We're also working on organizing an institute in which we hope to start working with other organizers, especially for people to go into white neighborhoods and work. There's some things coming up.

RZ : Thank you so much to all of the speakers. I wanted to make a comment that has to do with the relationship of this conversation to the present. I just had this conversation in class earlier today, about the *Organize Your Own* exhibition and this idea of 'organize your own,' which seems to emphasize the community-specific or

ethnicity-specific organization. So much of this conversation has been about coalition that it's interesting to think about the difference of emphasis; on the one hand 'organize your own,' on the other hand, coalition. When I've taught this kind of material before, I've expected and found it to be the case that my students tended to expect integration to be the goal, and that I've had to pull them back from that to think about why you would want to have separate groups organizing specific communities. Now, I think the political mood has kind of changed, and the community-specific kind of organizing, specifically young black leadership in Chicago, is more self-evident to young people now. It may be that it's coalition and how to build coalition that's a little bit less obvious. I feel like thinking about how to organize in white neighborhoods, how white kids or white students could think about organizing in white neighborhoods, is something that there might not have been pathways for for a while. It's great to think about how that can work and then serve as a basis for a kind of coalition in which groups come together, on not necessarily equal terms, but in terms of partnership coming from a base of power within particular communities. It's just interesting to hear this conversation and think about it in terms of its relationship to the present moment.

. . . .

AL : On the one hand, this is a different politics of solidarity or a different tradition of solidarity. In raising up the anti-colonial movements, the National Liberation movements in the third world with the Bandung Conference, they had already solved this really primary contradiction that you're describing, which is how do you retain self-determination and the unity? How do you balance that? Most folks think solidarity is like, "Let me run off and go work over here." The "organize your own" model, the things that we're describing here, are about how do you retain that self-determination and yet unite with other communities? That contradiction had been solved already among the revolutionary forces in the Third World. It's to the credit of the Black Panther Party that really, in my mind, the US Third World Left reconnected to those movements that were happening globally. It was happening before in the US with people like Paul Robeson and the different tradition of anti-colonial struggles. But it was through the Cold War and the way that the Civil Rights Movement had developed and kind of paused, and then with the Black Panther Party, that that contradiction was solved and reignited that politics of solidarity.

BCB : When you say, "All power to the people," basically you're talking about a concept that is developed within the infrastructure of the leadership of the Black Panther Party,

with the specific emphasis on developing strategies to make that happen. Back in the day we used to refer, in particular, to Students for Democratic Society as mother . . . not motherfuckers, but mother country radicals. What does that mean? It means that . . . the biggest problem we were dealing with was racism. So then it was your responsibility to go back to your community and work on developing a functional ideological approach to deal with that. One of the problems that we dealt with repeatedly was white folks telling us what to do. "We think you guys . . ."—No, fuck that. We have an ideology, we have a philosophy, we have a 10-point platform, we have 26 rules, this is who we are, this is what we do. We considered ourselves, and to this point still do today, the vanguard for the revolutionary struggle. Early on it was said that it's an ongoing struggle. That's what a protracted struggle is.

Archival material from *Keep Strong Magazine*, Columbia College, Chicago, 2016.

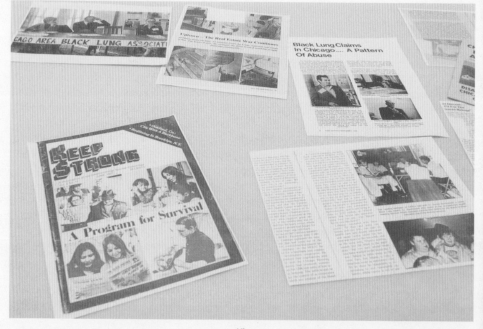

It's an ongoing process. When you're dealing with value systems, when you're dealing with ideas, when you're dealing with a governmental process that has institutionalized hate in the form of racism, that's a lot of work to do. We can talk coalition politics. We could talk communism vs. socialism. We can go from Bob Avakian to Bernie Sanders, in that respect. Mike—

MJ : Just so we're clear, I never told him what to do ever.

BCB : No, no. Me and Mike have been like this since day one.

MJ : When I came to the Panther office and they had all these doors and rifles, I just kept my mouth shut.

BCB : I wasn't a part of that, Rebecca. That was my cousin; that wasn't me. Only Rebecca knows the truth! My point is this: coalition politics catapulted this asshole Obama into the presidency. That's what did it. And we believed in Barack. We believed in the audacity of hope. And rightfully so! We need to believe in something. This country is so…. So now we have another diplomatic process that we're trying to deal with, Bernie/Hillary. We have a Green Party candidate, Jill Stein. Barack was a Democrat; you voted for him. We used to say, it don't make no difference. I'm a Black guy. That's why. I haven't seen anything that distinguished him from George Bush, other than the fact that he's black. When I looked at his policies, when I look at the erosion of civil liberties, when I look at the Voting Rights Act . . . yeah we're gonna 'miss this guy' about as much as we miss George Bush. When you look at the controlling interest in this country, its corporations, big banks, and money interest that's still running it. Anyway, the key to the whole concept of coalition politics is people believing in people. People wanting to work with each other. But more importantly, people loving each other and caring about each other and really wanting to make a difference. I believe in people. I actually believe that when people are educated, when people get to a point where they've done their pre-requisite research, and can critically think, then we can talk about processing some real change in this country. Until we get to that point of understanding the dialectical nature of what it is that we're dealing with, we're going to continue to bump heads. We're going to continue to be petty and squabble. That's why it's so critical for us to be role models for our young people and really emphasize that they learn from our mistakes. We made a ton of them.

Thank you, everyone on the panel. This has been wonderful and incredibly informative to hear from your life experiences and your perspectives. This is a question about coalition politics. It seems, in the way that we're talking about it, that it's not always, but is sometimes about electoral politics. I'm thinking about the Peace and Freedom Party, about Harold Washington, talking about electoral coalitions and electing somebody to office. We're also talking about community organizations, we're talking about self-determination projects. That's a different mode of interacting or acting politically. My question is about, how do coalitions act? When we're talking about the Rainbow Coalition, their action is not electing someone to office, necessarily. In the work that everyone here has talked about, their action is marches, protests; it's some other domain. My question is, when we're talking about coalition, when are we talking about electoral coalitions? When are we talking about some other form of coalition? And what is that sort of power? What is coalitional power when it's not electoral? Of all the different ways we've used this word, I'm just trying to make sense of the relationship between coalition and the political.

BCB: Coalition politics is like any other form of politics. When we speak of coalition politics within our understanding, it means that ideologically, philosophically, people come together for a common cause and they get rid of their differences. There are no gender issues. There are no institutional issues. One of the things that we had in common was that we all had programs. That's the key.

MJ: I think that we want to keep in mind that we really have to talk about organizing. How do we get people to be motivated to organize, however they do it, in whatever group? A lot of stuff has been said here that would be fun to talk about. I'm going to just talk a little bit about what happened in the 49th Ward after the [Jesus "Chuy" Garcia Mayoral] campaign. After Chuy lost the campaign—but it was a really good run—we decided to set up Network 49. It wasn't just about electoral politics. I think what we wanted to do was to educate people. We wanted to support other groups. What I was saying in these meetings—and there's a lot of new people so I'm not sure how it's all going to roll—but I would say, "We want to be able, when we need, to pull out 50 people to 100 people." That's a goal. So that we can support, whether it's school teachers, whether it's a health care issue, whatever it would be, we've got people that we are in touch with that we can mobilize. We also want to have forums and ways that we can really address issues that people think are important. There's a real educational factor. I don't think you can let go of electoral politics. As incremental as it is, as tortoise-like as it is, as three steps backwards, two steps forward—whatever analogy we're using—I think that we need . . . we're not going to have armed struggle

and take power that way. We've got to have elected representatives who are rooted in the community. Increasingly, it's really about education, building a movement, and actually running candidates and grabbing some turf. It's very difficult for those of us who read a lot of dialectical materialism and studied a lot of things, to even find a glimmer of hope in, maybe, Obama as the president. I certainly hoped for a lot more, but what is key to get out of the Obama years right now is how deeply rooted racism and class oppression and all these issues are in our society. You've got a situation where here you have this president, who certainly wanted to do more than he did, not only does he have laggard Democrats he has to deal with, but he's got an organized, financed right wing that is already over the edge fascist. It's a long time.

AL : Think about it like this: there's no group or ethnic group that's monolithic or pure. All politics is coalitional in that sense. But what we're talking about is really class struggle, and how do you educate folks to understand that struggle? If you think about it, within any ethnic group, there are coalition politics involved there. You've got to bridge diversity within every ethnic group. This is a really political strategy; that's what the original Rainbow Coalition was. It was a calculated political strategy to educate communities about class and class struggle.

PS : The relationship between coalition-building and electoral politics is a tricky one. In Uptown, we elected an Alderman. It was a hellacious class struggle to get that done, in terms of challenging an entrenched machine. When you say that the Rainbow Coalition wasn't around electoral politics, it wasn't. But coalitions of oppressed people that wanted to really challenge the structures of oppression wound up going into electoral politics, just like Mike said. It turns out the gun's not available as a tool in this society, under these conditions. It's very tricky to navigate the relationship between getting too defined by the electoral struggle. There was a citywide coalition challenging the Chicago 21 Plan, challenging the Master Plan, with terrific roots in Pilsen, in Cabrini-Green, in Uptown and some other neighborhoods. It all went into the Harold Washington campaign. Then what we did was that we had to fight to protect Harold Washington and the government we had elected. We wound up getting so defined by it that people channeled into the government. When Harold Washington died and a lot of things changed in the world, the coalition we had started to build wasn't really there, and we had to start all over again. I agree with Mike. You can get away from it, but it's tricky.

Moderator: Daniel Tucker
Participants: Amber Art & Design (Keir Johnston and Ernel Martinez),
Dave Pabellon, Mary Patten, Dan S. Wang,
Works Progress (Shanai Matteson) with Jayanthi Kyle
Columbia College's Averill and Bernard Leviton Gallery, Chicago, IL
March 5, 2016

Organize Your Own's exhibiting artists introduced their contributions, highlighting how the invitation to participate played a role in the development of their work.

MARY PATTEN: In terms of this show, the prompt for me with regards to Daniel's conception of the show and invitation was the poetry books, because of the chapbooks and the importance of writing, and the importance of books and literature and self-produced literature to create a kind of living alternative in the present. The whole issue of *books and change* was a really important thread for me. I started thinking about how I was schooled, or sometimes self-schooled, and the role of particular texts for me in changing consciousness and finding a different worldview, and how I began to do that when I was much younger. One of the first books for me was Langston Hughes' *The Ways of White Folks*. When I was in high school, my cousin gave me the *Autobiography of Malcolm X*; my mother was sort of scandalized, but that was hugely formative. It was a little bit later that I read the stories in *The Ways of White Folks* and was really struck by Langston Hughes's decentering of the world and the perspective of whiteness and white folks in that text. I'm sure some of you know it; it's pretty amazing and I've reread it in the course of preparing for this project. So that kind of led to the idea of creating an extensive virtual bookshelf of "black books," in the sense of decentering a white worldview or default middle-class whiteness, which Adrienne Rich writes about so

beautifully. That led to reading and rereading a lot of material including some current material. I was looking for texts to rethink, and my way of rethinking sometimes is about redrawing them, and sort of paying attention to the fonts in which they are designed. *The Ways of White Folks* is, I think, in Bookman; it's a really old school sort of font. There are other texts that are taken from more current events; I chose thirteen. There are five drawings here that are taken from those, that are mostly from black writers and also a bit from Adrienne Rich. I was trying to choose some texts that I was reading and rereading that are very thoughtful and had a lot to teach about the present moment that needs to be savored.

Mary Patten speaking at Columbia College's Averill and Bernard Leviton Gallery, Chicago, 2016.

KEIR JOHNSTON: Hello everybody. We are two members of Amber Art & Design. We're a Philadelphia-based collective. There's about six of us, and we center and focus on collaboration, community engagement, and public art. We are very honored to be invited to take part in Daniel Tucker's exhibition *Organize Your Own*. Dealing in public art is an issue that we dance around quite often. The reality that a lot of the communities that we work with share similar experiences with us is a very powerful standpoint in terms of creation. We focused on transitory realities and realities in which culture is exchanged, and where history evolved through certain networks and paths that led into the city. We decided to focus on Lancaster Avenue, which is one of the historical avenues leading into Philadelphia. It was the link that led to the first cross-country highway, and it was also one of the pivotal routes—Lancaster and Haverford—for the Underground Railroad, coming from Philadelphia. From

that initial point, we delved into a lot of diverse approaches to research. We had talked a lot about our own experiences with the lawn jockeys, so lawn jockeys were our starting point. For me, there was always a point of contention growing up because I understood some of the history behind [lawn jockeys] but they always seemed to have racial tendencies to them. For me, they were rooted in the experience of slave owners coming home: young slave children who couldn't work the fields were responsible for looking after and taking care of the horses when the master got home. Upon further inspection, you realize that these lawn jockey figurines were a very important part of the Underground Railroad, in terms of a coding system. A certain type of stripe configuration, or dots, or colors—that all signified a dialogue that the runaway slaves were in tune with. Depending on the type of configuration within which a figurine was positioned in front of the house, it meant that you could stay in the barn, you could stay overnight, that there was food and water, that your transitional reality was temporary, that you could only stall, or that you had to keep it moving. Coming upon that information, we decided to delve into a series of performances along Lancaster Avenue that kind of spoke to the history, placing the black figure as a prop within various scenes and landscapes.

ERNEL MARTINEZ: A city like Philadelphia is rich; there's this very strong sense of community. One of the things we always gravitated toward was giving voice to communities who tend to be sort of marginalized or left out of the creative process of art. For us, art has always been a vehicle and tool for engaging with communities, but also for amplifying or putting focus on or drawing attention to the plights, issues, and commentary that affect or are produced by those communities. When you look at the jockey series, which is one of several series and collaborations that we have done, it speaks not only to the history of Lancaster Avenue, but also to the realities and disparities between different communities in general. If you go to Philadelphia, you'll notice that there is a very obvious transition between the "haves" and "have nots." There is a street called City Avenue, and City Avenue is a sort of border between two sections of Philadelphia. In West Philadelphia, in which we spend much of our time, you'll see marginalized communities with not a lot of resources, but across City Avenue, there's wealth. A lot of the work we make is about highlighting the disparities between these two different cultures, and when they're put together, what happens to that public space—the tensions, the conversations, the exchange process, and so forth. Over the last three to four years, we've traveled across the country, we've done projects in different cities, spoken with a lot of different people in these communities, and tried to collaborate with them as a means of expressing their concerns through the creative process. We think that, and I say "we" as our collective, art can function as a tool of empowerment. A lot of these communities

don't have the access or the means to vocalize their concerns, so we try to be a tool as artists, not just as laborers but also as amplifiers of what we see as injustice in our communities.

DAVE PABELLON: My name's Dave Pabellon. I'm a practicing graphic designer. I was tasked with a request to submit work for this project with Daniel Tucker. We've worked on several projects before, and always in the realm of graphic design. This was a different take on projects I've worked with him on in the past, in that it's sort of like a mirror: you're holding up the mirror to yourself and you're saying, "What is my organization? Who is my own?" I was thinking about that, in regards to the show, which is historical—how do you bring the contemporary to it? My parents were immigrants from the Philippines, and they weren't necessarily political or politicized, so to speak, so I had no reference point to go from there. The idea of trying to use historical references didn't necessarily apply, so I thought about what other things defined "my own." I work as a practicing designer, not necessarily as a studio artist, so I decided to look through the design lens to create a project. Not knowing much about the Young Patriots, but knowing a little bit about the Panthers and especially the work of Emory Douglas, I looked at that aesthetic. With that lens, I looked at color, I looked at composition, and I looked back at reference points as a designer. The work that translated best when I was looking through those points that Daniel sent regarding the poetry of the Young Patriots was the work of Reid Miles with Blue Note. He was a white designer who didn't really listen to jazz. He had one of his friends, who was a producer, interpret what these jazz albums

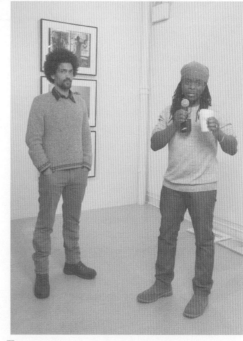

(L to R) Keir Johnston and Ernel Martinez speaking at Columbia College's Averill and Bernard Leviton Gallery, Chicago, 2016.

sounded like. So he would say, "Hey, what does this Mobley album sound like?" And he would get a little reference point. He would listen to like a song or two, but for the most part, he referred to what other people told him that jazz album sounded like. I thought, what can I use as a reference point as a designer? I went with the visual. I struggled with this for a little bit because I was like, "Well, if I typeset a poem again, that's not as neutral as I could be." Designers, I think, are tasked with this idea of neutrality. I thought, what is another form of language that we could use, if I'm not here in the space? I'm not doing a sound piece. I thought sign language was a good way of going about it, and it was also a good reference to learning in the modern age, in this technological world. I thought this was going to be tough. I asked around, I asked a bunch of people who knew sign language, "Do you want to do a video piece with me?" And that just didn't feel right. So I thought, what if I just did it by any means necessary? I decided to make posters based on what I had access to, which was Wi-Fi and a laptop. I looked up what every single word translated into sign language might be. I ran it through some video processing and I created stills; that became my typography. From there, I used Reid Miles's idea and said, "Well, this is what it translates to. How could I energize it through my own visual eye in the most neutral way possible?" I made the choice of picking a website, handspeak.com, for sign language references. I picked that because it features a white woman. This is a poem by a white woman, Peggy Terry, leader of the Young Patriots. I'm just going to read the poem. This is how it translates, word for word, break for break, in the same way the spacing works out in the poster.

```
"HANDS"
Peggy Terry

Hands
That are
Not allowed to touch;
White hands,
Black hands.
Hands
That hold too much
Power,
Hands
That hold none
at all.

Fear of hands—
Fear of progress
(evolution).
```

```
Hands
That are
Not allowed to touch
Become
Hands
That will destroy
The myths.
```

That's the purpose, and the way that I made this poster. When I made the poster in Philly, it had restrictions. Designers work within contexts and restrictions. I work best when there are rules. The rules were that they had to fit into this space. When the exhibition moved to Chicago, Daniel said, "You can do something different." I was, like, "What are the rules?" "There are no rules!" And I thought, I need to make a set of design rules, whatever they might be. So I made the rule of three; it's a three-color poster, broken into three parts, and they're there for you to take. Thank you.

Dave Pabellon speaking at Columbia College's Averill and Bernard Leviton Gallery, Chicago, 2016.

DAN S. WANG: This is the exhibition component of the project that I contributed to this show. Where do I start? I came of age politically in the 1980s. I realize now that many of my teachers back then were refugees from the social movements of the 1960s and '70s. A lot of these folks, after the mass movements of their youth disintegrated for many complicated reasons, became classroom educators (as did some of the famous names that came out of those movements, such as Mario Savio and Mark Rudd, for example). It was my generation that benefited from that. That's partly how I became interested in activism and social movement history. I was also brought up in a fairly traditional, extended Chinese, Chinese-American clan; my parents were also immigrants. It was much later on, after I started making regular trips to China, that I would find myself in the position of wishing that I could show some of these really clever, politically astute, super-smart Chinese artists and intellectuals that I was meeting there, parts of American history that they didn't know about. For example I watched the video document of the Amber Art conversation that happened earlier during the Philly show, and in the course of that conversation they brought up a couple of times the story of MOVE, this militant Philadelphia Afrocentric commune. I was interested in all these militant subcultures; I had an obsession with MOVE. And there were times that I would be in China wondering, how could I even begin to explain what MOVE was to folks without much of a grasp of the American political context? For this show I started to think about these folks coming here, namely Chinese Nationals who are choosing to come to the United States to go to college, as an emerging population. It's been increasing year by year for the past ten years. It comprises more than a quarter-million people in the United States now, including here at Columbia College, where I taught for a number of years, and in many schools and universities around the US, for many reasons. It's both "push" and "pull"—conditions in China pushing them and reasons on this side attracting them, resulting in so many taking the leap to study here. This was my idea. What would it mean for me to take on that role of attempting to transmit some of these histories that were so important to my own political identity to these folks? I have something of an understanding of the context, certainly the cultural context, but also the contemporary Chinese social context as well. I've been making fairly regular trips to China, starting to understand the complexity of it, and my language skills are getting better all the time. This [poster] right here is based on end of semester registration time, at, say, Columbia College, where over 70 percent of the faculty are adjunct faculty. That's what I was. We teach these core classes, but once in a while we get to teach the elective that we really want to teach, but it only happens if enough students register for the course to run. So around registration time, like at Columbia, in the lobbies and halls you'll see posters and flyers that the faculty make for the course that they want to teach; they're advertising: "Are you interested in this? Look for this course number. Please sign up for this course!"

So this is what the print was based on, that vernacular campus form of the course advertisement poster. But this one is a high-end, handcrafted thing, what I'd imagined would be expected for posting at an art academy. Accompanying it is an actual syllabus that I wrote up, and that's meant to be a practical resource. The syllabus is posted in full on the website but also in the back of the *Organize Your Own* exhibition guide that was distributed for the Philly show.

SHANAI MATTESON: When Daniel invited Works Progress, which is technically me and my husband Colin's art and design practice, to do something in relation to this exhibition, I was super excited by the themes. And immediately the wheels started turning. What does it mean to me? What does it mean to organize your own, to think about these things in the context of Minneapolis, in St. Paul, Minnesota, which is where I'm from and where I live. What I ended up coming to was this idea that I wanted to think about how violence is organizing every aspect of our lives. Not just in the ways that we think about police violence being separate from or somehow distinct from our everyday experiences, but how are the institutions that we participate in as people in our everyday lives also marked by that violence? For example, the institution of marriage can be seen that way; it can also be seen as a union that's very much about love. I just started to think on those themes and I decided I wanted a collaborator who would inspire me and help me think through this in the way that it is part of my life. I thought of my friend, Jayanthi Kyle, who is also an artist and singer and also lives in Minneapolis, who also has a family, children, a life.

Dan S. Wang speaking at Columbia College's Averill and Bernard Leviton Gallery, Chicago, 2016.

We've been having conversations. What I came to in the project was that, for me, it would need to be a very personal writing project to think about these ideas: a family, a wedding, a police funeral, and a domestic uprising. The reason is that as we started on this project, there was a police officer killed in the community where I'm from, which is a very small town in rural Minnesota. He was killed by a man who was in his custody because the man had abused his wife and then tried to kill himself. The death of this police officer became a statewide spectacle. Essentially he became a hero, and he became a means to organize around police and the difficult task that police have of protecting their communities. That's the story. I knew him as a member of my hometown and as a former friend of my mother's. That was very personal. Also in the middle of talking about this, another event happened in our community that I'm not going to speak to from the personal place of having experienced it in the same way, but there was another police killing in Minneapolis about which some of you might have heard, a young man named Jamar Clark. That became an important touchstone. Our project at this point is still being worked through. I am still writing. I have the website where the essay that I'm working on as a triptych will be published during the course of this exhibition.

JAYANTHI KYLE: Hello. Like [Shanai] said, we've been having a lot of conversations, and I do believe that having conversations is a lot of the work. My father is from Chennai, he's from India, and my mother is black and Choctaw Nation. So I'm a woman of many nations, and I have to weave in and out of communities, and, sometimes, since I'm a songstress, I like to think of myself as a harmonizer. I try to bring harmony. In Minneapolis, when we were occupying the 4th precinct, I was there to bring harmony. I was there for hours and hours every day just to try to keep that peace, that sense of peace and that sense of harmony. A lot of times that was through singing. My dear friend Wes Burdine and I, we both made a song for the movement that we would sing with a lot of people who would gather, with people who were protesting and marching. I'm part of the Million Artist Movement; we believe in dismantling and ending white supremacy and supporting black liberation through the power of art. Like what was said earlier today, I believe art is a powerful means to dismantle those things. In the Million Artist Movement we also believe in having conversations and facilitating conversations and having people provoke each other's thoughts—provoke each other's hearts in these matters—thereby provoking the truth and inviting the truth.

DT: The way that this exhibition came together was that I invited a number of artists from around the country whose work I admired, some of whom I had worked with before, and some with whom this was an occasion to do something new together. I

provided them with a few bits of material. Those materials were the scans of the poems that you see on the wall here, from the Young Patriots' poetry book *The Time Of the Phoenix*; a link to a film called the *American Revolution 2*, which deals with some of the early meetings of the Young Patriots organization and the Black Panther Party here in Chicago; and a quotation from Stokely Carmichael, who was one of the leaders of the Student Nonviolent Coordinating Committee. In 1966, Stokely Carmichael set forth an idea into the world and it ended up having a big influence and ripple effect in terms of how people were doing community organizing at that moment, which was a moment in the shift from the long history of civil rights activism toward a more focused articulation of a concept of black power. Stokely Carmichael said in 1966:

One of the most disturbing things about almost all white supporters of the movement has been that they are afraid to go into their own communities, which is where the racism exists, and work to get rid of it. They want to run from Berkeley to tell us what to do in Mississippi. Let them look instead at Berkeley. Let them go to the suburbs and open up Freedom Schools for whites.

What was kind of compelling about this quotation was that I felt it was something that was very much echoed rhetorically at rallies that were connected to

(L to R) Jayanthi Kyle and Shanai Matteson speaking at Columbia College's Averill and Bernard Leviton Gallery, Chicago, 2016.

the Black Lives Matter movement that I was going to in Philadelphia. There was often a kind of refrain that reminded me of that quote, which was, like, "White people, it is your responsibility to organize against racism in your own communities." It was not only inter- esting to think about what it meant that a mandate and directive was issued by black activists to white activists today, but also important to crack it open in a way that it could relate to other kinds of communities of concern, other kinds of bodies and concerns, which people organize around and say, "What is the relevance of that quotation for the present?" And to explore it through an art show and a series of performances could in some way grapple with it in a more subtle or nuanced way than one can often do in the context of a social movement, where things are rolling and moving very fast and often times there is not necessarily the space to slow down and ask questions that need to be asked. In the spirit of those questions, I gave these resources to artists whom I was inspired by to start thinking about, but also made it very clear to them that the reason why we were doing this now was not because this is a "New Left" heritage exhibit, but that these questions continue to urgently concern us in our present moment. We live in a moment of deformed social relations and we are all implicated in thinking and working through solutions to reform those social relations. With that I want to ask some of the participants what that quote means to you. Does it mean something to the work that you made? But also: what does it mean to your work more broadly?

SM: For me, the idea of "organize your own" and also the responsibility of white activists and white people to organize against racism has been a question of what my potential role might be in connecting and communicating with the folks who I know. Minneapolis is the big city in an otherwise largely rural state, and information and events travel through that. I've also been thinking a lot about how white communi- ties already organize around race and racism, not always against racism but actu- ally for racism. I've been very interested in how events recently, like the Black Lives Matter movement and a number of police killings, have actually inspired organizing among white people for police brutality. Basically, the idea "Blue Lives Matter," or these counter-conversations about re-centering white supremacy and the naturalization of violence toward people of color. How is that happening through social media? How is that happening in communities that I'm from and that I know? What is my role as an artist to try to make that clear and hopefully to do something to counteract that?

JK: We talk a lot about that . . . because often I feel like I'm doing a lot of white people's work and that they're asking me to do that work and I end up with stacks high of manila folders and their arms are empty. We talk about that and how the field

of responsibility to community and to self and to others and how we interact are very different. When we were occupying the precinct, I was out there every day for hours and hours and hours, with my family, with these three kids and my husband. We were out there every day. I was talking with a fellow artist. He said, "I did this thing. . . . I just sent this thing out there since I can't go there because I have kids." And I was like, "What? I have kids." They were in front of the precinct with guns pointed at them. How does he not feel a responsibility, while I feel, like, how could I possibly stay home when the police have murdered a kid in the streets? It's odd to me.

MP: I'm really struck with what you just said about the pile of manila envelopes that you're carrying and white people who ask you. . . . I'm imagining it's, like, "Well, what can I do?," as if we don't all have a very knowledgeable relationship to this vexed history. It's really difficult and people are afraid of making mistakes or being racist but that's just the ground that they're standing on. It's history. Can I just read something from Claudia Rankine's *Citizen*. It's a very simple text and it's conveying something very ordinary about a relationship between a white person and a black person where there's already an assumption that we're together, that we're part of each other's community:

> A friend argues that Americans battle between the historical self and the self self. By this she means you mostly interact as friends with mutual interest and for the most part compatible personalities. However, sometimes your historical selves, her white self and your black self, or your white self and her black self, arrive with the full force of your American positioning. Then you are standing face-to-face in seconds that wipe the affable smiles right from your mouths. What did you say? Instantaneously your attachment seems fragile, tenuous, subject to any transgression of your historical self. And though your joined personal histories are supposed to save you from misunderstandings, they usually cause you to understand all too well what is meant.

DW: It is a good moment to put some reflection toward that Stokely Carmichael quotation and the story of SNCC turning toward a Black Power orientation. To me, it speaks to what I'm thinking of as the *curse* of imposed segregation and the *gift* of self-segregation, or if you prefer, separatism. And that is a persistent contradiction in American social movements from at least the last fifty years. I think it's a question about how we think ourselves around that contradiction. The ways that I see much of the conversation about race happening is not going to resolve that contradiction. For me, it's more about

getting back to the question of *class construction*. I'm not talking about economic class and I'm not talking about class as an identity, I'm talking about class as a political formation that needs to be constructed, in order to get enough people, enough of society, aligned politically in one direction for long enough to actually get something done—something fundamental and structural, something serious. To me that is the problem. If we can work on that then I think that contradiction of segregation and self-segregation becomes a fact of life that each of us has to negotiate in our own ways, as well as on a policy level. But then at least there's a chance for that contradiction to fade from its place now as basically the primary blockage in being able to really produce social movements that have some serious power.

EM: The quote resonates with me in a very specific and personal way. Mr. Stokely is from the Caribbean. There's the reality that when a person from the Caribbean or Latin America comes to the United States, they have to go through an awakening process, specifically the awakening of their black consciousness. When you come from the Caribbean or Latin America, you're forced immediately to identify in one category or another. I think there are a lot of political and social implications within that process. A lot of the work that we've collaborated on has been about how that space, the urban space, forces you to deal with the reality of identity and how you fit into that particular space. The urban space jockey piece that we did with the stage performances and the construction of these temporary monuments, takes place in a space that's charged politically and socially. West Philadelphia is a space where there's a deep history of activism. We did a series of projects on the MOVE bombing and what happened there in West Philly. These spaces are places that in my eyes are sacred. When we do these performances or create this artwork, we're paying homage to the history of the space, we're paying homage to the power of these spaces, we're paying homage to how these spaces are charged in terms of empowering the people that surround them. Just to further the point about the quote, we feel that true empowerment comes through that awakening of consciousness between people. If you align yourself politically one way or another, if you identify one way or another, and you vote one way or another, that impacts or creates space for true change and the betterment of your community. For us, it has become a tool for dialogue and exchange. It becomes not only a process of acknowledging our own placement within that space, but also a means of helping people who don't feel as if their voices are being heard in one way or another feel that they're acknowledged and that their opinions count and mean something. It's an ongoing process that we continue to dedicate ourselves toward, and at the end of the day, we hope that the work that's shown within this exhibition documents that process.

HY THURMAN: I just want to say thank you very much for what you're doing. The Young Patriots fifty years ago never envisioned that we would be having this conversation years later, but we are. So it's something that we have to keep reminding ourselves about over and over. I just wanted to ask if anybody has any other particular ideas or actions on how we can continue this type of discussion into the future, bring it to people who need it. If we're going to be organizing our own in our own communities, we can't exclude other communities also. Somehow we have to communicate with those other communities. That was the whole concept of the Rainbow Coalition. The Rainbow Coalition wasn't an organization but a concept. It was an idea that was brought about by Fred Hampton. No one had the power over anybody else in that coalition. Everybody was pretty well equal, even though we knew that in reality, we weren't. People were unequal. But everybody was treated with respect and everybody could go back into their own community and strive for self-determination. For instance, when the Black Panthers, or the Young Lords, or even the feminist movement that was

(L to R) Daniel Tucker, Ernel Martinez, Dan S. Wang, Dave Pabellon, Keir Johnston, Mary Patten, speaking at Columbia College's Averill and Bernard Leviton Gallery, Chicago, 2016 .

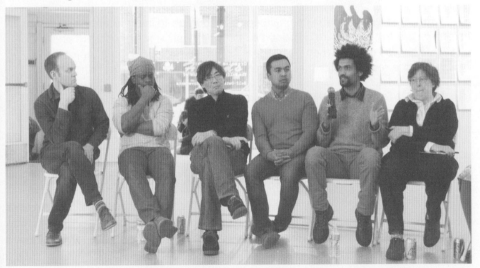

starting in those days, needed help, we would all come together, but no one had leadership within that. I think we have to go back to the grassroots politics that was started back then. And perhaps this is a way of doing it. But does anyone have any ideas of other ways to do it?

JK: I remember I was talking with a dear friend and she was commending me for the work that I do going and talking to white people about their responsibilities and what they truly can do as allies. And she said, "Oh, that's so powerful . . . but you know, my grandpa, he does say really racist things sometimes at the table. And it really makes us uncomfortable!" And I was like, "Oh, my gosh." And she said, "But he's so sweet, though." And I looked at her and I said, "So am I. I'm so sweet. And when I see your grandpa at the grocery store he doesn't say it to me as funny and quirky as he said it to you guys at the table, even though it made you feel uncomfortable. I'm in fear for my life, and heartbroken, and questioning, wondering what I did. And I'm, like, can't you just handle that for me at the table so it doesn't even get to me?" Those are the kinds of things that I think need to be happening. Yes, we need spaces, and it's great to have space, but we all live somewhere. We all have dining tables. We all have houses where we can be meeting with each other and talking to each other and figuring out how to do this. As these brothers said, even in your own community, this is the same, organizing your own, keep showing up.

MP: I think that by having the commitment and courage to interrupt the conversation, there are things that are going to be said when only white people are present versus when it's impolite, when people feel free to be racist in a more upfront kind of way and the responsibility that we have to interrupt that. I was just thinking about when Hy asked about having any ideas, and of course that brings up the most recent thing with the Trump shit in New Orleans. The big rally that he had was interrupted in a much more significant way by a lot of people. A lot of black people; some white people too. I just saw pictures, so some of you might know more about this. But of course, in response to people chanting, "Black Lives Matter," they immediately started chanting "All Lives Matter." And if we remember a year-and-a-half ago, that language of "all lives matter" was being used by liberals or people who were, like, "Yes, of course black lives matter, but so DO all of our lives matter," and invoking a kind of common class position. We know a lot better, in terms of the history of this country, the way that class and white supremacy have been so deeply and complexly interwoven. I think, on the level of family conversation, about where we are where now, and it's no accident that the Trump thing is getting all of its energy from people who feel deeply bitter and

disenfranchised, mostly white people. But it's all done under the umbrella of the worst kind of racism that is completely connected to our history in this country, our intertwined histories. I just think there's a way people talk about the Trump phenomenon, how basically it's about class rage and about resentment at the kind of dysfunctional government that we have, but that's an impossible way to talk about it.

EM: I think that of course when you talk about white privilege in America it tends to be a conversation between black and white people. There are lots of voices that are excluded in that process and that dialogue and I appreciate that you brought up the fact that there are people who consciously or unconsciously align themselves with one political power structure as opposed to the other. The Asian community or the Latin community, when they come to the United States, they immediately face that reality— they have to pick sides with where they fall. I think there's been a deafening silence from many communities about this particular matter. I don't know if it's because it's an issue for people to deal with and acknowledge their own racist perspectives, in terms of separating themselves from what's black, because they see blackness as a negative. Having dark skin is a negative. If you travel the world, [depending on] where you are, the darker you are, the blacker are you are, the chances are that you are going to be subjugated or oppressed in one capacity or another. When they come to the United States, these people see whiteness as a privilege and a means of power. Unfortunately, there is that tendency to align themselves with that. There's an artist, Maya Lin, who was speaking about how growing up in the Midwest, she didn't really realize that she was Asian until she traveled to Europe. That's the first place she actually encountered racism. There's something about how we tend not to want to have that conversation unless we're forced to have that conversation. When we talk about race and we talk about privilege and what side you want to align yourself with, it becomes very hard, because you start to realize, maybe I do a benefit in certain ways that I might feel guilty about. For me as an African in America, the reality is that I have this color that I can't take off. I can't relieve myself of this responsibility or of the challenges that come with being black, so I tend to embrace it. I embrace it and I use it as a means of empowerment. What's really great about this conversation is that this exchange process that we're going through, this enlightening of perspectives or sharing of perspectives, is the only way that you can implement that change. It takes people to be honest. It's going to take people being forthcoming in terms of where they are and what their real perspectives are. We can have a good conversation, we can feel good about having this kind of talk, but if we don't take a really good look in terms of who we are and what our perspectives are and really challenge that reality, and we don't see one thing as being better than the other.... At the

end of the day, that's what I think actually perpetuates and sustains white supremacy in this country. We start to say, "To be white is better. It's better to be white than it is to be this or be that." I think that change comes from us actually changing ourselves.

KJ: Recently, Noam Chomsky came out and said that Trump is a result of white America losing its grip on control. It's a very interesting thought to really ponder. These avid fans of his have somebody to rally around who is publicly projecting these very racialist ideas that they embody, but all of a sudden it's okay to make the sentiments public. I think it's really showed the contemporary divide, mainly between the urban and non-urban settings, but also between the coastal and the central part of this country. I think we need to really delve into those concepts a little bit more and take leadership when we can and use what instances we can to root out any possible change that you can arrive at.

DW: When the show was in Philly, Daniel and a partner organization, Asian Arts Initiative, brought me and Rosten Woo to do a few things, including a workshop based on the syllabus. One thing that really floored me happened while on a walking tour near where AAI is based, what they call North Chinatown. Our hosts guided us through, and Philly is a city that's tremendously rich in murals, including in Chinatown. We walked by a mural, and it wasn't even pointed out to us, but I looked up at it and I was like, "What?!" This was a memorial mural for Daniel Faulkner. And I'm like, in Chinatown? OK, this must have been where his precinct was or something like that. For those who don't know, Faulkner was the policeman who was killed in the incident for which Mumia Abu-Jamal was convicted under highly questionable proceedings. [Abu-Jamal] was a Philadelphia journalist, a muckraker, and thorn in the side of power in that city. His case has been visible in the activist subculture for more than a couple of decades now, but seeing the mural blew me away. I was, like, I don't know if I could live in Chinatown if I had to see this every day! In between that time, which was only a month ago, until now, a national day of protest took place, organized by and for Chinese Americans, in support of New York officer Peter Liang, a policeman who was convicted, rightly so, of manslaughter for discharging a firearm recklessly and having that result in the death of an innocent unarmed young black man. These protests were a *defense* campaign. I'm just saying. This is an urgent situation all the way around because people are organizing their own, whether you're talking about the Trump thing or the Peter Liang thing, but from the reactionary side. That's why we have to do what we're doing here, and not just talk and meet each other, which is inspiring and lovely, but actually organize.

PROJECTS AND CONTRIBUTIONS

AMBER ART AND DESIGN

Amber Art and Design's practice employs artistic freedom in the exploration of archival material and works to re-contextualize historical narratives through the modern black male perspective. In this work—a pointed critique of the entrenched void of the black perspective—we generate a cultural and social dialogue around historical inequities of the missing black voice, especially in creative institutions, by focusing on the economically, multi-faceted, and historically saturated route between the former and current locations of the Barnes. We have used prints, sculpture, performance, and video documentation in creating this new body of work, in which black men in jockey attire posed symmetrically in various spatial contexts are photographed during site-specific, public performances along Lancaster Avenue. The Avenue connects one of America's wealthiest suburbs to West Philadelphia—a route that was implicitly involved in the Underground Railroad and also the endpoint of one of the first national highway systems, which brought new wealth and possibility to Philadelphia. This work explores class, wealth disparities, and social perspectives of indifference and ambivalence within these two communities. In addition to site-specific performances, we have created a series of temporary monuments—three miniature monuments comprised of antique lanterns placed on pedestals, which function as historical markers of significance—that will stand as reminders of the legacies of injustice.

(All images) Amber Art and Design, *Urban Space Jockeys*, Digital Prints, 2015. Photo Credit: Taji Nahl. Performance: Ernel Martinez, Keir Johnston.

ANNE BRADEN INSTITUTE FOR SOCIAL JUSTICE RESEARCH

This project grew out of the University of Louisville's Anne Braden Institute for Social Justice Research, namesake to longtime Louisville-based, anti-racist journalist Anne Braden. A coalition of historians, students, and workers connected to the Institute partnered with community group Louisville Showing Up for Racial Justice (LSURJ) to create two digital stories that examine the ways in which the 1966 call to "organize your own" infused organizing for racial equity, in and around Louisville. One story focuses on Anne Braden and her husband Carl's influence on several generations, as committed white allies to the cause of African American freedom, since the 1950s. The second digital story explores more contemporary manifestations of whites organizing other whites by profiling Showing Up for Racial Justice (SURJ), a local and national network organizing white communities to join with people of color in ending racism. These stories juxtapose oral history audio snippets with relevant historical images and artifacts. The creative and production team included graduate student Wes Cunningham (lead oral historian and narrator), community activist Carla Wallace from LSURJ, historian Lara Kelland, technology assistants Jamie Beard and Nia Holt, and Braden biographer and Institute director Cate Fosl.

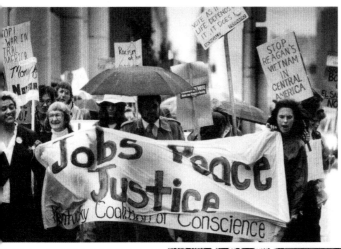

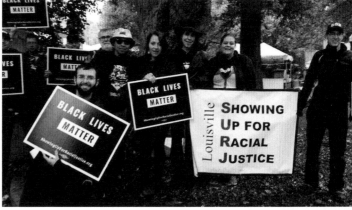

Clockwise from top left: March for Jobs, Peace, and Justice (sponsored by the Kentucky Coalition of Conscience), Louisville, 1984—L to R: Betty Payne, Anne Braden, John Johnson, and Carla Wallace; "Black Power and White Organizing" is from an issue of *New South Student* titled "The Black Power Controversy," December 1966; Members of Louisville Showing Up for Racial Justice (LSURJ), 2015; *Rights* pamphlets published in February and July 1956 by the Emergency Civil Liberties Committee, New York.

Catching Students Falling In

When some civil rights leaders moved toward a Black nationalist philosophy fifty years ago, turning a struggle for equality into a struggle for liberation, the directive to "organize your own" was taken seriously by youth radicals of all colors and communities. In a United States just emerging from Jim Crow, they applied the idea according to the racial groupings then taken as self-evident. Whites organized white people, blacks organized black people, natives organized native people, and so forth. But half a century later, the idea of organizing one's own—still an appealing idea—must be tested against a social landscape that constantly shifts, a demographic complexity barely hinted at two generations ago, and a media universe that at once homogenizes on a global level and yet enables the infinite proliferation of subcultures. All this while the need to organize for political action and cultural autonomy is more urgent than ever. *Falling In* is an experiment in organizing my own with an attention to the peculiar contemporary contours of both "organizing" and "my own."

The Census Bureau projects the Asian population of the United States to more than double from the 17-plus million of the 2010 census to 34.4 million by 2060. The rate of increase already has overtaken that of the Latin@ population. Of the more than fifteen ethnic groups comprising the umbrella category Asian, those identifying as Chinese are the most numerous at a little less than four million. As with some of the other groups, the Chinese increase is immigration driven. Over 70 percent of the current population is foreign-born, the fastest growing subgroup among which is likely those who enter the country as students. The number of students from China choosing to attend American universities has increased every year for the last ten years, to more than a quarter million and growing. They come with differing levels of resources, ranging from children of new wealth to those whose

parents (and sometimes both sets of grandparents) have faithfully saved for their only child's education. They live in an age of mobility and easy communication, lessening the rupture of leaving home for a strange land on the far side of the globe. On many campuses they are enrolling in numbers that make social lives centered around people like themselves possible. To take the flagship campuses of the Big Ten as examples, there are more than 4500 students from China at the University of Illinois at Urbana-Champaign and over 5000 students at Michigan State University, the majority of them undergraduates. The University of Minnesota enrolled some 2700 students from China for the 2015–16 academic year, more than the entire student body of the liberal arts college I attended. Profiled and assembled, here is a social body seemingly primed for engaging with Americans who wish to interact. *Falling In* works from a recognition that student populations are pre-organized by the schools that admit them.

Unlike the earlier generations of Chinese who arrived for higher education—often with the intent to stay, drawn by a one-way vision of opportunity—the current generation comes with mixed intentions. I have known students who wish to stay and those that plan on returning. I am not sure anybody knows which direction holds the majority belief at any given time. The narrative of the latest wave is only in its beginnings, so it is impossible to say with exactness, but it should not be surprising if a significant number find ways to reside in the United States for the long term. There will be "pull" factors like staying for advanced training as graduate and professional students. Some will obtain ten-year work visas with support from employers. Some will switch to a citizenship path through marriage or family relationships. At the same time, China's economic slowdown, environmental disasters, and relatively constricted political culture, to name a few "push" factors, may make life in the United States more attractive. But it all depends on what is going on in each country at the time, layered over each

Recent reports:
<http://foreignpolicy.com/2015/11/16/china-us-colleges-education-chinese-students-university/>.

<http://www.theatlantic.com/education/archive/2015/05/american-universities-are-addicted-to-chinese-students/394517/>.

<http://www.nytimes.com/2016/01/20/world/asia/china-us-college-application.html>.

<http://www.wsj.com/articles/heavy-recruitment-of-chinese-students-sows-discord-on-u-s-campuses-1458224413>.

<http://qz.com/31376/40-of-foreign-students-in-the-us-have-no-close-friends-on-campus-the-culture-shock-of-loneliness/>.

<http://www.theatlantic.com/education/archive/2015/01/what-students-in-china-have-taught-me-about-us-college-admissions/384212/>.

individual's trajectory. These are attitudes and plans that can change quickly. Whether they stay or return, the steep increase in international students from China greatly enlarges the class of transnationally experienced Chinese. *Falling In* concerns itself with the making of this class.

Many of my American-born, Midwestern, and suburban Chinese peers had one or two parents who arrived as students in the 1960s and '70s. This was true for my family, as well. Today's students represent both a continuation and a mutation of the path to the United States, as mapped in the generational experience of my parents. What they are experiencing neither mirrors nor updates the experience of my American-born generation. This is merely one of many disconnects between my experience and theirs. By comparison of citizenship, country of upbringing, and primary language, we are plainly different and without basis for any shared experience beyond the most universal. As well, there is the irreducible gap in age—I myself having come of age in the 1980s. On balance, it is reasonable to say that these students are most certainly not "my own." But they could be—and I could be theirs, a possibility founded on introducing students to the concept of identification as construction, the dialogic process traveled between the social position one is assigned and the social position to which one lays claim. Everyone one of us is implicated in this process of changing consciousness. *Falling In* is meant to raise consciousness.

Presently there is little attention paid to these students once they have arrived, apart from the necessary work of the admissions and registrar's offices. From what I have read in news stories and been told, services and support designed particularly for Chinese international students are generally thin. With international enrollments exceeding 10 percent recently for the first time on dozens of campuses—and reaching nearly 30 percent on a few—colleges and universities are in new territory, playing catch up on designing basic support. Where additional preparation is offered to faculty, it is mostly of a functional kind—for example, briefing them on how to properly pronounce Chinese names. Many schools provide international students with their own orientation, recognizing their need to be informed about a host of details that American students already know. Some schools are folding their international students into the general orientation of first-year students, thinking that the social integration will assist with their adjustment. Most campuses fund clubs and student activity groups through which students from China may organize programming for themselves. Some schools are beginning to recognize the particular needs of these rapidly materializing cohorts and strengthening their English tutoring services or hiring counseling staff with a knowledge of Chinese language or context. But these are all very basic services, nothing very imaginative or even necessarily educational.

Moreover, treating engagement as only a question of university services may limit responses to administrative solutions—practical actions backed by resources but constrained by procedures, mandates, and conventional structures. Starting instead with the production of symbolism as a jumping off point, one can think bigger. Instead of foregrounding the shortcomings of university services or puzzling over students' tendencies toward insularity, let us ask: What parts of American culture and history do we want these students to know about? What cultural and political achievements ought those living in the United States be conversant in? What are the roots of today's public controversies and political conflicts that an international student may never have heard of? What are America's most alluring and exciting intellectual and cultural traditions? *Falling In: A Course in American Counterculture for Students from China* is my answer to these questions.

Course Poster, Woodcut and letterpress on Japanese paper, 2015. This poster accompanies the syllabus *Falling In: American counterculture for Chinese Nationals*.

DAVE PABELLON

The process of gathering information and making for this project was intentionally rogue, laced with naiveté. It's how my parents would have done it in 1971, when they migrated to the United States from the Philippines. They weren't overly politicized, technically savvy, or even organized when they arrived in Chicago, but they were scrappy, hard-working, and had a network, albeit a rogue and naïve network. Their gumption, paired with their innocence, created many unorthodox means of getting by—be it sardine-type living conditions, the imaginative reuse of food and packaging, or low-fi technological mash-ups. This was present in our household throughout the years—at times it was frankly embarrassing—but it was their process and they owned it.

 c/o Jolanta is a visual response to and interpretation of Peggy Terry's 1972 poem "Hands." The project had two parts, or versions, that were specific to the location of the *Organize Your Own* exhibition. The first was a 13" x 19" digital print for the show in Philadelphia, framed and hung. The second was for the show in Chicago and was a deconstructed 3-piece, 3-color risograph poster, which (when displayed together) measured at 17" x 33" (17" x 11", individually), and was available for take away on the gallery floor.

(evolution)

Not knowing a great deal about the Young Patriots when I was approached to participate in the exhibition, I used the resources I had readily available (similar to my parents), the internet, and my network. When researching the Young Patriots' *Time of the Phoenix* poetry chapbooks, I gravitated towards Terry's "Hands." Being brutishly literal as a graphic designer, I saw how the poem could easily translate the written word into a new visual typography, through the form of sign language. Tapping friends of friends and colleagues through social media, I was able to work with an ASL (American Sign Language) instructor to proof the project.

I liken this method of making to the work of Reid Miles, the infamous Blue Note album cover designer. When first hired in 1955, Miles knew very little about jazz, nor did he care for it. Instead of investing time and energy into the genre with the hopes of gaining appreciation, he relied on colleagues like record label producer Alfred Lion to synthesize the albums to only their most necessary details or descriptions.

(evolution)

All images on this
page spread: *c/o
Jolanta 2.0*, 3 color
risographs, 2016.

Page 179: *c/o Jolanta*,
digital print, 2016

FRANK SHERLOCK
No Border No Cry

Forget that your dancers were outlaws
Forget the famine
Forget genocide
Forget that Walt Whitman hates you
Forget your distant reflected face as the Other
Forget that they made you police to prove that you could obey
Forget the tenements
Forget that the Alien & Sedition Act was created because you couldn't be trusted
Forget the shame that was thrown over you in the form of flags to contain
Forget that they made you beg to be white
Forget your witchy pagan days & the wildness that makes power nervous
Forget red scares
Forget anthems of organized labor that were accompanied so often by reels
Forget brigadistas harvesting Sandinista coffee in hills
Forget 1649
Forget slave rebellions in Barbados fighting shoulder to shoulder with Africans
Forget that you're still called lazy & drunk
Forget you were hanged over & over again
Forget that Empire changed their recipe to absorb you
Forget that they said you were savage
Forget who they called "Castro in a mini-skirt"
Forget Africa Forget Palestine Forget a burning St. Michael's on American Street &

Become a Big House enforcer
Become a Rizzocrat
Become UDA here in Southwest or South Boston
Become well-versed in Cromwell's Pocket Bible
Become a Shankill Butcher
Become a crown grunt for the reward of being able to wear whiteness
Become a ham-head who murders Fred Hampton
Become Volunteer of the Year
Become a sniper at 60th & Springfield
Become someone who Master lets hold the whip
Become top gun Stephen McKeag
Become an apologist for law enforcement
Become a victim of compassion fatigue
Become a mouthpiece for detention without charge
Become a holocaust denier
Become against immigration
Become Sean Hannity
Become a dues-paying member of institutions that hate you deep down
Become an amnesiac
Become a new Nativist
Become a church arsonist
Become a burner of crosses or

Remember Black Provos
Remember Assata when you think of Joe Doherty
Remember Free Derry's roots in Free Berkeley
Remember your kin as boat people from Cork Saigon or Aleppo
Remember the lily to be worn on Easter & Mayday
Remember the Irishness of Che Guevara
Remember Indian Parliament's moment of silence for martyrs
Remember Fanny Howe
Remember Mac Maharaj
Remember your people became Puerto Rican
Remember the IWW on Philadelphia docks organizing Irish & Polish & Black
Remember Palestinian prisoners who smuggled out letters of Sinn Fein support
Remember San Patricio Battalion deserters
Remember the rising of the moon over Sharpeville
Remember the Berrigans beating missiles to ploughshares
Remember the Bloody Sunday March modeled on Selma-Montgomery
Remember Nelson Mandela never forgot you
Remember Bobby Sands Street in downtown Tehran
Remember Panthers who were gifted the key to New York
Remember Justice in the North is about justice first
Remember Guantanamo when you think of the hunger strikes
Remember No Border No Cry

IRINA CONTRERAS

It's Firm Ground Here... and *It's Firm Ground Here: Azteklatron* are video-based works that document and literalize the ways in which we wrangle with the tension of racial or cultural identity. Within my performance and video-based practice, I view open and closed public spaces, private spaces that seek to function as publics, and exclusive spaces (women only, people of color only, queer only, activist spaces, artist spaces) as source material. My practice considers the discourse surrounding both publics and counterpublics, while also thinking about the work of sociologist Harold Garfinkel and his breaching experiments of the 1960s, as well as the effect these types of work had on social justice organizing and educational theatrical pedagogies, such as Augusto Boal's Theatre of the Oppressed.

Using various interviewing, facilitation, and theater techniques, I inquire about our abilities as activists or otherwise concerned people to project what we intend into the world. This body of work builds upon my investigations into decentered performance as a way to highlight our internal public and private spaces. In particular, I have looked to people within my social, political, and artistic circles, who wrestle or have wrestled with the personal ideology of the race traitor. Conversely, I have looked at those who wish to eliminate whiteness from their lives. The people chosen reflect those within proximity, whom I have interacted with within the last fifteen years.

Within my project, I have sought to look for possible questions and/or relationships between these various groups. As part of my process, I informally and formally interviewed 20–25 members of various communities, to which I range in emotional closeness. The initial interviews were not traditionally documented, though I took notes, did drawings, and in some cases, took photographs with each person, in an attempt to understand where we place ourselves now—whether they felt they were

in opposition to where they came from, and in some cases, were point-blank asked if they felt they were race traitors.

The second iteration (and certainly the first, too) involves my own responses and foreseeing of speculative events that might occur, given my distance from both groups in which I saw myself a part of, while considering the various consequences of such socio-political outcomes. The images I have decided to include utilize both the re-alization of this speculative present/future I find myself in, as well as my current reality.

Above: Irina Contreras, video still from *It's Firm Ground Here: Azteklatron* (2016)—Gee and Belly, who are representatives of a post-Angeleno community, comprised of brown women living with pit bulls; right, top: Irina Cotreras, video still from *It's Firm Ground Here* (2015)—Interview/informal conversation, taken over the course of three months, about those of the artist's friends and collaborators, who may have self-identified as race traitors at some point; right, bottom: Irina Contreras, *Social Circle Diagram* (2015)—Diagram of a possible way in which com-munities I am a part of may or may not intersect: field research to establish my own understanding and possible ignorance about the way my social circles are segregated/non-segregated.

"On the Street" was a recurring section in *Keep Strong*, the magazine of the Intercommunal Survival Committee. *Keep Strong* began publishing in July 1975 and continued monthly publishing until October 1980. Each month, random people on the streets of Uptown were asked their opinions about a specific question. Their photos were taken and their answers taped. This became the monthly "On the Street" column. The primary goal of *Keep Strong* magazine was to provide an opportunity for poor white people to see their day-to-day struggle to survive alongside the struggles of Black and other poor and working peoples, in order to create and heighten a sense of commonality and mutual respect.

Based in Chicago's Uptown neighborhood and working under the direction of the Black Panther Party, the Intercommunal Survival Committee was founded in 1972. The ISC built upon the work of the Black Panther Party, the Young Lords, the Young Patriots Organization, and Rising Up Angry survival programs, which included free breakfast for kids programs and neighborhood health clinics, and later, legal defense, welfare defense, and tenants rights organizations, as well as the Chicago Area Black Lung Association and numerous city-wide coalitions. In 1978, the Survival Committee was reorganized as the Heart of Uptown Coalition.

Throughout the past year, as part of *Organize Your Own*, student workers from Leviton Gallery have scanned 5,000 negatives from the photo archives of *Keep Strong*, in an effort to support Helen Shiller's ongoing archival efforts.

KEEP STRONG

Published by the Intercommunal Survival Committee
VOL.1 NO.3 OCTOBER, 1975 25 CENTS

What Is Wrong With The Schools?

JoAnne Little Speaks In Uptown

Protect Our Future

Photos from *Keep Strong* magazine, November 1975-December 1979. Courtesy of the personal archive of Helen Shiller.

MARISSA JOHNSON-VALENZUELA

Sieve It

The following is an extended version of what I read at the opening reception for OYO *in Philadelphia:*

By choice and by force I've traveled far from the communities into which I was born and raised, so when I was initially asked to be a part of *OYO*, I wasn't sure who my own was—in a traditional sense. But then I remembered, like many people who cannot go back, I have long sought intentional community. Radical weirdos. Queer family. A loose network of writers of color from across the country. These are the people I organize with. And the small press I founded, Thread Makes Blanket, which released a book by Martine Whitehead as part of *OYO*, is one of the most tangible ways I've organized as of late.

 Another way is through the West Philadelphia collective house I live in. The archival materials that provided the foundation for *OYO* are rooted in neighborhoods and change, and in creative responses to systemic oppressions. And so, I've started by riffing on the complexities of one corner on one block in Philadelphia.

 Further, this work is inspired by an idea I first came across years ago in Robin D. G. Kelley's book, *Freedom Dreams: The Black Radical Imagination.* Kelley argues that if we judge movements by whether or not they met their goals, then everyone has failed. But if we instead look at what they were able to imagine, then we truly have something to build upon. As he writes in his introduction:

> Trying to envision "somewhere in advance of nowhere," as poet Jayne Cortez puts it, is an extremely difficult task, yet it is a matter of great urgency. Without new visions we don't know what to build, only what to knock down. We not

only end up confused, rudderless and
cynical, but we forget that making a
revolution is not a series of clever
maneuvers and tactics but a process
that can and must transform us.

★ ★ ★

In August of 2000, a big house at 50th and Catharine was bought by AIDS activists whom I'd never met before I arrived with everything I owned in the trunk of a car. I came from Wichita, by way of Lawrence and Detroit and DC and the southern Mexican state of Chiapas, where I'd gone to learn from an indigenous uprising known as the Zapatista movement; an impressive asymmetrical war for dignity.

Where I remember looking at a *La Jornada* photo spread of the 1999 WTO protests in Seattle and finding myself for the first time, oddly, still somewhat disturbingly, proud to be American.

The Europeans and Chilangos who'd so easy dismissed Estados Unidos were also in awe at the pages of photos. Even the ever unamused IRA guy leaned in to see the images of clashes with cops, teargas, barricades, and people in the streets resisting global capitalism. That moment taught me something about responsibility.

Add in the US military helicopter ostensibly given to Mexico to assist in the "drug war" that instead aimed its machine guns at unarmed villagers—and at foreigners like myself so a soldier could take our picture—and responsibility is compounded.

And then, a few days later, when I was in the internet cafe fielding emailed questions from friends in the United States who said the coverage there was much more limited and vague than what I'd read in the Mexican newspaper, I learned something more about the intentional dismissal of rebellion by media outlets. And how to join in the taking of responsibility when we don't even know about the efforts of others?

15 Years This
Corner

Little Monica told me
she would lay
out her outfit
the night before
And mine
is a different
corner
from the one
she sold on
but both have
chicken bones,
loosies, and
debilitated men
So I could've taken
her advice and laid
my clothes out
It'd make me better
with timing, with
attention to detail
More like the woman
in the park
refusing
the man begging,
saying she doesn't
do that to women
she likes
Meaning to herself
Meaning he ain't it
Meaning it's not
personal
when probably it was
Streetology
Degrees in
Pay up or pay me
For generosity
of spirit
For the consultation
required

When, with roughly $30 to my name, I returned to the United States, to Wichita, to the top of a friends' bunk bed at her dad's house, I started thinking about a next move. In the way that one's options at age 20 can seem simultaneously endless and yet so limited, I'd narrowed my choices between going back to college at KU, renting a trailer home and being a foster mom—somehow I'd already been approved— or moving to Philadelphia.

I chose Philly. And its history of collective houses around Baltimore Ave. And a college that, even when I scammed to get in-state tuition, I didn't know how I would pay for.

The continuation towards a college degree was residual. Was a way I was lacking imagination.

Where I planned on learning, where I had already learned so much, was in a loose network of people I had, long story, stumbled upon. People who wrote political zines with names like *ATR*, which stood for *After the Revolution*, who organized benefit shows and protests and alternative spaces like the A-Space and the Wooden Shoe anarchist bookstore. Who talked about racism and voluntarily, so eagerly, went to trainings on how to combat it—in the world and in the self.

I resist the ways that radical communities and spaces are so often written about. The way that to this day some people in Philadelphia seem to write off the West Philly weirdos. Mocking dismissal and easy critiques. I also resist romanticism. I know the critiques are easy because there is truth in many of them. But I am forever indebted to my communities; my chosen family. I believe that daily they make this life worth living.

But yeah, the so called scene I speak of was predominantly white. Yes and. Let's not whitewash it. There were many of us who weren't.

And shout out to every white activist who gave me shade until they heard my mom is Mexican and wanted to be my new friend. Yeah—hope ya'll went to anti-racism 2.0. The

in the audition
all the notes
taken
And the symbol
may be
ice cream
The increase
in ice cream
American ice cream
Because Yoga left
She was replaced
by records
I don't want to buy
Meaning
it's even
Meaning
not really
Nowadays
just a different
problem on
the opposite corner
that shit bar a hotter
uninviting scene
when many of the
leather cut bikers
didn't have bikes
When all queers
were ageless
Nowadays
Abdul Faruk is dead
But forget him or his
carpeted sidewalk
scene? Never
On top of that matted
brown square:
Sofa-bed, coffee table
and dresser
with streetlight lamp,
Chinese store
as kitchen, and the
neighborhood

class that covers tokenism and people collecting. And still, I wonder if I can't mark my poc-ness, my poc-markedness, by all the white people I scare. With my ambiguously ethnic. With my blunt. With my earnest insistence that we can all do better.

The color of capitalism, maybe even of racism, is beige resignation.

The collective house I moved into was trying to extend the affordable housing model beyond the standard five 20-somethings with marketable skills sharing a kitchen. Its organizational structure resists traditional rent and ownership models. It consists of both sides of a twin so it has 4 apartments on one side and a 3-story, 6-bedroom group side on the other. This allowed for 3 of the apartments to be occupied by older members of the AIDS activist organization ACT UP who were in recovery from addiction. The founders of the house imagined a new model, and they created it. And when it worked, it worked.

That first month, Abdul Hakim, an older bearded man dressed in the traditional white robe worn by many American Muslims, and I, a young woman with purple hair and lip rings in black Dickies and a black t-shirt, went to some scratch and dent place in North Philly to buy 5 fridges, and he was amused by my assertive deal-making attempts. As if I knew anything about fridges. A few months later, we paired up again to remove an ugly stubborn deep rooted bush in the front yard, and he laughed when I caught him trying to bullshit me, when I shook my head and pointed out that crack was just shitty coke.

But we weren't a recovery house. We had not proactively figured a way through relapse. We did not want to monitor each other in that way. Of the three housemates with histories of drug addiction who moved in, only one successfully moved out. He's since passed away, but his impact on people in Philadelphia, particularly those with HIV and histories of incarceration, was so great that he now has a health center named after him: the John Bell Health Center at Philadelphia FIGHT.

the TV
Better step
into the street
because to walk
through his living
room
is rude
And that day
it rained he,
wet and unlucky,
cold melted
into the couch,
such a contrast
to his first day
in the sun—
evicted—
my heart wanted
to take him in out
of the depression
But he was mean
On her only hit record,
Nonchalant said
ya better get
yourselves together
Don't just stand there
on the corner
watching
things change
without you
But do what about
the click of heels
and their mothers'
on the sidewalk
going to the beer
going to heaven
going to graduate
soon
so fast forward
through this part
it is all the corners
in America

However, because of what went down as the result of their relapsing into addiction, we had to ask the other two housemates to leave. It was awful and felt like failure.

We went back to mostly housing queer white women. We asked some of them to move out, too.

Of course, the West Philadelphia I first moved to has changed in other ways. From what I gather, UPenn no longer, in orientation, advises their students to not go past 44th, 46th, 48th, 50th? Higher incomes have moved further and further west into rentals and mortgages that have "followed the market." Without exaggeration, my house could easily be sold for 22x its year-2000 purchase price.

I no longer have a key to the co-op grocery store that allowed me to go in at 1AM on a hot summer night and, on the honor system, write down the name of the ice cream I was taking.

More significantly, for my ideals of hybridity, cultural-crossover, and solidarity at least, even the segregation segregated. By which I mostly mean the weirdos subdivided. I can now go to a party made up primarily of radical people of color, or one that is mostly trans and genderqueer folks, or even one that largely consists of radical trans and genderqueer people of color. And sure, this is a good thing. I am an advocate for people finding community.

But I'm still a bit sad that there may never be another new year's eve party like that first one I DJed at Cindergarden (another West Philadelphia collective house with probably my favorite name of them all). The party happened just a few months after I'd arrived, and it was one of the first times I ever DJed in Philly. I had this old Gemini Scratchmaster mixer—the one *without* the sampler. Didn't yet have two turntables, so I borrowed one from Bull. And we had to ground the sound system to the kitchen sink. As midnight approached, I was running out of records, so I took a risk. After playing hip-hop and R&B most of the night, I prepared a song I wasn't sure would work for the punks, activists, weirdos, artists, queers, and especially for the

you gotta let
them play
Don't tell me
there's something
me and my
keloid don't know
about living despite
opulent violence
This is love mama
this is love—
people and place—
that has nothing
to do with the fact
there are fewer
tiny plastic bags
fewer shells
and stroller
after stroller
Stroller armies
and hey, I like
kids even though
I kill them
There has always
been black fabric
for death and fashion
And I don't mind
the changes
at the state store
it's the reason
why, the whiter
reason why
the remodel
But Peking Inn
and Choy Wong
stay bulletproof
and open
Someone is still
eating
Generous
car system
subwoofers

other folks of color. But I had to try for an anthem of some sort. It was New Year's Eve. I went for Bon Jovi's "Living on a Prayer."

Here again, I want to resist nostalgia. I have to. It was never not flawed. I mean, I played Bon Jovi.

But everyone sang along. Knew all the words. *We're halfway there. Take my hand we'll make it I swear.*

How to resist nostalgia, oversimplification and "back in the day" self-limitation, but not forget what has already been proven possible? Rather than, so savvy and studied and serious, reject cheesy moments of exception, how can we enjoy such emotion and sieve it? How to, even as we get older and so many go back to the seeming security of traditional family structures, not forget our collective accomplishments? Which surely must contribute to some sort of collective possibility? Some sort of collective imagination.

For, as David Graeber so eloquently puts it, "If you're not a utopianist, you're a shmuck."

Recently, some random guy was insistent that we need a leader, and I was immediately exhausted. My exhaustion begins with a questioning of who the "we" is—who was included/excluded in dude's "we" and who would be in mine?—and moves on to how I am much more interested in collective responsibility.

No matter one's rhetoric, waiting around for a leader to follow is a cop out. And it's worth noting that capitalism is subsistent on such inequality (which is why we will not soon, if ever, be post-racial).

Yes, some well-known radical people did some well-known radical stuff, but mythologizing them does us little favor. In fact, it harms because it may make it harder for many people to realize that they too can act, and because such heroism almost always comes with a failure to recognize everyone who marched with, took care of, and otherwise nurtured the person being deified.

Rather, if we are serious about the need for dignity for all; about our demand for a more just world, we need

reflecting
sound waves,
24hrs a day
Meaning there
are sounds
I don't want
to wake to
bitch beat bass
and crying
Once, when I
was breaking up
on the front steps
we've come
to the end
of the road,
still I can't let go
it's unnatural. . . .
rolled by
and we both
had to take
a moment
a pause
In so many
I've known
on this block
And I wanna
be bulletproof
In the search
for honesty,
One + One
dollar store
became
One + Five
In the search
for coffee,
likely a long line
of unhappiness
or patience—
it's all about who
you are—
and six people

more examples like the ones *OYO* offers of non-famous people organizing and creating together. And we need to know we need them. Examples that transcend demographic boundaries such as the Japanese-Mexican Labor Association in Oxnard, CA, in 1903, who stood in solidarity against the bosses and against the racism of white unions, or like the successes and complications documented in books like *Detroit: I Do Mind Dying* and *Freedom Dreams* remind us that humanity, however briefly, has already proven itself capable. Change need not go slow. It need not be left to those with positions and degrees and questionable investments.

<div align="center">★ ★ ★</div>

I'll end with a poem that "flips" a quote from the family of George Zimmerman, the man who shot and killed Trayvon Martin in Florida on Feb. 26th, 2012.

you've known
before
Bricks in need
of pointing
More dogs
on leashes
Monuments
to thieves
Elena burnt down
and left,
and her soul
I still mourn
She had
Hennessey
She had
real possibility
She had
range

Line for Collective Song

"No economist should pretend that all America got from slavery was cotton." —Jericho Brown

Many solace in old-fashioned surfaceskimming
While some of us look like splashing
fools for rescue;

puce, humorless.

And clearly can't repeat wrongs to correct them,
so maybe the skaters are getting off
easy. For such whiteness not only blinds,

it coddles; not only starves, it feeds.

So basic that babies know: cry or stop crying.
Coo innocent, coo cute. Spit it all up
because the difficulty / humility

is so hard to digest.

Which is what the Zimmermans said about their sadness.
We live with a situation that cannot be easily imagined.
Even in dissonance, a line for collective song,

a plea for imagination.

Necessary though only some of what is selling is sold.
Necessary because, though people may try fire and bleach,
there is no new skin.

We live with a situation

that cannot be easily imagined

or forgiven. Eaten and swallowed
as god-witnessed dirt. What looked like
alternative routes brought us

to the same watered sand.

Unpacking My Library: Black Books, and The Ways of White Folks

While beginning my research for *Organize Your Own*, i happened to hear Emory Douglas speak. What a thrill to hear him talk about Letraset and all the other tools of layout and paste-up from the graphic design and poster art he made with the Panthers. In the Madame Binh Graphics Collective, we used those exact tools, too, clumsy and inexact, but very tactile, like all old-school printing processes.

This made me think of fonts, and particularly our preferred ones back then—Franklin Gothic, Optima, and Cooper Black. Fonts, the crucial element in what used to be called "typesetting"—in book design, pamphlets, chapbooks.

Thinking about poetry and pamphlets, books and literature, brought me to the role of reading in de-centering my world, and worldview . . . remembering how reading brought me into life, and how important to life are building libraries and archives of knowledge.

i looked again at my own library, at my disorderly collection of Black books, gathered across a span of nearly fifty years—tracing titles, finding Post-it notes and ragged book jackets, rereading precious words on cheap, available paper . . . thinking about Walter Benjamin's idea that one comes alive in and through one's books. But mostly i thought about the disorganizing power of knowledge, and the power that books have to dismantle worlds, even.

The Ways of White Folks

In 1935, Langston Hughes published these stories, holding up a mirror to white America . . . or maybe not. Maybe the book, like any book, was a window for people to look through, and to choose whether or not to recognize themselves in its pages.

i found a copy of the first edition hardcover in the Carter Woodson Library, in Washington Heights, on the far South Side of Chicago. It's part of the Vivian G. Harsh Research Collection of Afro-American History and Literature.

Top: *The Ways of White Folks*, 4-color process serigraph, 2015. Bottom: *Black Bookshelf*, Archival pigment print, 2015. Page 203: Installation view, Kelley Writers House, Philadelphia, 2016.

A small olive green book (i later learned that another edition had been bound in a rusty red), with an art deco/art nouveau engraving of the title. i opened it, and found Langston Hughes's signature sprawling across the frontispiece, big and elegant in india ink.

(i hear his velvety voice, reciting. . . .)

But there was no dust jacket. Most libraries don't keep those. They rip, fall apart, and disappear. After weeks of hunting, i found the dust jacket at both the Beinecke Library at Yale University, and at an antiquarian bookseller's in Connecticut. Big, blockbuster sans-serif type—reverse type (white) on a soft black-brown background. Very different from the quiet embossing on the actual book.

This was one of the first books to profoundly change the way i looked at the world, and the first time i encountered a writer who made me look at White People as a uniquely strange species. It was unnerving. . . . i was compelled to read, look, listen, and feel from Hughes's point of view, but the species was "my own"—a kind of double (shot—reverse shot) vision.

Black Books, White Readers (A Postscript)
Books are not bragging. i do not believe in an interpretation of "organize your own" as white people quoting Black people to other white people. i can embody the righteousness of Aimé Cesaire's "Leave this Europe," but only for a moment. i cannot live there.

The history of their acquisition is the history of my initial encounters with my books. In his essay, Benjamin writes that "ownership (is) the most intimate relationship one can have to objects." But as much as one might try, one doesn't "own" a body of knowledge. My library and all our libraries continue to live in and beyond us, the more we put them to use.

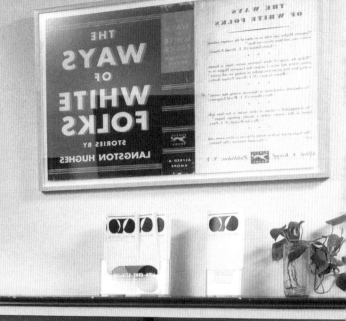

MATT NEFF

THE DEVIL DOES NOT NEED AN ADVOCATE, HE IS CLEARLY RUNNING SHIT, and *AND HE WEARS BLUE* functions as an ephemeral triptych of dissent. Formally, these prints recall the protest posters and banners of our past—their limited color palette and modest scale reference prints made on small, lightweight, one-color, offset presses, which were popular among the protest communities of the mid-1960's. These presses were widely used by young activists to produce a high volume of posters, pamphlets, and radical publications at a low cost, and to serve as a visual signifier of the rich history of dissent in the United States.

These images were made from printing glitches, damaged proofs, and found textures, which were scanned, layered, and printed on a Risograph printer. When paired with the text, they function as reverberating visual feedback.

In line with the overarching concept of "Organize Your Own"—the still timely advice from the Black Panthers to the Young Patriots to focus their efforts on organizing their own communities—the text in these prints was derived from both observations of and participation in discourses between different groups of white people, in the wake of the multiple murders of unarmed people of color by white police officers. These prints stand in defiance not only of those in power who are perpetrating this horrendous violence, but perhaps even more saliently, in protest of the white communities that continue to passively stand by as these horrors unfold.

Top to bottom:
THE DEVIL DOES
NOT NEED AN ADVO-
CATE, Risograph
prints, 2015; HE
IS CLEARLY RUN-
NING SHIT, Risograph
prints, 2015; AND HE
WEARS BLUE, Risograph
prints, 2015.

RASHAYLA MARIE BROWN

In *The One-Woman Gentrification Project*, I read from texts related to histories of liberation, confinement, and displacement such as Victor Frankl's *Man's Search for Meaning*, Ntozake Shange's *For Colored Girls Who Have Considered Suicide/When the Rainbow is Enuf*, and *The Autobiography of Malcolm X*. I perform these texts through a megaphone I've placed in top-floor building windows in neighborhoods that have experienced high levels of displacement. Passersby can cross the street to visually locate the megaphone's position or they can choose to stay directly below it to hear what my voice is saying. Usually, they can't see and hear the voice's source at the same time, due to the distance from the sidewalk to the window. They have to make a choice. My neighbors often file noise complaints and the police sometimes intervene.

This work was inspired by my move to the Gold Coast neighborhood of Chicago, one of the most affluent neighborhoods in the country. Friends were surprised to find out where I lived, wondering how I could afford it and what it was like for me socially. The nature of gentrification is complex for me, as I am on the line between several groups socially, economically, and culturally, and the now-demolished Cabrini Green Projects are close to my home in the Gold Coast. Instead of moving to a working class or "up-and-coming" neighborhood, I specifically chose to move to an area that will affect me more than I can affect it. Or can the reverse ever happen?

Rashayla Marie Brown
performing *The One-Woman Gentrification Project*, Kelly Writers House, 2016.

Against the Picture—Window: A Time of the Phoenix *Compendium*

Starting in the late 1960s, the Young Patriots, a group of radicalized street kids from Chicago's Uptown area, began to produce a series of poetry chapbooks entitled *Time of the Phoenix.*

The poetry featured in *Time of the Phoenix* reflected the lives and histories familiar to the members of the Young Patriots, their families, and their neighbors in Uptown: white, southern migrants living in poverty.

Against the Picture—Window has compiled these "of the moment" poems, written by Uptown residents, from the original chapbooks, along with present-day interviews, documents, new works, and conversations about the chapbooks and the role of poetry and verse as non-didactic tools for sociopolitical engagement. In particular, the book acts as a bridge, using poetry as infrastructure, to highlight that very role, its past uses, and its present condition.

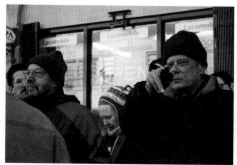

This title has been produced in collaboration with and with the assistance of: Daniel Tucker, Hy Thurman (of the Young Patriots), Anthony Romero, and the editors at Society Editions (Mary Austin Speaker, Chris Martin, and Sam Gould).

Against the Picture—Window was released on April 8, 2016, at Carol's Pub, Chicago, during a special event featuring bluegrass band Growler and following a walking tour of the Uptown Neighborhood, led by Hy Thurman and special guests.

(From left to right): Walking tour of Uptown Neighborhood, Chicago, 2016; Publication release party, Carol's Pub, Chicago, 2016; *Against the Picture-Window: A Time of the Phoenix Compendium*, Wooden Leg Print & Press, 2016.

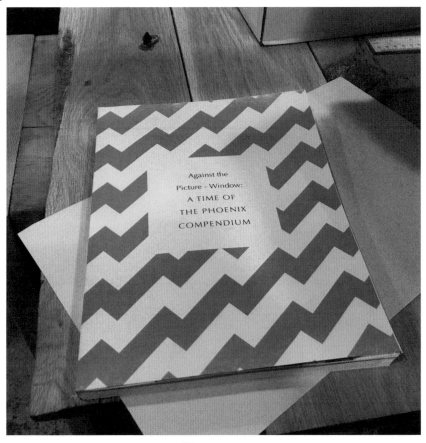

ROBBY HERBST

"I used to be a white American"

Not to worry, the event was about more than simply lis-
tening to speeches. The crowd also had the opportunity
to join in a sing-along with a quartet whose repertoire
included lyrics attacking US military contractors and
mocking national missile defense. For those who survived
the day's program, there remained the treat of perusing
the literature tables that overflowed the front patio of
the auditorium. Here one had the chance to obtain materi-
als explaining the cruelties inflicted by the United States
on the rest of the world, the urgency of releasing Cuban
political prisoners (held by the US Government, not Cuba),
and the need for the state to pay women for their house-
work. One could also purchase a t-shirt emblazoned with
the words, "I used to be a white American, but I gave it
up in the interest of humanity.

From "Leftists Rally Against Bush in Los Angeles" by Edgar B. Anderson
(*FrontPageMagazine.com*, Friday, February 22, 2002)

A young lady handed me a square of posterboard washed in
pink watercolor with a brighter pink star painted on it
and PEACE painstakingly lettered across the front. A fam-
ily displayed a photograph of Afghan women, labeled "Our
Afghan Sister Family." They gave me a printed handout stat-
ing that the Revolutionary Association of the Women of
Afghanistan had "condemned the U.S.-backed Northern Alliance
for a 'record of human rights violations as bad as that of
the Taliban's.'" The handout ended with the sad and deflated

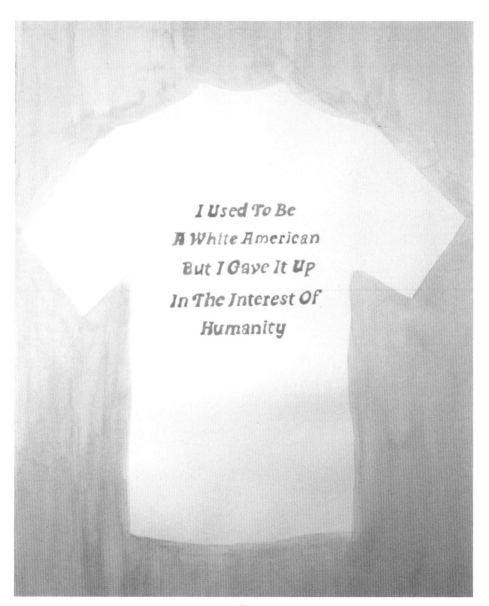

I Used To Be
A White American
But I Gave It Up
In The Interest Of
Humanity

sentence: "This statement has apparently been ignored by George Bush and his associates."

A young man wore a T-shirt saying, I USED TO BE A WHITE AMERICAN BUT I GAVE IT UP IN THE INTEREST OF HUMANITY. But another demonstrator wore one of the Abercrombie & Fitch t-shirts that recently had been withdrawn from stores following accusations of racial insensitivity. A fat, slant-eyed bodhisattva appeared above the slogan "Get your Buddha on the Floor." Nearby was a banner from the Buddhist Peace Fellowship.

From *Peace Kills: America's Fun New Imperialism* by P. J. O'Rourke (Grove Press, 2005)

The murder of James Byrd, Jr. didn't happen just because three white men got into a drunken rage. This was a crime birthed and nurtured in the cradle of AmeriKKKa. Lawrence Brewer, Sr., the father of one of the men who killed James Byrd, spoke to this as he repeatedly stressed his sympathy for the victim in this case, "If the color of your skin is gonna cause you to be killed, there is something wrong with society."

In the hours after hearing about the murder of James Byrd, Jr., I spoke to many friends about it. A lot of white friends expressed their horror and disgust at the murder. What they were saying reminded me of the Refuse & Resist! slogan: "I used to be a white American but I gave it up in the interests of humanity." A few Black friends seriously challenged me off of hearing about the murder. They wanted to know if, in the face of all this—all the insane cruelty and hatred crammed into the murder of James Byrd, Jr.—I still believed that things can and will change.

From "Amerikkka 1998: The Lynching of James Byrd" by Michael Slate (*Revolutionary Worker* #962, June 21, 1998)

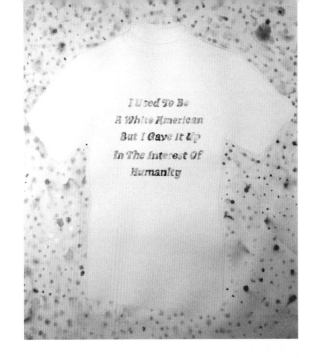

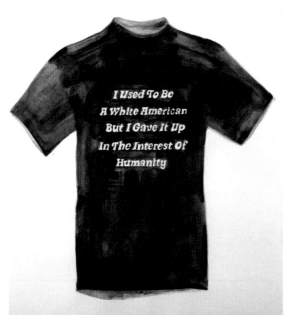

I Used To Be a White American, Pencil, watercolor paint and gouache on paper, 2015.

Not too long ago, I helped design an interface for some popular mapping software. As I learned one day in a Southern Californian office park conference room, a popular use for this software is the visualization of "market segmentation." Imagine that Starbucks wants to open a new location. They might want a map to show where existing Starbucks locations are and aren't, and where people are and aren't. And not just any kind of person—they might want to know where the kind of people that they imagine going to Starbucks are. This is market segmentation. This particular company split people up into 100 segments, 100 types of households—each a particular amalgamation of income, race, household composition, and consumer preferences. The actual market segment "Laptops and Lattes" describes people "with no home ownership or child-rearing responsibilities, singles who live alone or with a roommate. The average household size is 1.8. The median age is 37.6 years. Although most of the population is white, Asians represent 10.4 percent of the total population. This segment is affluent; the median household income of $84,612 supports these residents." Every census tract in America is then assigned a value based on how many instances of each kind of household are present (or predicted). And thus decisions are made.

Market segmentation abstracts people into assemblies of traits—traits that allow corporate deciders to make predictions. The desire is for "actionable" data. The assumption that you meet the description of the kind of person who might want a Starbucks (based on your income, race, household size, gender, etc.) is factored into a calculation on a map, and it leads to the construction of that actual Starbucks in the world. The category presupposes and then generates the reality.

We are often led to believe that identity politics are the product of social movements. But those who think about the politics of self-determination make up just a tiny segment of those who structure their understanding of the world around

"identities." The actual practice of identity politics is mostly done by governments, politicians, marketing departments, demographers, and corporations—anyone who needs to "target" services, products, or less friendly modes of contact. Whether as citizen, resident, or consumer, you are being hailed by your categories right now.

Historian Matthew Hannah coined the term "statistical citizenship" to describe the political power of our participation in the count. His primary example is the census. The way you fill out a census card may have a greater effect on your neighborhood and your life than how you fill out your ballot. How many services are offered, and of what kind?

Visitor Survey presents some of the primary categories used to hail individuals and households in the United States as subjects (the US Census), bodies (the National Health Survey) and consumers (the Survey of the American Consumer). These categories have been designed to make predictions about your behavior, what you care about, and what you will do in the future.

Demographers have distinct ideas about which of your categories mean the most about you, and by "mean," they mean the categories that can *predict* the most about your future behaviors. These judgments are given concrete significance by the weight that the algorithm of something like market segmentation accords your data.

Visitor Survey is less interested in your answers to the questions it asks, and more interested in creating a space to imagine your own weighing system. Can you take the reigns of your own categorization? What categories do you believe are most fundamental to your life? In which categories can you imagine working for political solidarity? How do these align? How adequately do they describe your intentions?

Visitor Survey (detail from Kelly Writers House), Inkjet plot and map pins, 2015. Following page spread: *Visitor Survey*, Inkjet plot and map pins, 2015.

VISITOR SURVEY

1. Please place a pin in each category that describes you
2. For the three categories that you believe play the large
3. Please place a pin in the three categories in which you

RACE

- Multiple
- Other
- Asian and Pacific Islander
- American Indian
- Black
- White

ETHNICITY

- Hispanic

AGE	MALE	FEMALE
85+		
80–84		
75–79		
70–74		
65–69		
60–64		
55–59		
50–54		
45–49		
40–44		
35–39		
30–34		
25–29		
20–24		
15–19		
10–14		
5–9		
< 5		

MARITAL STATUS

- Never married
- Married
- Widowed
- Divorced

HIGHEST LEVEL OF EDUCATIONAL ATTAINMENT

- 7th and 8th grade or lower
- High school graduate, GED, or alternative
- Some college, less than 1 year
- Some college, 1 or more years, no degree
- Associate's degree
- Bachelor's
- Master's degree
- Professional school degree
- Doctorate degree

LANGUAGE SPOKEN

- Speak only English
- Speak Spanish
- Speak other Indo-European languages
- Speak Asian and Pacific Island languages
- Speak other languages

INCOME

- Less than $10,000
- $10,000 to $14,999
- $15,000 to $19,999
- $20,000 to $24,999
- $25,000 to $29,999
- $30,000 to $34,999
- $35,000 to $39,999
- $40,000 to $44,999
- $45,000 to $49,999
- $50,000 to $59,999
- $60,000 to $74,999
- $75,000 to $99,999
- $100,000 to $124,999
- $125,000 to $149,999
- $150,000 to $199,999
- $200,000 or more

MEANS OF TRANSPORTATION TO WORK

- Drove alone
- Carpooled
- Public transportation (excluding taxicab)
- Bus or trolley bus
- Streetcar or trolley car
- Subway or elevated
- Railroad
- Ferryboat
- Taxicab
- Motorcycle
- Bicycle
- Walked
- Other means
- Worked at home

WORKERS AGE 16+ YEARS (WHO DID NOT WORK FROM HOME) BY TRAVEL TIME TO WORK

- Less than 5 minutes
- 5 to 9 minutes
- 10 to 19 minutes
- 20 to 29 minutes
- 30 to 39 minutes
- 40 to 59 minutes
- 60 to 89 minutes
- 90 or more minutes

OCCUPATION	INDUSTRY
Management	Agriculture, forestry, fishing and hunting
Business and financial operations	Mining, quarrying, and oil and gas extraction
Computer and mathematics	Construction
Architecture and engineering	Manufacturing
Life, physical, and social science	Wholesale trade
Community and social services	Retail trade
Legal	Transportation and warehousing
Education, training, and library	Utilities
Arts, design, entertainment, sports, and media	Information
Healthcare practitioner, technologist, and technician	Finance and insurance
Healthcare support	Real estate and rental and leasing
Protective service	Professional, scientific, and technical services
Food preparation and serving related	Management of companies and enterprises
Building and grounds cleaning and maintenance	Administrative and support and waste management services
Personal care and service	Educational services
Sales and related	Health care and social assistance
Office and administrative support	Arts, entertainment, and recreation
Farming, fishing, and forestry	Accommodation and food services
Construction and extraction	Other services, except public administration
Installation, maintenance, and repair	Public administration
Production	
Transportation	
Material moving	

HOUSEHOLD SIZE

- 1
- 2
- 3
- 4+

DID YOU LIVE IN THE SAME HOUSE 1 YEAR AGO?

- Yes
- No

IS YOUR HOUSEHOLD INCOME ABOVE OR BELOW THE POVERTY LINE?

For reference, in the United States the 2015 poverty level is defined for a household of two as less than $16,000 (or a household of four, less than $24,250.

- Above
- Below

RENT OR OWN

- Rent
- Own
- Own Multiple Properties

EMPLOYMENT: ARE YOU...

- working for pay at a job or business
- with a job or business but not at work
- looking for work
- working, but not for pay at a family owned job or business
- not working at a job or business and not looking for work
- Refused
- Don't know

EMPLOYMENT: ARE YOU...

- Employee of a PRIVATE company for wages
- A FEDERAL government employee
- A STATE government employee
- A LOCAL government employee
- Self-employed in OWN business, professional practice or farm
- Working WITHOUT PAY in a family owned business or farm
- Refused
- Don't know

WHICH OF THE [...] HOW YOU THINK [...]

- Gay
- Straight, that is, not gay
- Bisexual
- Something else
- I don't know the answer
- Refused

WHAT DO YOU [...]

- You would straight, but don't whether their such an operation of gender [...]
- You are transgender, gender [...]
- You have not figured out or you are in the process of figuring out your sexuality
- No, do not think of yourself as having sexuality
- You do not use labels to describe yourself
- You mean something else
- Refused
- Don't know

HOW WORRIED [...] ABOUT NOT HA[...] RETIREMENT?

- Very worried
- Moderately worried
- Not too worried
- Not worried at all
- Refused
- Don't know

HOW WORRIED [...] NOT BEING AB[...] SERIOUS ILLN[...]

- Very worried
- Moderately worried
- Not too worried
- Not worried at all
- Refused
- Don't know

HOW WORRIED [...] NOT BEING AB[...] GAGE, OR OTH[...]

- Very worried
- Moderately worried
- Not too worried
- Not worried at all
- Refused
- Don't know

in determining your fate, please replace your pin with a pin
most inclined to organize

REPRESENTS
ELF?

ABOUT HOW LONG HAVE YOU LIVED IN YOUR PRESENT NEIGHBORHOOD?

Less than
1 year

1–5 years

6–10 years

11–20 years

More than
20 years

Refused

Don't know

HOW MUCH DO YOU AGREE OR DISAGREE WITH THE FOLLOWING STATEMENTS ABOUT YOUR NEIGHBORHOOD? THERE ARE PEOPLE I CAN COUNT ON IN THIS NEIGHBORHOOD. WOULD YOU SAY...

Definitely
agree

Somewhat
agree

Somewhat
disagree

Definitely
disagree

Refused

Don't know

IS THERE A PLACE THAT YOU USUALLY GO TO WHEN YOU ARE SICK OR NEED ADVICE ABOUT YOUR HEALTH?

WHAT KIND OF PLACE DO YOU GO TO MOST OFTEN - A CLINIC, DOCTOR'S OFFICE, EMERGENCY ROOM, OR SOME OTHER PLACE?

FINANCIAL

HEALTH

AUTOMOBILES

TRAVEL

INSURANCE

BEVERAGES

HOME

GROCERY

PETS

GENERAL ATTITUDES

READING MATERIALS

SALEM COLLO-JULIN
What Am I Doing Hanging Round?

I'm interested in examining the social lives of the historical people we laud. In the case of members of groups such as the Young Patriots organization, I am especially interested in the places and situations in which they might have found playtime, fellowship, and fun. Exploring country and western music of the late 1960s and early 1970s, along with my previous knowledge of folk and rock, led me to imagine a singing duo. Frankie and Todd are a fictional group that lived in the same buildings in the Uptown neighborhood of 1960s and 1970s Chicago that our radical activists would have. They are singers and musicians, but their very existence is a threat to some in the neighborhood. What Am I Doing Hanging Round? *is conceived as a play with music and has a create-your-own element in that several of the pieces of dialogue and musical structure will be up to the performers to improvise or write themselves.*

Here are some words from a brief performance of initial excerpts. While I per-formed solo for the Organize Your Own *opening in Philadelphia, the finished version of* What Am I Doing Hanging Round? *could be performed by one to four people.*

OK, this is an excerpt of a work in progress, inspired by the post-1971 atmosphere of the grittier neighborhoods of Chicago. We start in a contemporary college classroom, a familiar place for some of you.

(A DEEP BREATH AND STRAIGHT POSTURE—THE INSTRUCTOR)

All right. If everybody is here now?
I'm going to start the discussion today with some questions regarding last week's reading and listening assignments—yes, Marcus . . . mm-hmm, it is the found

cassette tape recording and transcription? No?

You'll catch up. No, assignment two—from the interview with Frankie, of the band Todd and Frankie, a sort of folk-rock-psych-should-have-been duo and a personal favorite which we are studying in our mid-American-'70s unit . . . great stuff. OK. First reactions to the material?

Any reactions to the material?

All right. Uh Why don't we just listen to part of the audio together and maybe it will inspire some—words from you?

(STAND AND TAKE OFF SCARF—FRANKIE)

Man, I don't know where he is, he was supposed to be here an hour ago, is the thing on? Do you need me to test the sound or—(TURN) no, man, I just want to lay my parts down now, I can't wait anymore. (TURN) Yeah, I called his Mom's house; I stopped by the A&P, no dice. Yeah, I'm worried.

(FRANKIE STARTS TO PUT SCARF ON—RETURN TO INSTRUCTOR)

So as everyone should remember from the readings, this recording was attributed to Frankie—Can anyone guess who the man is that we hear in and out, especially at the end, pretty much ruining the recording session? Yes, Marcus, it's not Todd. The coffee is kicking in.

Anyone else? Reactions? Brittney? Yes, it is a little more introspective and experimental as opposed to their *actual* demo record, which I played for you last week. And as you read, this recording happened after the damage was made to their apartment, so we can assume that some emotions are raw.

So, we can look into the lives of more famous musicians from this period and their disillusionment with the systems crashing around them—thinking of Phil Ochs here and his songs of protest being pushed away for one example—but I hope that the reading assignment helped to illuminate why we focus so much on this particular duo and their unfortunate turn of events.

In the spirit of our research into the emotional landscapes of living histories, why would we look at something as small as a casual recording session such as this one? Yes, James?

Yes, there is something great about hearing actual human voices from history, and in the spirit of that, we'll listen in a bit to part of a 1987 interview with Frankie, from a public radio program shortly before her liver failure.

Ah, one thing I wanted to note is that I do appreciate the multiple journals I have read from those of you who were shocked and disturbed by the interpersonal violence we've been forced to look at when discussing this situation. S,o as I shared from the first class, I'm not *for* violence, especially against women, but it is impossible to understand Todd and Frankie's brief, late work past '72 without talking about the beating incident.

(TAKE OFF SCARF AND RESUME—FRANKIE)

Ok, you can sit down here with me. Don't get excited. No reason to—no, I don't know where he is. NO, I don't think he said that to you. Listen we paid you—I don't know where he is! We paid you rent and . . . that doesn't give you the right to go to all the shows, it was a meeting and I will entertain anyone I want to in my own home—just get out of here now. Just get out of here. Just leave me al—

(breathe)

(SCARF ON—INSTRUCTOR)

Thanks for sharing that Marcus, yes, I agree. I wasn't aware of the "trigger warning" term, but I would say—it's an unfortunate feeling I have that many things in life these days are both a trigger and a warning. I-M-H-O as they say. But it is good to validate out loud for ourselves that in all time periods, the idea of the hood, the mask, shows an attempt to "cover" one's identity—meaning, do the supremacists really believe in these racist beliefs or is just this a violent person drunk on power. . . . (BEAT) OK, in this particular situation we're talking about an insane racist lunatic.

Yes. James. No, I'm not saying that all white people of the time were violent racists—of course, look at Frankie. Frankie was white, was she a target of this person because of a modicum of fame among musicians in Chicago at the time, or because of Todd and Frankie's known "radical" ties? You'll remember we discussed and debated the restructuring of the "radical" ideal in the symposium last semester—it's possible that she was just targeted because of the interracial relationship. We can debate this endlessly, but let's listen to the older Frankie for a second—

(SCARF OFF—FRANKIE SITTING WITH RADIO REPORTER)

So the album never made it past a few tracks. Uh, which I have listened to because the parts that Todd was there for are maybe the last times he was recorded and playing in an aware and with it manner. (SIGH) I mean, we're all responsible for what we decide to do when we try to comfort ourselves, but he just couldn't ever reconcile with not being able to help me, and one thing led to another. And then, years later, he did some time, and then they found him dead in the halfway house. 1978.

I didn't sing much during that time. I had already moved away a few years before. I didn't really sing seriously in public until a few years later. Not until they started asking me to do the benefits. Which is funny, cuz in a way my fans can thank Reagan for that. I mean, I certainly think the movement has shifted in some regard,

Salem Collo-Julin performing *What Am I Doing Hanging Round?*, Kelly Writers House, Philadelphia, 2016.

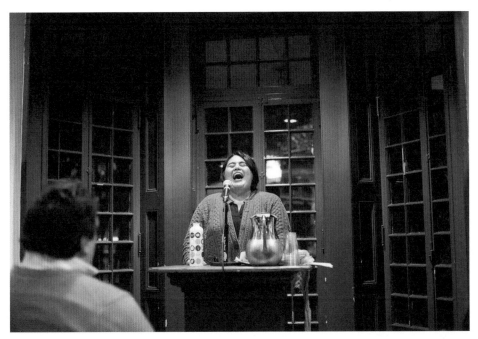

but there's nothing like a blustering demagogue to bring people together. That one *Rock Against Reagan* show was very strange but I was honored that they asked me to sing that hippie death knoll song—I was backed by that band, I think, MDC? Yes, Millions of Dead Cops, or Children, depending on the record of theirs, I think. Not a usual collaboration, but it was an excellent time. You know the worst thing about the early days, and even now I guess, is that it's hard to feel like you're in the right place in the world. Todd felt that as well and you get that spark of recognition when you're young—you both realize that even though your families look different you come from the same stupid assholes, they're just from different states, you know. But then we choose to move to neighborhoods in cities and there's still stupid assholes there too. And it sometimes feels insurmountable, like there's nowhere to live and everyone is fucked up. Even now, even without a lot of strife in my life, I'm still thinking sometimes "Who are my people? Who am I doing this for? Who am I supposed to be speaking to now?"

END

R. F. KAMPFER REVOLUTIONARY LITERATURE ARCHIVE

On January 15, 2016, Brad Duncan presented and discussed materials related to American social movements of the 1960s and '70s that inspired *Organize Your Own*, as well as those from contemporaneous international radical movements. Duncan has gathered printed material produced by radical Left and liberation movements from around the world for the past twenty years; his collection, nicknamed the R. F. Kampfer Revolutionary Literature Archive, is located just west of UPenn's campus in West Philadelphia, and includes thousands of pamphlets, newspapers, flyers, and books, from Nicaragua to Vietnam to Detroit. Visitors had the chance to explore the collection and view rare and unique paper items related to a series of radical social movements.

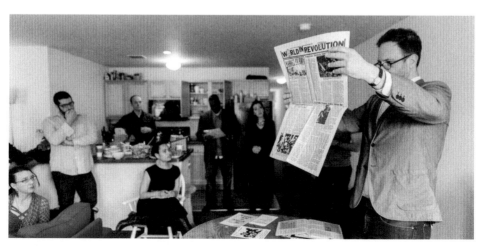

Caption
Top: A selection of materials from the R.F. Kampfer Revolutionary Literature Archive. Philadelphia, PA, 2016.
Bottom: Brad Duncan's personal archive of social movement ephemera (nicknamed the R.F. Kampfer Revolutionary Literature Archive). Philadelphia, PA, 2016
Previous page: Brad Duncan presenting materials during a tour of the R.F. Kampfer Revolutionary Literature Archive.

JEN: ok. we call this ownership ritual no 1.

all land space and articles for well-being and enjoyment are structured through an agreement around belonging. all articles require a containment device and a single individual or group of individuals responsible for the containment device. these medallions mark the territories of agreement. i will convey myself safely upon your perimeter once the medallion has been displayed.

THOMAS: you mention containment devices. is it true that even the bodies themselves require containment? that the bodies don't touch and are containered to protect for separation?

JEN: yes. all things being ordered, the highest principle of course relates to the creature's body whereupon a container is placed. here on display is a host of body containers to prevent touch.

THOMAS: it's true that there is no touch? no wrapping up? no engagement of skin? no patterns of cross-pollination? no cycle of errant action?

JEN: no fingerlock, no hair-forwarding, no salination, no gridlock of mutual meetings.

THOMAS: lingua franca? saxon-b stylus? quantities of flippancy? mixing metaphors?

JEN: nor frothing, cutting, protrusion practices, drinking of juices undescribed, carrying unto death, carrying forthright, carrying for simplicity.

THOMAS: does carrying occur?

JEN: with personal containment devices in place, sure. but as you can see, great pride is taken in containment. it's far from static or ordinary. it is at once an ordering and an organization and not.

THOMAS: no carrying?

JEN: no, really not that much carrying.

Jennifer Kidwell and Thomas Graves are presenting the very first workshop of an original performance piece to be built over the coming year. We are beginning with the idea of a visit from an outsider to allow us the opportunity to step back and take a fresh look at the structures that we have built, to talk about the unwritten rules, and to laugh together about how tragic it is. Imagining an alien interlocutor also provides us the possibility to imagine how things could be otherwise and think about what it means to fit in and what it means to stand out.

THREAD MAKES BLANKET

Thread Makes Blanket is a small press that embarks on collaborations with artists and authors to produce books of substance and beauty. In conjunction with *Organize Your Own*, TMB hosted a publication release and performance in Chicago that featured poets Roger Reeves, Cynthia Dewi Oka, Marie Alarcón, and Anna Martine Whitehead. Whitehead's book, *TREASURE | My Black Rupture*, is a collection of poems that imagine Blackness as a multiverse containing black holes, time loops, ghosts, space sex, and more.

www.threadmakesblanket.com

Anna Martine Whitehead's debut depicts a series of encounters with Blackness in its incalculable manifestations. From jail cells to middle schools, interrogation rooms to the zombie apocalypse, Whitehead traverses the real and unreal, the remembered and the forgotten. It would seem, Whitehead argues, that Blackness (and its attendant affects, physicalities, subjugations) exists everywhere—including all the places we haven't thought of yet. Using essays, poems, and striking images from Whitehead and Suné Woods, *TREASURE | My Black Rupture* powerfully adds to the growing canon of Black Feminist Futurism.

/

Somewhere I know that I am dying I am dead, I am the ghost of a
groaning warehouse. I am Saint Elizabeth's, I am Lorton, I am Elmina. I
groan as I gorge myself, I buckle, I sag like a heavy load. I am crumbling
with osteoporosis and I watch my bones disintegrate. The way I look, I
remind everyone of the Twin Towers at 9:58; I am inevitable. I am
unstable. I am unmistakable. I am 18 lying face down in Missouri at 12:01

on 8/9, traveling backward in time. Backward has 10 dimensions with me—time moves quickly but it is dense. In my final moments I peel back the corners of my hours, recalling all that I can in order to let my memories dance out and away from me; set my damn self finally free.

Beautiful and face down; I am unremarkable in this way. I am overly remarked upon; as I waste away I am composed into a subject to be wasted. I am a continent constituted by desire and theft. I am a peninsula, grounded and growing toward escape. I am a state preparing for my own implosion, at war with my own condition. I am on fire!

Excerpt from *TREASURE | My Black Rupture* by Anna Martine Whitehead

Top: The cover of *TREASURE | My Black Rupture* featuring artwork by Sune Woods. Layout and design by Aay Preston-Myint. Left: Cynthia Dewi Oka, whose *Nomad of Salt and Hard Water* was published by Thread Makes Blanket, reading at publication release, Averill and Bernard Leviton Gallery, Chicago, 2016. Right: Poet Roger Reeves joined Marie Alacorn, Cynthia Dewi Oka, and Anna Martine Whitehead at publication release, Averill and Bernard Leviton Gallery, 2016.

A wedding,
A funeral,
An uprising.

How does violence organize our relationships and communities? How do the mythologies we institutionalize obscure histories of abuse? Are we all, in some sense, working from a script? What happens when we break character and exit the stage?

 This project takes as its departure point three seemingly distinct events: a family wedding, a police funeral, and a domestic uprising. Using found images and text, along with gathered reflections, Works Progress and Jayanthi Kyle compose a new record of these events in the form of a triptych—three essays and three songs—presented on a project website.

 For the full web/audio version of this project, see: weddingfuneraluprising. squarespace.com.

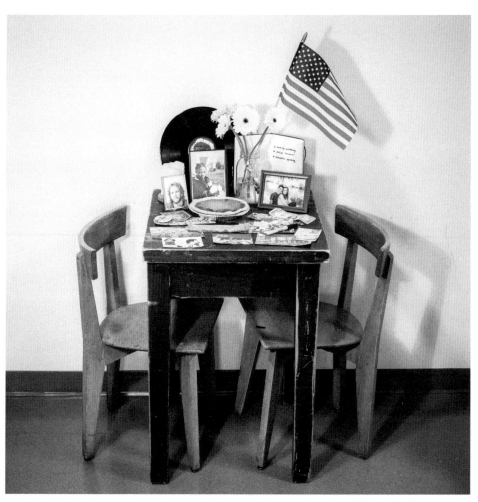

A wedding, A funeral, An uprising, Record cover, 2015.

Amber Art & Design is comprised of five international public artists with years of specialized experience. Based in Philadelphia, PA, Amber Art & Design is committed to creating meaningful public art that transcends and continually challenges the norm with innovative designs and cutting-edge fabrication. amberartanddesign.com

Emily Chow Bluck is a socially engaged artist and community organizer currently based in New York. She works with communities to build local campaigns for social justice that foreground the experiences, stories, and skill sets of her collaborators. Food is consistently an important part of her work. emilychowbluck.com

The Anne Braden Institute for Social Justice Research was established in 2007 at the University of Louisville, and works to bridge the gap between research and action for racial and social justice in the tradition of longtime Southern white anti-racist journalist Anne Braden. The Institute convened a coalition of Louisville historians, students, and community workers who developed a vid-cast project for *Organize Your Own* to explore the influence of Anne and Carl Braden on contemporary activists with Showing Up for Racial Justice (SURJ), depicting the importance of organizing in white communities with ongoing Black leadership. The creative and production team included graduate student Wes Cunningham (lead oral historian and narrator), community activist Carla Wallace of LSURJ, historian Lara Kelland, technology assistants Jamie Beard and Nia Holt, and Braden biographer and Institute director Cate Fosl. anne-braden.org

Billy "Che" Brooks is the former deputy minister of education for the Illinois Chapter of the Black Party for Self-Defense. Brooks has dedicated his life to serving the people and was instrumental in setting up free health clinics, Breakfast for Children programs, legal and housing services, and the fight against racism and social injustice for all peoples. Bill was also a member of the original Rainbow Coalition, and though presently retired, still active in reaching the youth of his community.

Rashayla Marie Brown is an artist-scholar who was lauded as a "2015 Breakout Artist" by *New City* and *Arc Magazine*, and who works in extensive cultural production modes, including photography, video, performance, curation, and writing. Brown also serves as the inaugural Director of Student Affairs for Diversity and Inclusion at the School of the Art Institute of Chicago (SAIC) and holds a BA from Yale University and a BFA from SAIC. Her work has been featured at Bellwether, Cleveland; Black Paper, Los Angeles; Calumet Gallery, New York; the Center for Sex and Culture, San Francisco; Monique Meloche Gallery, Chicago; the Gene Siskel Film Center, Chicago; the Museum of Contemporary Art, Chicago; the Museum of Contemporary Photography, Chicago; the University of Chicago; and other venues. rmbstudios.com

Salem Collo-Julin is a performer and writer who strives to be a good neighbor and likes talking to everybody. From 2000-2014, she collaborated with the artists Brett Bloom and Marc Fischer in the group Temporary Services. Some of their accomplishments included creating and running Half Letter Press (a publication imprint), cofounding Mess Hall (an experimental cultural center in Chicago that closed in 2013, after offering completely free programming for ten years), co-creating over eighty publications, collaborating with a variety of people from all walks of life, and realizing public space projects in cities all over the world. Collo-Julin is currently bridging her experiences in theater, comedy, and music with her day-to-day life as a nonprofit worker and community volunteer to build a series of projects to solve all the world's problems. about.me/hollo

Irina Contreras is an Oakland/LA-based interdisciplinary artist. Her projects examine personal reflections and the speculative origins of collective memory and trauma. Recent projects and interests take the form of speculative fictions inspired by security culture and social media, and realize the manipulation of physical

Installation view.
Kelley Writers House,
Philadelphia, 2016.

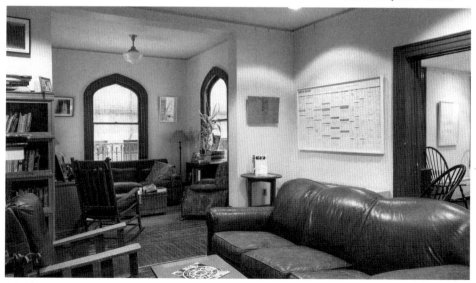

space. Contreras has been working for the last fifteen years at the intersections of mental health, public education, and the arts within institutional (job) and community-based (organizing) platforms. She currently serves as the School and Community Programs manager at the Museum of African Diaspora in San Francisco and holds a Dual-degree MFA/MA from California College of the Arts. She publishes text and image for various anthologies, as well as regularly working with publications like *make/shift magazine*. She still loves zines, Xerox, 7-inch vinyl, and is the founder of a twelve-year-old project, the Miracle Bookmobile. Her work has been featured at the University of Texas at Austin; the Ghetto Biennial in Port Au Prince, Haiti; the Lab in San Francisco; the Hemispheric Institute for Performance and Politics in NYC; the Entzaubert in Berlin, and other venues. machinegunsteady.tumblr.com

Brad Duncan is a nationally recognized collector of printed materials produced by twentieth-century radical Left social movements. Duncan's archive highlights the ways that these movements were interconnected during the global radicalization of the 1960s and 1970s. His archive was the subject of a recent critically acclaimed exhibition at Trinosophes in Detroit, *Power to the Vanguard: Original Printed Materials from Revolutionary Movements Around the Globe, 1963–1987, from the Collection of Brad Duncan*. Duncan has worked for the University of Pennsylvania Libraries since 2011 and is currently working on the Gotham Book Mart collection. Select items from Duncan's archive are profiled on the blog radicalarchive.tumblr.com.

Bettina Escauriza is an artist and writer living in Philadelphia, born in Asuncion, Paraguay. She received her BFA in sculpture from the San Francisco Art Institute and her MFA in electronic arts from Rensselaer Polytechnic Institute. Her work deals with a broad range of issues, including urbanism, anarchism, indigenous issues, immigrant experience, environmental justice, and feminism, frequently expressed through mixed media and actions. Among these, she organized a series of conferences around prison issues and the abolition of the prison industrial complex, together with Native American groups and others in 2008. She has also herded sheep and built outhouses in Black Mesa, Arizona, as a way to support Diné elders resisting relocation. She is a fellow at the Slought Foundation in Philadelphia. tightrope-walker.tumblr.com

Known for mixing history and culture with contemporary themes, **Eric J. Garcia** tries to create art that is more than just aesthetics. Garcia has shown in numerous national and international exhibitions; his awards include a Jacob Javits Fellowship. Currently, he is an artist-in-residence at the Hyde Park Art Center. Originally from Albuquerque, New Mexico, Garcia came to Chicago in 2007 to study at the School of the Art Institute of Chicago, where he earned his MFA. By day, Garcia works at the National Museum of Mexican Art, where he teaches Chicano history and art; by night, he is a versatile artist working in an

assortment of media. From hand-printed posters and published political cartoons to sculptural installations, all of his work has a common goal of educating and challenging. ericjgarcia.com

Paul Gargagliano is a Philadelphia-based photographer. Environmental portraiture is his specialty. His practice has always primarily been about the event of human connection. He brings this sensibility to his work in photojournalism, art documentation, personal projects, and weddings. www.paulgphotog.com

Thomas Graves is a co-producing artistic director for Rude Mechs in Austin, TX. As such, he has developed, performed in, and produced *The Method Gun*, *I've Never Been So Happy*, *Now Now Oh Now*, *Stop Hitting Yourself*, and *MatchPlay*. Graves was formerly a co-creator and performer in Dayna Hanson's *The Clay Duke* at On The Boards in Seattle and the Noorderzon Festival (NL). He also is a dancer and choreographer for the queer performance group Christeene. Graves holds an MFA in performance as public practice from the University of Texas at Austin. For *Organize Your Own*, Graves performed with Jennifer Kidwell. rudemechs.com

Born in Chicago, **Maria Gaspar** is an inter-disciplinary artist who negotiates matters of geography, space, and authority through her work. She creates action-based and performative interventions with youth and adults that explore the social and political body through long-term processes. Gaspar's art practice includes founding major community projects such as *City As Site* (2010) and The *96 Acres Project*, a series of public, site-responsive actions that examine the Cook County Jail and the impact of incarceration on communities of color. Gaspar has been awarded a Creative Capital Grant, a Joan Mitchell Foundation Emerging Artist

Top: Opening night reception, Averill and Bernard Leviton Gallery, Chicago, 2016. Bottom: Installation view, Averill and Bernard Leviton Gallery, Chicago, 2016.

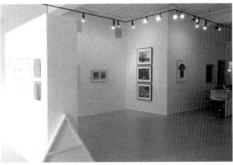

Award, the National Museum of Mexican Art Sor Juana Women of Achievement Award, and residencies at the Experimental Sound Studio in Chicago and Project Row Houses in Houston. She was featured in the Chicago Tribune as Chicagoan of the Year in the Visual Arts in 2014. She is an assistant professor at the School of the Art Institute of Chicago. mariagaspar.com

Robby Herbst is an artist, writer, and radically oriented cultural organizer. He is a cofounder and former editor of the critical art collective, the Journal of Aesthetics & Protest, as well as the instigator of the geographically sited critical landscape projects of the Llano Del Rio Collective. His writing and artworks engage with contemporary and historic experiments in sociopolitical aesthetics. He is the 2014 winner of the Graue Award for a public project to be completed in 2015 in San Francisco, exploring the legacy of the humanist New Games Movement. cargocollective.com/robbyherbst

Jen Hofer is a Los Angeles-based poet; translator; social justice interpreter; teacher; knitter; book-maker; public letter-writer; urban cyclist; and cofounder of the language justice and language experimentation collaborative, Antena, and the local language justice advocacy collective, Antena Los Ángeles. She publishes poems, translations, and visual-textual works with numerous small presses, including Action Books, Atelos, belladonna, Counterpath Press, Kenning Editions, Insert Press, Les Figues Press, Litmus Press, LRL Textile Editions, NewLights Press, Palm Press, Subpress, Ugly Duckling Presse, Writ Large Press, and in various DIY/DIT incarnations. Her visual-textual work can be found online at Alligatorzine, Public Access, and Spiral Orb, and in Exhibit Hall 1 at the Center for Land Use Interpretation's Wendover site. antenaantena.org

Maori Karmael Holmes is a filmmaker, curator, and producer. She is the founder and artistic director of BlackStar Film Festival. She was named an inaugural Philadelphia Creative Ambassador by VisitPhiladelphia in 2009. Her award-winning film/video work has been screened internationally and broadcast throughout the US, and she has written about the arts for various publications. She received her MFA in film from Temple University, studied theatrical design at CalArts, and earned a BA in history from American University. Maori has curated and produced events for over fifteen years, including Kinowatt, a social justice film series (2011–12), and the Black Lily Film & Music Festival for Women (2006–10). blackstarfest.org.

Mike James is a life-long activist known for his commitment to fighting social injustices, since his college days in the 1960s. He was a part of the original Students for a Democratic Society that blanketed the United States in the 1960s by moving into poor neighborhoods to fight for poor people's rights and help them organize for the self- determination of their communities. One of his most notable accomplishments was his work as an organizer in

Chicago`s Uptown neighborhood, which was under the control of a Richard J. Daley machine that held contempt for poor people. He and the community residents organized against police brutality and slum landlords, ultimately creating tenant unions. James served as campaign director for the Eldridge Clever/Peggy Terry presidential campaign and co-creator of Rising Up Angry, which carried on many of the programs from the Original Rainbow Coalition. He is also an accomplished actor and presently co-host of "Live from the Heartland," a radio program that showcases many activists and performers from across the country.

Marissa Johnson-Valenzuela's poetry and prose has been recognized by the Leeway Foundation, Hedgebrook, and others, and can be found both in print and online. She was a 2015 Lambda Literary Fellow, and served as editor for their annual anthology that year. Johnson-Valenzuela is also a member of the Rogue Poetry Workshop, and is the organizer of a quarterly literary salon, still untitled, in West Philadelphia. She is the founder and primary obsessor at Thread Makes Blanket Press, which publishes a range of historical and creative work, including *Dismantle: An Anthology of Writing from the Vona/Voices Writing Workshop*. As part of her teaching at the Community College of Philadelphia, she teaches in Philadelphia jails. threadmakesblanket.com

Valerie Keller, award-winning and twice-Emmy-nominated motion media editor, created original experimental videos for satellite, as well as co-produced videos for the Philadelphia Mural Arts Program and the cable series *Big Tea Party*. Her work has aired on the Travel Channel, Discovery, Sundance, and Comcast; has appeared on THE DISH and VOOM satellite networks; has been featured in festivals and art galleries around the world; featured in art galleries; and has been broadcast on both PBS and cable television. Her original short *Stepping On Upworld* screened at the Philadelphia Art Museum and her short *Discarded* was part of the exhibition *Out Of Frame: Motion Art* at the Philadelphia Art Alliance. vimeo.com/channels/valeriekeller

Billy Keniston, raised as a white man in the United States, has spent his adult life focused primarily on understanding and confronting the destructive dynamics of American racialism. Keniston is a historian and a writer. His two books, *A Problem of Memory: Stories to End the Racial Nightmare* and *Choosing to be Free: A Life Story of Rick Turner*, both reflect his strong desire for a society rooted in meeting human needs.

Jayanthi Kyle is a Minneapolis-based vocalist in more than seven bands, including Black Audience, Jayanthi Kyle and the Crybabies, Romantica, Gospel Machine, Davis Bain Band, Passed Presents, Give Get Sistet, Miss Pennie's Microphone, and the Blacker the Berry Arts Collective. Her musical genres include gospel, African-American heritage/roots music, spirituals and work songs, folk, world music, blues, and Americana. She specializes in music

for "arrivals and departures" (music for infants and funerals), is a mother to three, a wife to one, and herself to all. She continues to work in the Million Artist Movement to dismantle racism and injustice towards people of color and to dream collectively to produce actions for black liberation. She also works with Mama Mosaic on MN Girls Are Not For Sale, which seeks freedom for women and girl sex slaves in Minnesota. For *Organize Your Own*, Kyle collaborated with Works Progress.

Jennifer Kidwell is a performing artist. Recent projects include: *Underground Railroad Game*, co-created/performed with Scott Sheppard (FringeArts, 2015 and 2016; NYC premiere at Ars Nova, 2016); the Bessie Award-winning *I Understand Everything Better* (David Neumann/advanced beginner group); *Antigone* (the Wilma Theater); *I Promised Myself to Live Faster and 99 Break-Ups* (Pig Iron Theatre Company); *Dick's Last Stand* (as the controversial artist Donelle Woolford, Whitney Biennial, 2014); and *Zinnias: The Life of Clementine Hunter* (Robert Wilson/Toshi Reagon/Bernice Johnson Reagon). Her upcoming performances include *Those With Two Clocks*, a drag quartet. She is a proud cofounder of JACK (Brooklyn) and co-artistic director of the Philadelphia theater company, Lightning Rod Special. For *Organize Your Own*, Kidwell performed with Thomas Graves.

Antonio Lopez is executive director of the Little Village Environmental Justice Organization (LVEJO). Born in Gary, Indiana, and raised in Chicago, Illinois, Lopez received his doctorate in Borderlands history from the University of Texas at El Paso. Lopez has written extensively on anti-poverty and anti-racist social movements in Chicago, and has also contributed to human rights, environmental justice, and environmental struggles in Chicago and at the US/Mexican Border. Prior to joining LVEJO, Lopez coordinated a membership program for youth incarcerated at the Illinois Youth Center, St. Charles, and contributed to the Chicago Grassroots Curriculum Task Force.

Lisa Yun Lee is the director of the School of Art and Art History and a member of the art history, museum and exhibition studies, and gender and women's studies faculty at the University of Illinois at Chicago. Lee is cofounder of the Public Square at the Illinois Humanities Council, an organization dedicated to creating spaces for dialogue and dissent and for reinvigorating civil society. She is the co-chair of the Executive Committee at the Institute for Research on Race and Public Policy at UIC, and she serves on the national boards for the American Alliance of Museums, Imagining America: Artists & Scholars in Public Life, and *Ms. Magazine*, as well as the boards of the Rebuild Foundation, the National Public Housing Museum, Young Chicago Authors, 3Arts, and the International Contemporary Ensemble.

Josh MacPhee is a designer, artist, activist, and archivist. He is a member of the Justseeds Artists Cooperative (justseeds.org) and is coauthor of *Signs of Change: Social Movement*

Cultures, 1960s to Now. He coedits *Signal: A Journal of International Political Graphics and Culture* and cofounded the Interference Archive, a public collection of cultural materials produced by social movements (interferencearchive.org).

Nicole Marroquin is an interdisciplinary artist whose creative practice includes collaboration, research, teaching, and strategic intervention. Marroquin is an experienced classroom teacher and has collaborated with youth on art-based action research. In addition to activism in education, Marroquin exhibits her sculpture internationally, including at the Museo Nacional de Culturas Populares in Mexico City and the National Museum of Mexican Art. After receiving her MFA from the University of Michigan in 2008, she moved to the Pilsen neighborhood in Chicago, where she studies participatory cultural production with youth and communities. She is an assistant professor of art education at the School of the Art Institute of Chicago. www. nicolemarroquin.com

Opening night reception, Averill and Bernard Leviton Gallery, Chicago, 2016.

Jenn McCreary has over fifteen years experience in event planning and fundraising, communications and publicity, and marketing and social media, focused but not limited to the Philadelphia market, including the management of and responsibility for a variety of special events (exhibition openings, lectures, film premieres, book release receptions, community engagement events, symposiums, and large annual fundraising galas). Until recently, she was director of communication for the city of Philadelphia's Mural Arts Program. McCreary was a 2013 Pew Fellow in the Arts for Poetry. Her published works include: *& now my feet are maps* (Dusie Press), *The Dark Mouth of Living* (Horse Less Press), *:ab ovo:* (Dusie Press), *a doctrine of signatures* (Singing Horse Press), and *Odyssey & Oracle* (Least Weasel Press).

Fred Moten is author of *In the Break: The Aesthetics of the Black Radical Tradition* (University of Minnesota Press), *Hughson's Tavern* (Leon Works), *B. Jenkins* (Duke University Press), *The Feel Trio* (Letter Machine Editions), and coauthor (with Stefano Harney) of *The Undercommons: Fugitive Planning and Black Study* (Minor Compositions/Autonomedia). His current projects include two critical texts—*consent not to be a single being* (forthcoming from Duke University Press) and *Animechanical Flesh*, which extends his study of black art and social life—and a new collection of poems, *The Little Edges*. Moten served as a member of the board of managing editors for *American Quarterly*, has been a member of the editorial collectives for *Social Text* and *Callaloo*, and served on the editorial board of *South Atlantic Quarterly*. He is also cofounder and copublisher (with Joseph Donahue) of a small literary press, Three Count Pour.

Matt Neff is a skilled artist, printer, and educator who has worked on a number of important projects with institutions including Philagrafika and the Wharton Esherick Museum. Neff's work is concerned with historical and current negotiations of power and privilege with regard to race, gender, and class. Formally, he is interested in a lack of images, anti-icons, and—much like semantic satiation—the repeated and shifting use of common materials like sugar, graphite, air, and ash to evoke visual mystery and a visceral reaction to objects and images. Neff teaches and runs the Common Press at the University of Pennsylvania and was awarded the 2008 PennDesign Distinguished Undergraduate Teaching Award. Neff holds an MFA from the University of Pennsylvania and a BFA in studio art and BA in art history from Indiana University. mattneff.net

Mark Nowak, a 2010 Guggenheim Fellow, is an award-winning poet, social critic, and labor activist, whose writings include the *New York Times*'s "Editor's Choice," *Shut Up Shut Down* (2004, with an Afterword by Amiri Baraka), and a book on coal mining disasters in the United States and China, *Coal Mountain Elementary* (2009), which Howard Zinn called "a stunning educational tool." He directs both the MFA Program at Manhattanville College and the Worker Writers School at the PEN American Center. workerwriters.org

Edward Onaci is assistant professor of history at Ursinus College. His courses focus on African American and Africana Studies, modern US history, women's global political struggles, and more. Onaci's pedagogy incorporates interdisciplinary scholarship and an activist orientation to teaching and learning. He encourages students to take ownership over their personal and group studies, produce their own knowledge, and apply what they learn to their current lives and future ambitions. Also known as Brotha Onaci, a DJ and music producer, he is the cofounder of the People's DJs Collective and Sonic Diaspora.

Dave Pabellon is a graphic designer. He constantly pursues endeavors that connect his graphic design practice with social empowerment through the studio and classroom environment. He has mentored and instructed in the non-profit sector, has taught at the university level, and lectures infrequently for professional design institutions and organizations. Pabellon is currently associate professor of graphic design at Dominican University and formerly a designer at Faust Associates, an award-winning visual communication firm specializing in intuitively guided and collaborative design solutions that disregard convention.

Mary Patten is a visual artist, videomaker, writer, educator, occasional curator, and a long-time community and political activist. Her practice is fueled by the desire to address collisions, as well as alignments, between politics and art making. She has exhibited and screened work for thirty years in alternative spaces, university museums, and international film/video festivals. Her work includes single-channel video, video installation, drawing, digital media, photography, performance, artists' books, and large-scale collaborative projects. Her book *Revolution as an Eternal Dream: The Exemplary Failure of the Madame Binh Graphics Collective* was published by Half Letter Press in 2011. Currently she collaborates with Chicago Torture Justice Memorials and Feel Tank Chicago. Since 1993, she has been teaching in the Film, Video, New Media, and Animation Department at the School of the Art Institute of Chicago. marypatten.com

Rasheedah Phillips is a mother, managing attorney of the housing unit at Community Legal Services, the creator of the AfroFuturist Affair, and ¼ founding member of the Metropolarity speculative fiction collective. She recently independently published her first speculative fiction collection, *Recurrence Plot (and Other Time Travel Tales)*, and an anthology of experimental essays from Black visionary writers called *Black Quantum Futurism: Theory & Practice, Vol. I*. Phillips was a 2015 artist-in-residence with West Philadelphia Neighborhood Time Exchange. afrofuturistaffair.com

Works Progress Studio is an artist-led LLC based in the Twin Cities of Minneapolis and St. Paul, Minnesota. Led by husband/wife collaborative codirectors Colin Kloecker and Shanai

Matteson, Works Progress engages an expansive network of artists, designers, organizers, researchers, and other creative people to realize imaginative public art and design projects rooted in place and purpose. *For Organize Your Own*, Works Progress collaborated with Jayanthi Kyle. worksprogress.org

Anthony Romero is an artist, writer, and organizer committed to documenting and supporting artists and communities whose narratives and practices are often excluded from art historical narratives. He currently teaches in the Department of Fiber and Material Studies at Tyler School of Art and in the Departments of Community Practice and Social Engagement at Moore College of Art and Design.

Frank Sherlock approaches the work of poet as conduit, and the writing process as collaborations of encounter. He is a founder of PACE (Poet Activist Community Extension), which enacts roving guerilla readings/performances in public space. Poems beyond the page have found their forms in installations/performances/exhibitions, including *Refuse/Reuse: Language for the Common Landfill*, *Kensington Riots Project*, *Neighbor Ballads*, and *B.Franklin Basement Tapes*. He is a 2013 Pew Fellow in the Arts for Literature, and the 2014–15 Poet Laureate of Philadelphia. franksherlock.blogspot.com

Aletheia Hyun-Jin Shin is a social practice artist based in Baltimore, Maryland. Incorporating organizing and storytelling in her artistic praxis, Shin collaborates with communities as an artistic asset to nurture and build solidarity and community voices.

Amy Sonnie is an activist, educator, and librarian. She is coauthor of *Hillbilly Nationalists, Urban Race Rebels, and Black Power: Community Organizing in Radical Times* (with James Tracy; Melville House, 2011), which explores the inspiration and impact of multiracial coalitions among poor/working-class white, Black, and Latino activists during the sixties and seventies. Her first book, *Revolutionary Voices: An anthology by Queer and Transgender Youth* (Alyson Books, 2000), has been banned in parts of New Jersey and Texas. Sonnie is cofounder and a current board member of the Center for Media Justice, and works as a librarian in Oakland, CA, where she coordinates adult literacy and civic engagement programs. @bannedlibrarian

Jennifer S. Ponce de León (née Flores Sternad) is assistant professor in the Department of English at the University of Pennsylvania. Her research is situated at the intersection of literary studies, studies of contemporary visual arts and aesthetics, and the study of social movements, bringing together contemporary US Latino and Latin American cultural production within a hemispheric framework. She received her PhD in American studies from the Department of Social and Cultural Analysis at New York University, her MA in art

history from the University of California, Los Angeles, and her AB in literature from Harvard University. Her work has been published in *Dancing with the Zapatistas: Live Art in LA, 1970–1983*; *Art and Activism in the Age of Globalization*; *MEX/LA: Mexican Modernisms in Los Angeles*, and in the journals *e-misférica*, *GLQ: A Journal of Lesbian and Gay Studies*, *Contemporary Theatre Review*, the *Journal of American Drama and Theater*, and *Interreview*.

Nato Thompson has organized major projects for Creative Time since 2007, including the annual Creative Time Summit, *Living as Form* (2011), Paul Ramirez Jonas's *Key to the City* (2010), Jeremy Deller's *It is What it is* (with New Museum curators Laura Hoptman and Amy Mackie; 2009), *Democracy in America: The National Campaign* (2008), Paul Chan's acclaimed *Waiting for Godot in New Orleans* (2007), and Mike Nelson's *A Psychic Vacuum* (with curator Peter Eleey). Previously, he worked as curator at MASS MoCA, where he completed numerous large-scale exhibitions, including *The Interventionists: Art in the Social Sphere* (2004), with a catalogue distributed by MIT Press. His book *Seeing Power: Socially Engaged Art in the Age of Cultural Production* is now available from Melville House.

Thread Makes Blanket is a small press that embarks on collaborations with artists and authors to produce books of substance and beauty. Each publication is seen as an opportunity to embark on a collaboration with the artist or artists. TMB believes that the process of publishing is as important as the final product, and the press seeks to engage with artists in a way that is supportive to their vision, creative in its means of distribution, and anti-capitalist in its intentions. As part of *OYO*, TMB developed and released the chapbook, *TREASURE | My Black Rupture*, by Anna Martine Whitehead, and organized a release event in Chicago that featured readings by Whitehead, TMB author Cynthia Dewi Oka, Roger Reeves, and Marie Alarcón. threadmakesblanket.com

Hy Thurman is originally from Tennessee and now resides in Alabama. A Southern migrant, he settled in Chicago's Uptown neighborhood, a predominantly Southern white community, in the 1960s at the age of 17. He became a community organizer and cofounder of the Young Patriots Organization, a group of displaced Southern white youth, and created services in healthcare, developed breakfast for children programs, and fought urban renewal plans to destroy the homes of Southern white residents. He was also cofounder of the interracial organization Original Rainbow Coalition—made up of the Young Lords, a Puerto Rican gang turned political, and the Illinois Chapter of the Black Panther Party—in order to fight for self-determination of the people in their communities. He received a BA in cultural anthropology in 1973. He is presently working to reboot the Young Patriots and make their forgotten history available to everyone. youngpatriots-rainbowcoalition.org

James Tracy is a longtime social justice organizer in the Bay Area. He currently teaches community organizing at City College of San Francisco. He is the coauthor of *Hillbilly Nationalists, Urban Race Rebels, and Black Power: Community Organizing in Radical Times* (Melville House, 2011) and the author of *Dispatches Against Displacement: Field Notes From San Francisco's Housing Wars* (AK Press, 2014). jamestracybooks.org

Daniel Tucker works as an artist, writer and organizer developing documentaries, publications, and events inspired by his interest in social movements and the people and places from which they emerge. His writings and lectures on the intersections of art and politics and his collaborative art projects have been published and presented widely and he collaborates on the Never The Same curatorial and archive project with Rebecca Zorach. Tucker is an assistant professor and graduate program director in social and studio practices at Moore College of Art and Design in Philadelphia. miscprojects.com

Dan S. Wang is a writer, organizer, blogger, and printmedia artist living in Madison, Wisconsin. Wang's texts have been published internationally in journals, exhibition catalogues, and book collections. His art projects circulate constantly in functional activist settings and through artist-run networks. Along with seven others, he cofounded Mess Hall, the renowned experimental cultural space in Chicago that operated from 2003 to 2013, and he regularly works within groups, including Compass, Red76, and Madison Mutual Drift. For the year 2013, Dan was named Fellow in Arts and Culture Leadership from the Rockwood Leadership Institute in Oakland, California. prop-press.net

Jakobi Williams is associate professor in the Department of African American and African Diaspora Studies and the Department of History at Indiana University. He is the author of *From the Bullet to the Ballot: The Illinois Chapter of the Black Panther Party and Racial Coalition Politics in Chicago* (University of North Carolina Press, 2015).

Mariam Williams is a Kentucky-based writer now living in Philadelphia. She was loving her job in social justice research and was in the midst of pursuing a master's degree in Pan-African studies from the University of Louisville when she decided it was time to pursue creative writing instead. Williams is a 2015–16 Trustees Fellow in the Creative Writing MFA Program at Rutgers University-Camden. She is interested in the intersections of identity, history, and the arts and wants to put her tangential background to use to help women and girls discover the power and importance of their own voices.

Nicholas Wisniewski is an artist and organizer from Baltimore, Maryland. He is a founding member of the Baltimore Development Cooperative, Participation Park, and Camp Baltimore collectives. He currently operates WZ, LLC, an experimental development and

community revitalization project based in the Midway neighborhood of Baltimore City. For the past eleven years, he has owned and operated Phrame, an art service company specializing in the fabrication of custom contemporary picture frames. Phrame has done work for Robert Brown Gallery, Neptune Fine Arts, Heiner Contemporary, Amy Kuhnert Art Consultant, Lauern Hilyard Art Advisory, Grimaldis Gallery, the Baltimore Ravens, the Maryland Institute College of Art, the Baltimore Museum of Art, and the University of Baltimore. phrameinc.com

Rosten Woo is an artist, designer, and educator living in Los Angeles. He produces civic-scale artworks and works as a collaborator and consultant to a variety of grassroots and non-profit organizations, including the American Human Development Project, the Black Workers Center, and the Esperanza Community Housing Corporation, as well as the city of Los Angeles and Los Angeles County. His work has been exhibited at the Cooper-Hewitt Design Triennial, the Venice Architecture Biennale, the Netherlands Architectural Institute, Storefront for Art and Architecture, the Lower East Side Tenement Museum, and various piers, public housing developments, tugboats, shopping malls, and parks. He is cofounder and former executive director of the Center for Urban Pedagogy (CUP), a New York based non-profit organization dedicated to using art and design to foster civic participation. rostenwoo.biz

Wooden Leg Print & Press (WLPP) is the on-going imprint for all publications produced or edited by the experimental publication platform Red76. Society Editions, a WLPP sub-imprint edited by Red76 editor Sam Gould, along with poets Mary Austin Speaker and Chris Martin, seeks to publish timely chapbooks, broadsides, books, and more that highlight the intersection of poetry and politics. In December of 2015, Red76 opened a multi-year initiative, Beyond Repair, a bookshop and publishing site for WLPP publications to serve as a "creative civics lab" for the 9th Ward of Minneapolis, MN. More can be learned about WLPP and Beyond Repair at thisisbeyondrepair.com.

Rebecca Zorach is a professor of Art History at Northwestern University, and she teaches and writes on early modern European art (15th-17th century), contemporary activist art, and art of the 1960s and 1970s. Recent books include the edited volume *Art Against the Law* (2014), and the co-written book (with Michael W. Phillips, Jr.) *Gold* (2016). She is working on a book on the Black Arts Movement in Chicago.

Photos on the following pages were taken by April Alonso: p. 5, 15, 17, 131, 134, 141, 153, 155, 157, 159, 161, 165. All other installation and panel photographs by Paul Gargagliano.

Soberscove Press
Chicago, IL
soberscove.com

Library of Congress Control Number: 2016943606

Second Printing 2017
Printed in Spain by SYL
Design by Josh MacPhee
ISBN 978-1-940190-11-2